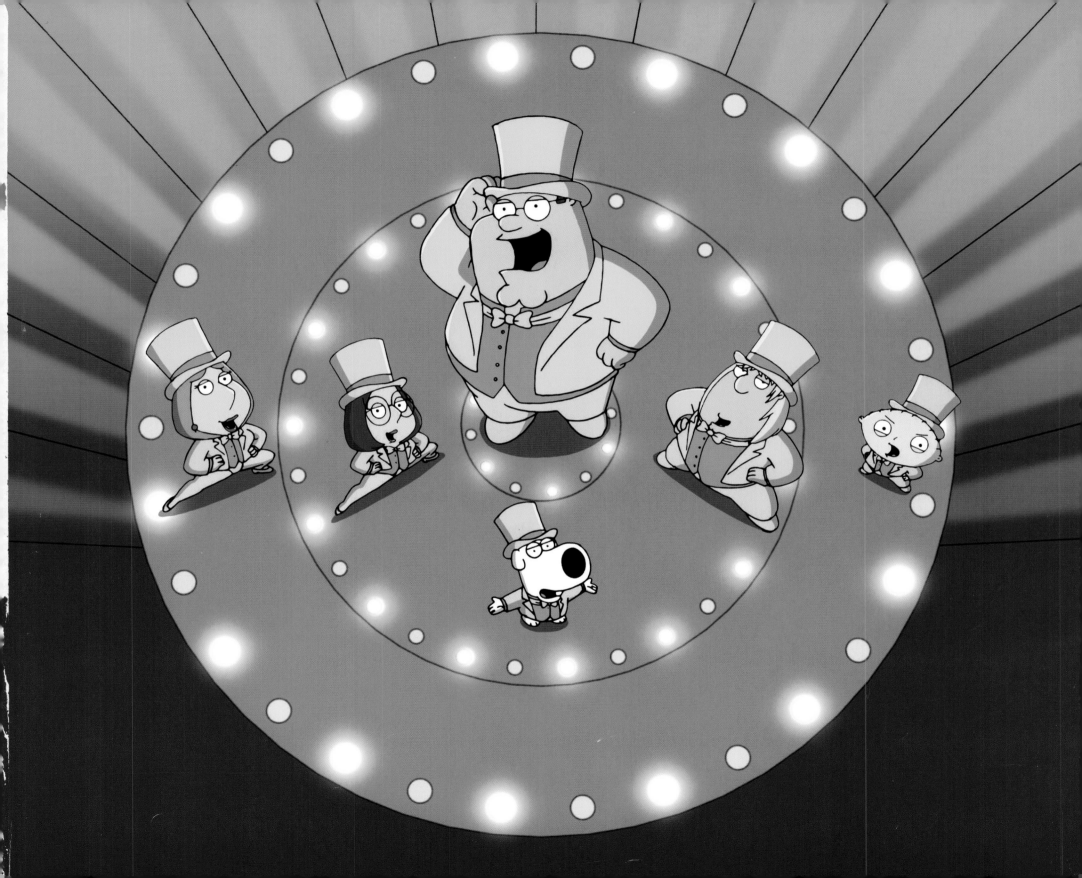

INSIDE

FAMILY GUY

An Illustrated History

FRAZIER MOORE

DEY ST.

An Imprint of WILLIAM MORROW

YOUR VIEWING GUIDE

FOREWORD

If you're holding this book, I assume you're in line at the airport gift shop and just realized you forgot to buy something for your nephew with the Adderall thing. Well, luckily for you, Fox figured, "In this digital world, what's better than a heavy, cumbersome coffee-table book that also destroys our quickly vanishing forests?"

It's hard to believe *Family Guy* has been on the air for 20 years. And that's because it technically hasn't. The show was cancelled multiple times by different people, all of whom have long since been fired. The last cancellation occurred in 2001, which historians agree was the worst thing to happen that year. Fortunately, *Family Guy* was revived in response to massive sales of DVDs, which, I assume, stands for "Dick Van Dyke."

When the show first aired in 1999, Bill Clinton was president, Roseanne had to express her racist thoughts to one person at a time and the quickest way to become a millionaire was to burn your balls with McDonald's coffee. Yes, a lot has changed since then. But one thing that hasn't changed are the jokes. We put the same ones in every week.

Few shows are lucky enough to last so long that their writers die of natural causes. As of this printing, *Family Guy* has aired more than 300 episodes and shows few signs of slowing down, having received a variety of awards printed on surfboards and a handful of positive reviews. Uhp, I'm now being forced to mention the *Family Guy* mobile game, *Family Guy: The Quest for Stuff*. Relive the fun of the show with hilarious in-app purchases. It's "freakin' sweet.™"

In all seriousness, I am truly grateful to everyone who has made this show possible. What started as the student project of a bespectacled RISD geek grew and flourished thanks to the tireless work and enormous contributions of a hugely talented collection of writers, producers, artists, cast and crew. But most of all, I'd like to thank the devoted fans, who literally brought *Family Guy* back from the dead and allowed us to continue working on this show we all love.

Sincerely,
Seth MacFarlane

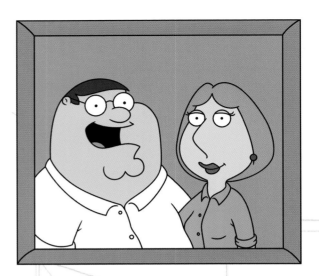
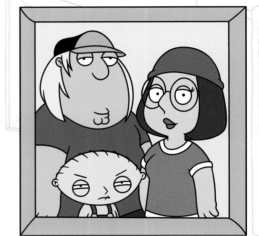

WELCOME TO THE FAMILY

He's some freakin' lucky guy, that Peter Griffin!

For 300-and-counting *Family Guy* episodes, the show's theme song has helped explain why.

After all, it's luckiness that, against all odds, has powered Peter Griffin throughout *Family Guy's* many seasons.

Want an example? Well, to put it bluntly, Peter is fat. Yet, lucky for him, this seems to have had no negative effect on his health, his lackadaisical lifestyle, his habit of running around the house or the neighborhood in his birthday suit, even his sex appeal in the eyes of Lois, his devoted, randy wife.

Another example. The Griffins' three children—dowdy, self-loathing 18-year-old Meg, simple-minded teenager Chris, and Stewie, a megalomaniac, sexually confused toddler—might be regarded as, well, problematic. But not to happy-go-lucky Peter, who skates through fatherhood with blithe unconcern.

All of this suggests a lucky streak long enjoyed by Peter Griffin, who first shared his good fortune with the television audience on the final night of January 1999.

From its inception, *Family Guy* tacitly promised to deliver us, the viewers, from all the violence in movies and sex on TV; to uphold "those good old-fashioned values on which we used to rely," at least according to the quirky cartoon Griffins of Quahog, Rhode Island, and framed, in particular, by paterfamilias Peter Griffin, the lucky man who positively can do all the—well, we already covered that.

On its premiere, *Family Guy* was a freakin' hit seen by nearly 22 million viewers.

Despite dozens of attempts through the years, by 1999 a prime-time cartoon series with any staying power was a rarity. *The Flintstones* had made prehistoric TV history on ABC four decades earlier. Then came *The Simpsons* in 1989. Then, just two years before *Family Guy* arrived, yet another Fox series, *King of the Hill*,

had begun its 13-season marathon just a few months after Comedy Central's scruffy satire *South Park* launched, with still no end in sight. Was *Family Guy* destined to score success on that grand scale?

Just as a frazzled old millennium was slogging toward its finish line and the people of earth braced for Y2K—a digital pandemic said to be lurking at the new year's arrival just 11 months away that, if it struck, would cause computers to crash, utilities to fail and planes to fall from the sky—*Family Guy* premiered.

PUSHING THE ENVELOPE

Fox had high hopes and had beat the drums like crazy. *Family Guy* was billed as *The Simpsons* and then some: an even more unsparing take on American life with a riotously dysfunctional cartoon family raring to go in this new, uncharted 21st century.

As viewers would quickly discover, *Family Guy* lives to mock human nature and human frailties. It dumps on the human condition without fear or favor. Sex, race, religion, physical infirmities and disabilities, Anne Frank, British bad teeth, the murders of Nicole Brown Simpson and Ron Goldman, the coma of Terri Schiavo, John F. Kennedy Jr.'s fatal plane crash—on *Family Guy,* nothing is out of bounds for ridicule. (Why leave it to the attending physician to tell a patient he has end-stage AIDS when Peter and a barbershop quartet can deliver the news with the jolly song "You've Got AIDS"?)

Above and below: **Very early promotional art for** *Family Guy.*

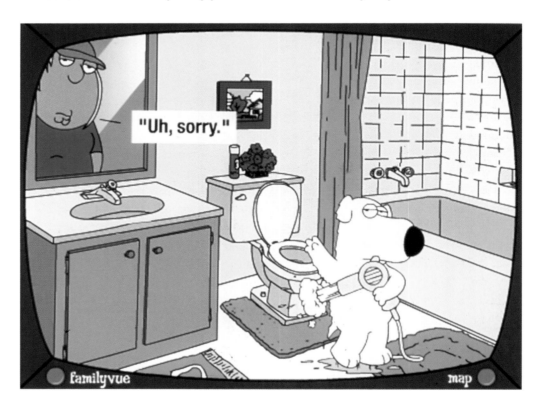

"The characters don't need to be redeeming," Seth MacFarlane declared in 1999 in response to early squawks of disapproval. "I just think we live in a culture where people are sitting with notebooks, dying to be offended, writing things down."

MacFarlane was the cheeky whiz kid who had whipped up this funny, shrewd and often cringe-inducing Our Town, populating it with characters he conceived and drew himself based on his own experience growing up in New England. Going forward, he would continue to play a major role in crafting the scripts. He would furnish voices for three of the Griffins (Peter, Stewie and Brian, the well-spoken family dog) plus dozens more characters. In short, he was running the show.

Just 24, he was coronated as the youngest executive producer in TV history. Besides, MacFarlane's show wasn't going to be on a niche cable channel, but a major broadcast network whose production arm had signed him to a contract said to be worth a freakin' sweet couple of millions. With this level of talent at such a young age, he was poised to be the Orson Welles of animation.

The January debut was a special Super Bowl–launched "sneak preview." The additional six episodes of the show's first season wouldn't air until April and May. But with its return that spring, its weekly ratings would prove promising.

Then came some legendary stumbles: Not just once but twice, the show would face death, then resurrection, by the Fox network. In retrospect, the fact that Family Guy survived, and would continue to thrive years later, isn't just unheard-of (which in the annals of TV it

pretty much is). It's also another sign of great good luck. But that all lay ahead the night of January 31, 1999, when viewers met the Griffins and the world they inhabit.

Family Guy tapped into a rich legacy of live-action family sitcoms reaching back to the birth of TV—though mostly focused by MacFarlane on 1970s and '80s comedy fare—typically lorded over by a blowhard manchild with a wife who would seem to be out of his league, and, usually, a brood of mouthy kids.

DRAWING ON THE PAST

Peter is the Family Guy manchild. He reigns with few moral or physical inhibitions. He accomplishes the outrageous or impossible, or more likely fails stupendously, then bounces back without a scratch or a clue.

This all would apply to many cartoon characters, including those who populate The Simpsons. And, yes, Family Guy drew inspiration from The Simpsons—an undeniable truth that has fueled recurring Family Guy gags.

In one episode, an inebriated Peter collapses into bed and, before passing out, mutters, "We act like we didn't take a lot

from The Simpsons. But we took a lot from The Simpsons."

On another episode, George Clooney and Peter meet at a party and introduce themselves respectively as "George Clooney—second-worst Batman" and "Peter Griffin—second-best Homer."

Peter and Homer have even crossed paths.

During the 13th season, Family Guy aired "The Simpsons Guy," where the Simpson family meets the Griffins after their car is stolen just outside the Simpsons' hometown of Springfield. Then a legal battle erupts between the two cartoon universes with the discovery that Quahog's native Pawtucket Patriot Ale is allegedly a rip-off of Springfield's favorite brew, Duff Beer.

But their first encounter was in the fourth season, "PTV," when Family Guy borrowed a time-honored gag from the Simpsons main

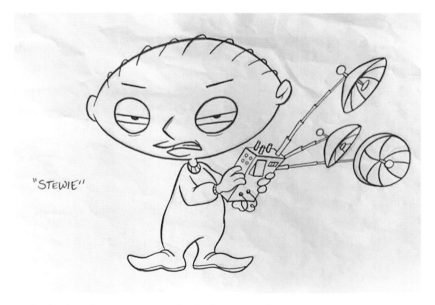

"STEWIE"

Early Stewie concept art by Seth MacFarlane.

title: As Stewie, astride his Big Wheel, pulls into the Griffin driveway, he sends an incongruous Homer Simpson scrambling to avoid getting run down.

"Hi, Stewie," says Peter on appearing in the garage's doorway. Then he notices Homer, knocked unconscious at his feet. "Who the hell is *that?*"

Based in their separate worlds, *The Simpsons* and *Family Guy* coexist beautifully on Sunday nights and in the culture. But *Family Guy* is no *Simpsons* knockoff, as a few *Simpsons* loyalists insist. In fact, in some ways it's the mirror opposite.

Take the differences between Peter and Homer.

Like the other *Simpsons* characters, Homer is generally bug-eyed with disbelief or comeuppance as he encounters life's incessant setbacks (a mortified "D'oh!" is his mantra). But like the others on *Family Guy*, Peter views life with a "What, me? Worry?" attitude through heavy-lidded eyes.

The Simpsons excels by continuing to inhabit Springfield as an oblivious world that seems resigned to settle for less in everything from public schools and religion to law enforcement and environmental issues, such as at the nuclear power plant that employs Homer, of all people, as a safety inspector. Denizens of *The Simpsons* stay happy just getting by (in Homer's case, junk food and Duff Beer). No corner is uncut. *The Simpsons* is a sustained, hilarious retort to the notion of American exceptionalism.

Peter, however, exists in a realm of post-worry. He is immune to shame or doubt as he engages in his across-the-board excesses. He

is spared any need for peer approval. He is a man who makes no excuses or apologies. He is absolutely *not* woke. He, in short, is a free man who, for at least each *Family Guy* episode, can serve as the audience's proxy and sets the viewer free.

AN UNLIKELY DUO

Peter may have signaled early on that *Family Guy* was going to be, well, new and different. But what instantly set it apart from every other family comedy, live-action or cartoon, were the

Griffins' aforementioned youngest child and family pet.

What was the deal with Stewie's football-shaped head? His mad-scientist brilliance? His twin all-consuming quests: to take over the world and to kill his mother?

As furnished by MacFarlane, Stewie's plummy voice was modeled on that of British actor Rex Harrison (best remembered as the English gentleman who coached a Cockney working girl in the ways of high society in the musical *My Fair Lady*). In Stewie's first-ever scene, he explodes when Lois takes away the toy pistol he believes is his mind-control device.

"Stewie," Lois says, "I said no toys at the table."

"Damn you, vile woman!" Stewie rages from his high chair. "You've impeded my work since the day I escaped from your wretched womb."

"You can play with your toys tomorrow, honey," says Lois, who seems to hear his outbursts only as benign baby talk. "Right now, it's bedtime."

Even less conventional was Brian, a pooch with a curiously human streak.

Like Stewie, Brian could speak. But unlike Stewie, whose ability to communicate with others seemed to vary from character to character, Brian could converse with everybody, none of whom found it the least bit remarkable that this canine not only talks but—as would come to light in future episodes—enjoys a dry martini, drives a car, fancies himself an accomplished writer and dates dishy women (while nursing an unrequited lust for Lois). He became, in short, the most erudite member of the family.

Granted, the bar was set low, especially with Peter, an overgrown child who luckily is given free rein by the show's elastic boundaries to do almost anything, no matter how moronic, dangerous or impossible, and never suffer any consequences.

In the 1999 pilot, he drinks too much at a stag party and, hungover the next day, loses his job at, fittingly, Happy-Go-Lucky Toys.

He doesn't want to tell Lois.

"If she finds out I got fired for drinking," he frets to Brian, "she's gonna blame *me*!"

He applies for welfare and, thanks to a computer glitch, starts getting weekly six-figure checks.

But then Lois learns their newfound wealth isn't really thanks to the big raise Peter had told her he got at work. As a grand gesture meant to placate her, Peter resolves to return all his ill-gotten cash to America's taxpayers—by dropping it from a blimp he and Brian pilot over Super Bowl XXXIII (bringing Fox's night of programs full-circle back to Miami's Pro Player Stadium, site of that year's Super Bowl).

The money drop causes a riot at the stadium as the blizzard of bills litters the field.

Then Peter crashes the blimp.

Then he and Brian are arrested.

"I really let Lois down this time," Peter moans to Brian in the jail cell they are sharing. "You think she'll wait for me?"

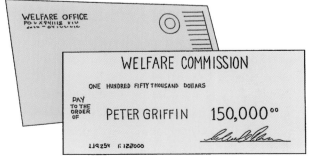

"Oh, c'mon," shrugs Brian, looking up from the book he's reading in his bunk. "If every woman dumped her husband just for crashing a blimp into the Super Bowl, *nobody* would be married."

EXTENDED *FAMILY*

Peter is driven by witlessness, and that's a driving force for many of the other characters as well.

The extended *Family Guy* family includes Peter's drinking buddies: airline pilot/sex addict Glenn Quagmire; Cleveland Brown, an affable black man who sees the good in everything; and paraplegic city cop Joe Swanson.

In time, other characters would be introduced: Herbert, a withered senior citizen with a walker and a vocal fetish for young boys; Seamus, a shiver-me-timbers sea captain whose body is all wood;

Tom Tucker, the stiff yet unsteady local TV anchorman whose son has a strange affliction (the head that rests on his shoulders is upside down); and, of course, the wacky, irrepressible Mayor Adam West, voiced with glorious hamminess by actor Adam West.

But however unhinged, the family and friends on *Family Guy* share one useful streak of self-awareness. As self-aware cartoons in a cartoon dimension, they take full advantage of it, and never lose sight of another guiding principle: They're on TV, whose many conventions they can highlight and mimic and taunt. Which they do.

We know the Griffins love television. We know this by the fact that, after each episode's usual establishing shot (a cheery view of the Griffin home that honors the way family sitcoms have begun since time immemorial) we then are likely to be whisked into the Griffins' living room, where the Griffins sit, gazing at their own TV.

Thus *Family Guy* acknowledges that it occupies a dual existence: as a cartoon sitcom with Quahog its home base—and also in a wide-open virtual dimension, a realm the Griffins can access on their TV screen. There, on the Griffins'-screen-within-*your*-screen even more than in the zany Quahog version of the physical world, anything goes. As it does for us who buy into *Family Guy*. (Note that a TV set serves as the dot for the "i" in the *Family Guy* logo.) This is the deal we strike with the Griffins. We watch TV. They watch TV. We watch them watching. We all watch together.

Very early promotional art for *Family Guy*. The Griffin house still resembles the original pilot design.

FAMILY VIEWING

"Quaint" isn't a word we normally associate with *Family Guy*. But during the run of the show, while, for most of us, the pastime of watching TV evolved into a personal affair spread across a variety of screens, the Griffins still do it the old-fashioned way: huddled around that family TV set.

Where video gadgetry is concerned, this is not a family of early adopters. In one episode Peter and Lois go shopping to replace their VCR. The salesman tries to sell them on a multi-featured digital marvel they've never heard of called TiVo.

"Should I ring it up?" the salesman presses.

"Hold on," says Lois, not about to be rushed. "I think we should discuss it first."

That's when the sly salesman activates a special TiVo remote to skip past Lois' real-time dithering. A few leapfrogged moments later, she and Peter find themselves at the checkout counter, their discussion over, as they eagerly make their purchase.

Even so, tablets, mobile phones and laptops channelling video are not part of the Griffins' daily media diet. Peter's only other regular exposure to a TV screen is the one at his bar, the Drunken Clam, a site that, like his living room, recalls television's distant past: It was in neighborhood bars as well as living rooms where TV first took hold. (Fun fact: In TV's infancy back in 1947, one-third of all TVs in Chicago were in taverns.)

Now, as we watch TV through the eyes of our *Family Guy* companions, what do we see?

VIEWING PARTY

We see a commercial for eye surgery bloated with the booming voice and hyperactive images of a monster-truck promotion: "This Sunday, Sunday, *Sunnnnday*, one day only, Lasik Eye Centers will *heal! your! eyes!* . . . So come on down to the Hydrox Arena this Sunday! *Sunnnday!* Get your eyesight fixed!" The surgeon, Dr. Lee Feldstein, is "fully licensed, fully trained, fully Jewish." A Star-of-David graphic streaks across the screen. *"Jewish!"*

We see an ad for Pepperidge Farm where the baked-goods brand's country gent blends his usual horse-and-buggy nostalgia with a threat of extortion: "Remember those sweet, warm New England summers? Remember sippin' lemonade underneath a shady tree? Remember when you hit that pedestrian with your car at the crosswalk

and then just drove away? Pepperidge Farm remembers. But Pepperidge Farm ain't going to *keep* it to Pepperidge Farm's self, free of charge. Maybe you go out and buy yourself some of these distinctive Milano cookies. Maybe this whole thing just disappears."

We glimpse the teen-angst drama *One Tree Hill* as, standing in a high school corridor beside their lockers, Lucas sighs, "I've got *so* many problems," whereupon his half-brother, Nathan, gently offers reassurance that his worries are "nothing that can't be fixed by staring at a lake."

The very first gag in the series' debut episode finds the Griffins watching *The Brady Bunch* as Dad inflicts draconian punishment on Greg and Jan for the most minor misbehavior: They are sentenced, respectively, to four hours in the basement snake pit and a day in the closet-installed chamber of fire.

In the series' second episode, Peter is forced to go more than a week deprived of TV after Quahog's community satellite dish is destroyed. In his cold-turkey state, he is reduced to surfing through channel after channel of snowy static on the screen.

The Griffins, like many TV viewers watching them, are dedicated couch potatoes. But Peter and his family are much more than passive observers. They also sometimes take charge.

In the episode "PTV," Peter fights back against the FCC's censorship crusade against his favorite shows by starting his own TV station. On his self-styled PTV channel, "you get to watch your favorite shows as nature intended them," he tells his audience, "with all the sex, violence, swearing and farts intact."

Lois objects to this new venture, for the sake of any children who might be tuning in:

"I really want you to cancel that show with the animals having sex."

"For your information," Peter harrumphs, "it's called *Dogs Humping*, and it is the cornerstone of our Wednesday night lineup."

In "Ratings Guy," the Griffins are chosen as a TV Ratings household, whereupon Peter, realizing his potential to control which TV shows seem popular and which shows don't, commandeers scores of TV ratings boxes and (briefly) rules the airwaves.

Stewie, equipped with a laptop and video software, reveals a perverse streak of TV creativity when he screens his brand-new music video for Brian. His video is set to a song he claims to have written himself (actually the 1991 Bryan Adams hit "(Everything I Do) I Do It for You"), a forlorn bit of treacle starring Stewie in a treasury of the stylistic tics and incoherent imagery that music videos feast on.

"*That,*" erupts Brian when the video is over, "is the *worst* thing I have *ever* seen. *EVER!*"

In the episode "Fox-y Lady," Lois lands a job as an investigative reporter on Fox News Channel, and on her first story uncovers an astonishing kinship between presumed political archenemies Michael Moore and Rush Limbaugh. (Turns out both of them are creations of actor Fred Savage in disguise.)

In another episode, Lois becomes friends with a local Channel 5 anchorwoman who betrays her trust, and divulges her embarrassing secret, for the sake of this scoop: Lois Griffin, Quahog's seemingly respectable wife and mother, made a porn film while she was in college.

The community is in an uproar. Lois is even banished from church.

"What does it *matter* what those people

in church think?" Peter comforts the sobbing Lois as, stepping outside of the series he exists on, he reminds her how *Family Guy* animates its crowd scenes. Referring to the scornful congregants surrounding him and Lois at that moment, Peter points out that "most of them are just random background people we've never seen before. Half of them never move. The other half just blink."

Even Brian gets in on the action of television production in the episode "Brian Griffin's House of Payne" from Season 8, when he successfully pitches a network TV pilot. However, almost

immediately network executive notes trample Brian's vision, transforming his earnest drama featuring Elijah Wood into a crude and moronic sitcom called "Class Holes," starring James Woods and a chimpanzee.

The nods to television and its kooky ways are ubiquitous. Since episode 1, the series' main title sequence finds Peter and Lois seated at their piano in an unmistakable nod to the Archie-and-Edith opening of *All in the Family,* a landmark TV sitcom.

But unlike that show, whose theme song, "Those Were the Days," could only look

backward wistfully, there's madcap, forward-looking optimism in the *Family Guy* theme, not only extolling the luckiness with which the show resonates, but also rejoicing in it. And in the main title sequence, *Family Guy* declares that while the show may be *on* TV, it can't be contained in a TV-sitcom universe: The action bursts from the Griffins' Quahog living room into a full-scale theatrical revue with Peter, Lois, Brian, Stewie, Chris and Meg all singing and high-stepping in matching gold finery. (That lavish production number, otherwise unchanged through the years, in the ninth

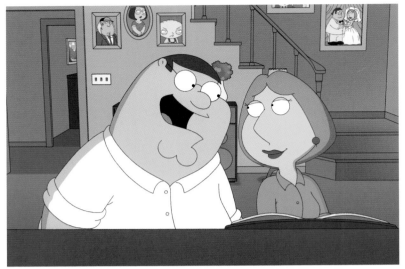

season swapped out its corps of generic background dancers and replaced them with a dozen *Family Guy* supporting characters, further certifying that all of Quahog, not just the Griffin family, is part of the show's time-and-space-defying act.)

If *Family Guy* has its roots in TV sitcoms, the process of producing each episode mirrors that for a sitcom, according to MacFarlane.

"Everything about the way a multi-camera sitcom works has an analogous step in animation," he said a few years ago. "We do our table reads like a regular multi-camera sitcom. *They* do their studio-network run-through, *we* do our animatic, which is a rough cut. *They* do their tape night, *we* do our color screening. Everything about it—it's the same process. It's just done in a different medium."

But he might have also acknowledged certain differences, notably the start-to-finish time span for each animated episode: more than a year, as compared to the cycle for a live-action sitcom, which requires just a few weeks from script to tape night.

The on-screen "performances" by Peter Griffin and his Quahog cronies is a painstaking process requiring numerous steps once the script is written, with an army of hundreds deployed for this exacting advance. The process of making drawings come alive flies in the face of cartoons' essence as an impetuous, anything-might-happen-at-any-moment medium. The characters on *Family Guy* seem, above all, to live in the moment. What happens from one instant to another seems as much a surprise to them, playing out in real time, as it does to the viewer.

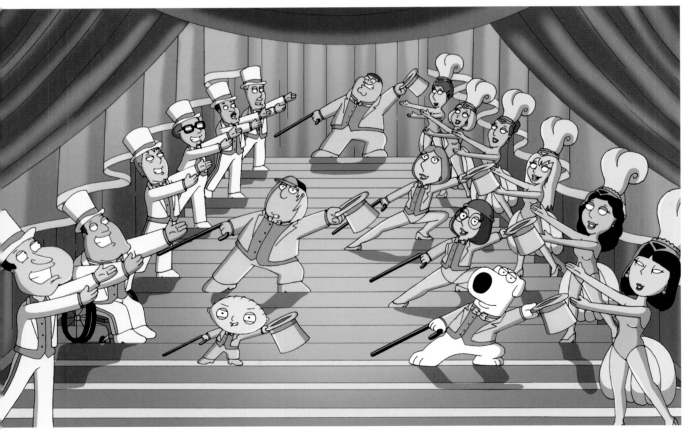

A FAMILY AFFAIR

And yet an episode of *Family Guy* is the collective product of a carefully regimented game plan.

There's a tempting but preposterous assumption that *Family Guy* might have been

a one-man show by the man who created it. But that turns a blind eye to MacFarlane's many colleagues, their myriad responsibilities and their systematic collaboration. A small percentage of their names accompany MacFarlane's in the on-screen credits of each episode, and although their accompanying titles may not spell out what they *do* (What exactly does each of the producers produce? Just what is it that the directors direct?), those names are hard to overlook as evidence that *Family Guy* is anything but a solo act.

Also hard to dismiss is the fact that since 2010, when MacFarlane began pursuing new ventures for himself, he largely bequeathed *Family Guy* to others, a number of whom have been there since the series started, or shortly thereafter, supporting and building on the vision he began with.

A cartoon comedy about a nuclear family in an all-American town wasn't a fresh concept when MacFarlane pitched *Family Guy* two decades ago. But the tone, look, structure and pacing he envisioned for it was. And still is, thanks to the people who still bring it to life every week.

What matters in the long run isn't what you do but how it's done, and by whom, MacFarlane explains.

"To me, a great show is all about the people who are running it," he says. "Consider *Seinfeld*. What's the concept there? It's just four people living in New York. What's *important* is who's writing the show and the performers and all the people who make the show what it is."

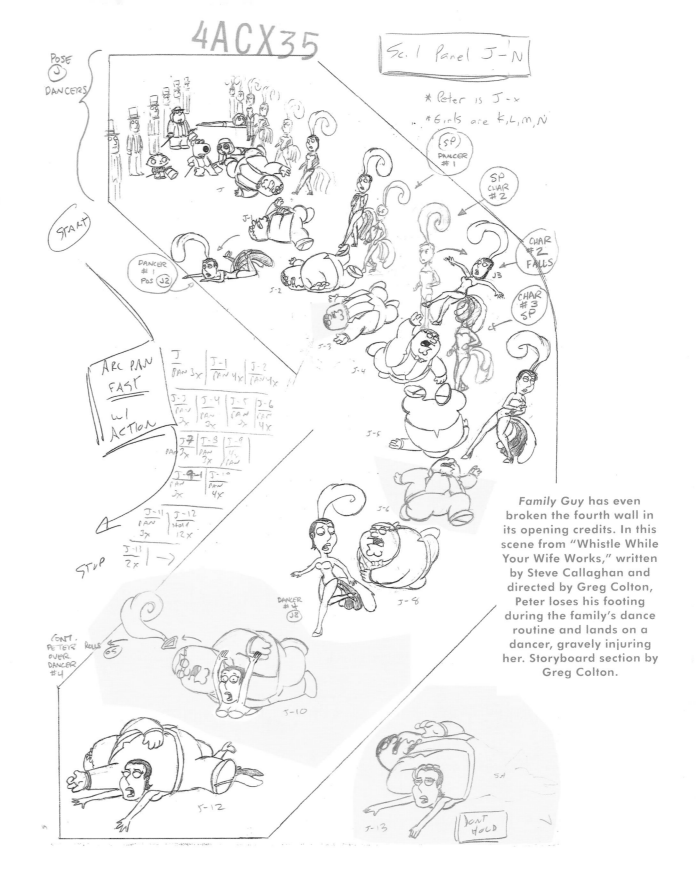

Family Guy has even broken the fourth wall in its opening credits. In this scene from "Whistle While Your Wife Works," written by Steve Callaghan and directed by Greg Colton, Peter loses his footing during the family's dance routine and lands on a dancer, gravely injuring her. Storyboard section by Greg Colton.

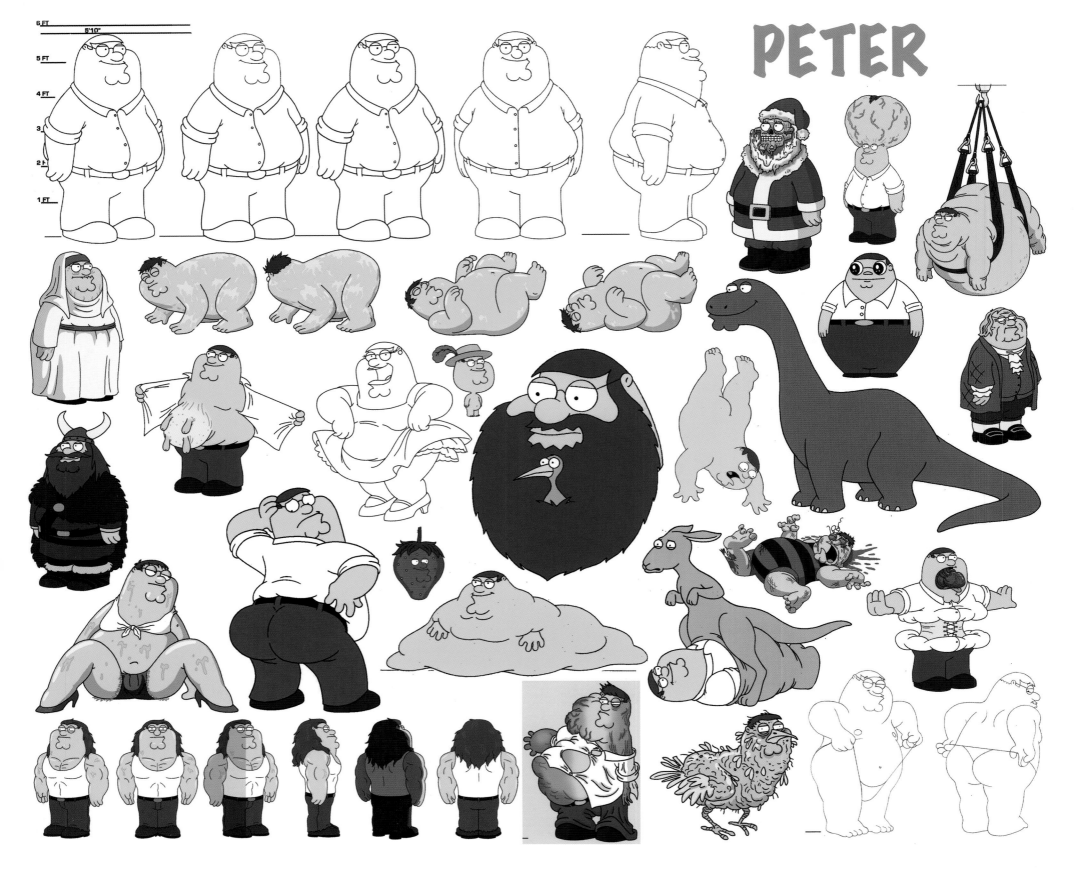

PETER

6 FT
5'10"
5 FT
4 FT
3 FT
2 FT
1 FT

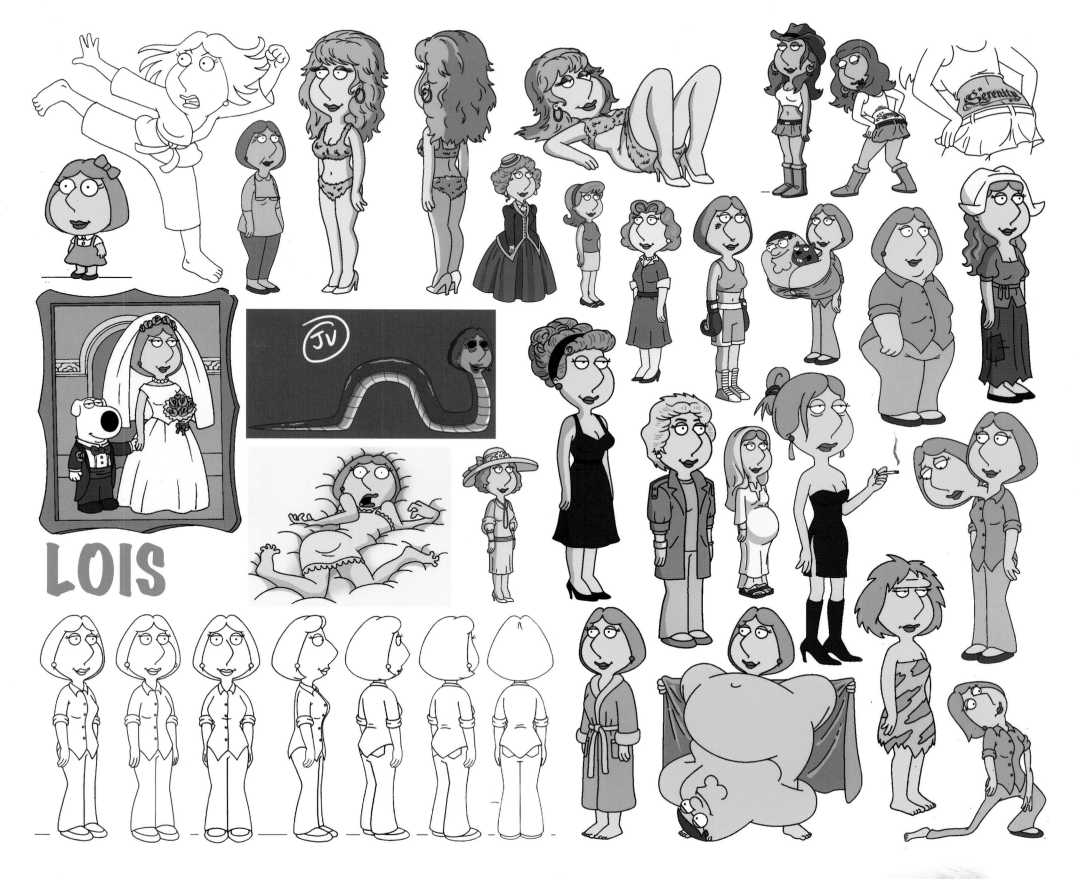

LOIS

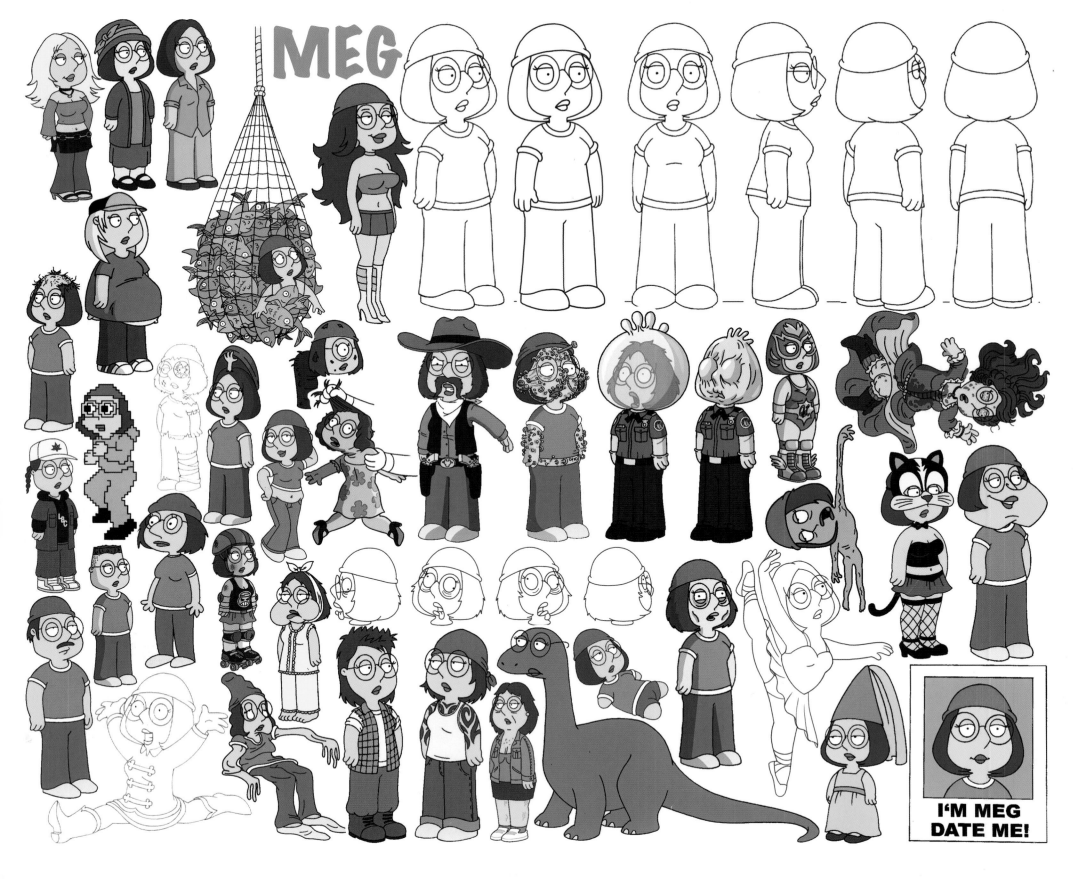

MEG

I'M MEG
DATE ME!

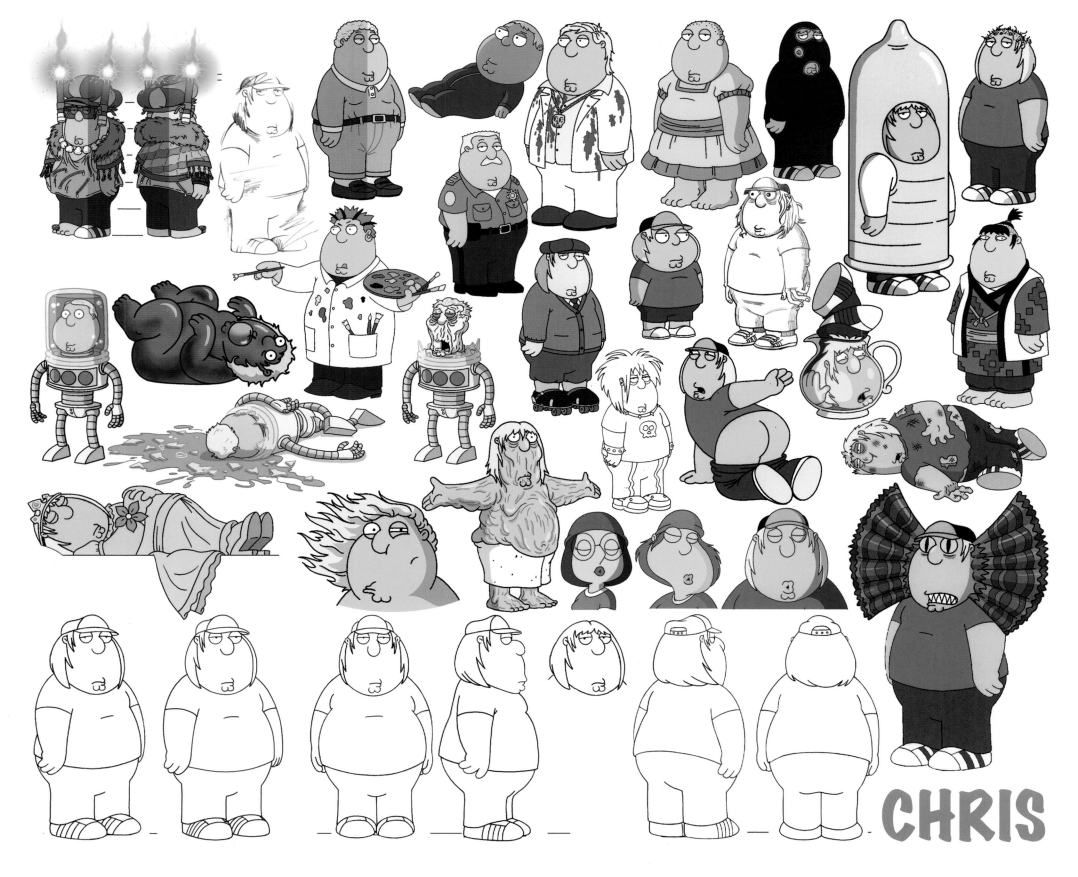

CHRIS

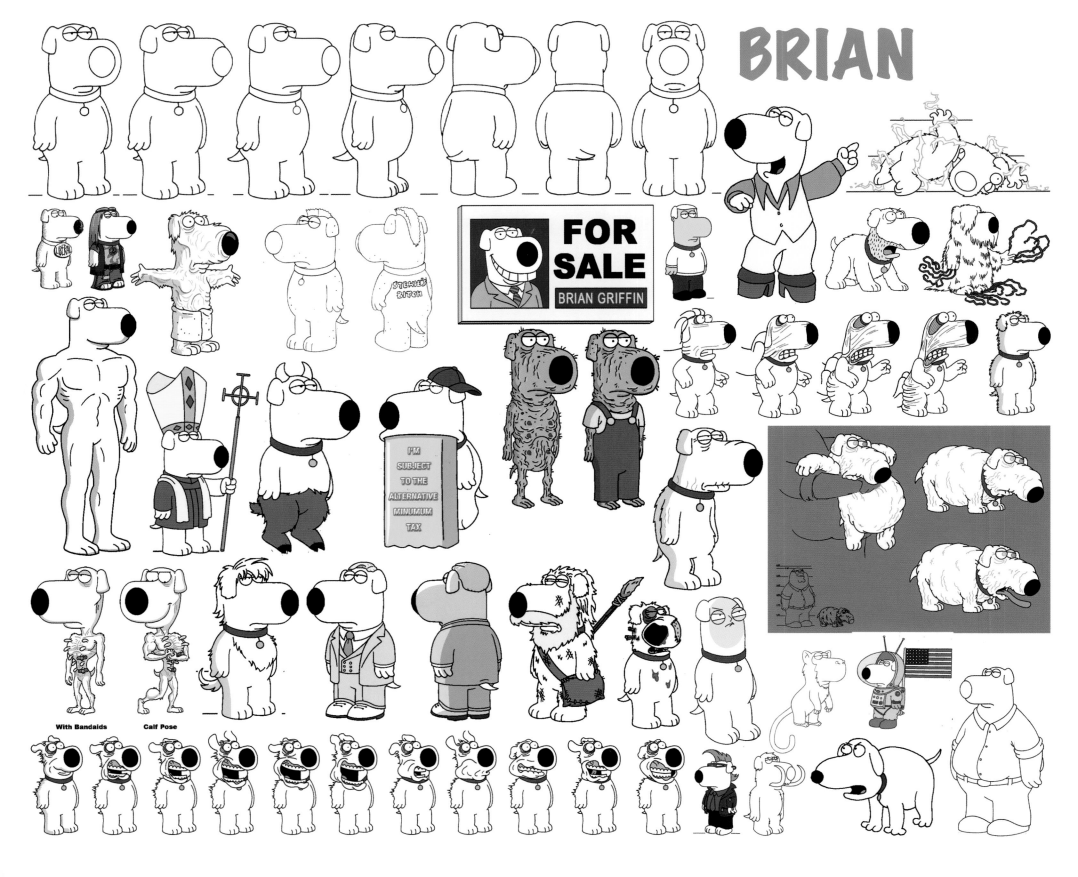

BRIAN

FOR SALE
BRIAN GRIFFIN

I'M SUBJECT TO THE ALTERNATIVE MINUMUM TAX

With Bandaids

Calf Pose

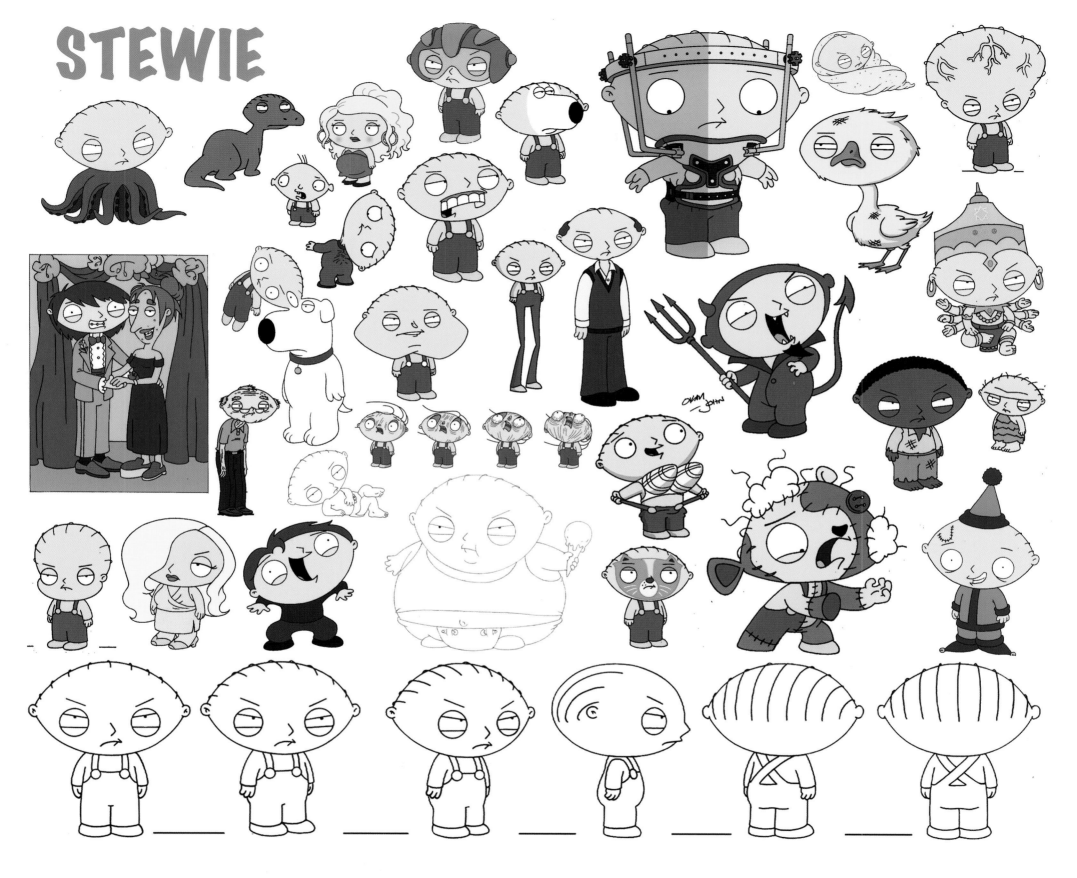

STEWIE

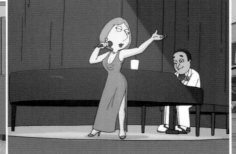

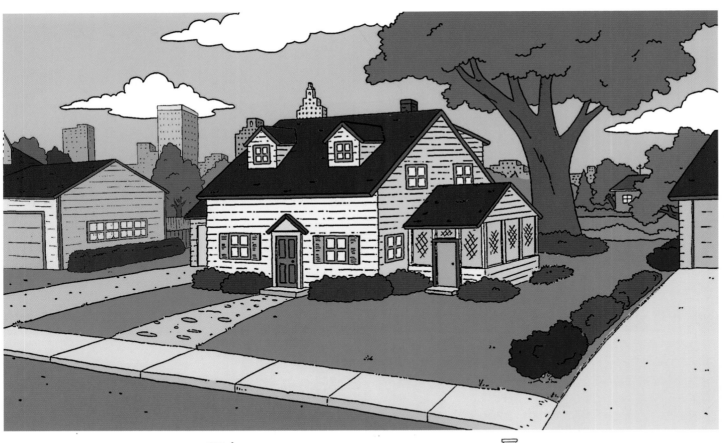

Different interior and exterior views of the Griffins' house. The family lives at 31 Spooner Street in the fictional town of Quahog, Rhode Island.

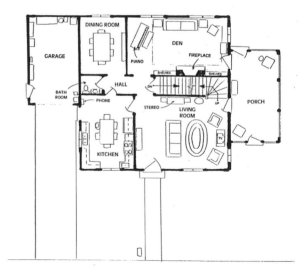

1st FLOOR

2nd FLOOR

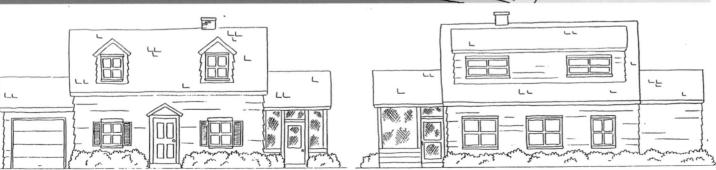

FRONT

BACK

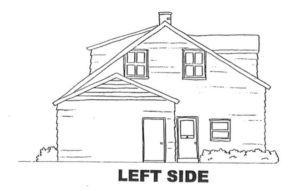

LEFT SIDE

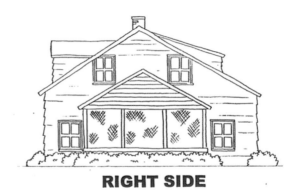

RIGHT SIDE

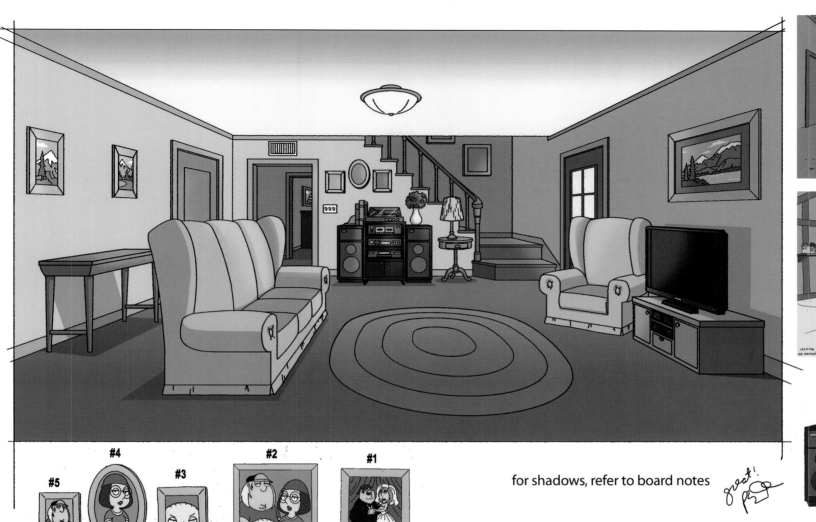

#5 #4 #3 #2 #1

for shadows, refer to board notes

great! P.S.

REVISED 03.26.10 NRC

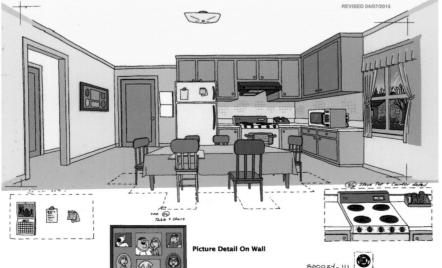

REVISED 04/07/2015

Picture Detail On Wall

BG0024-111

Revised 3-26-06 MD

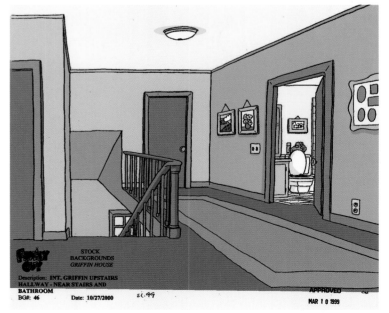

STOCK
BACKGROUNDS
GRIFFIN HOUSE

Description: INT, GRIFFIN UPSTAIRS
HALLWAY - NEAR STAIRS AND
BATHROOM
BG#: 46 Date: 10/27/2000 sc.99

APPROVED
MAR 10 1999

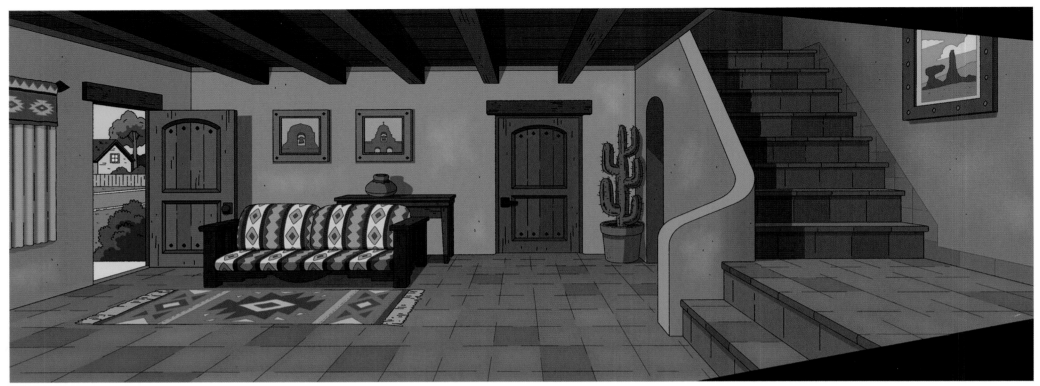

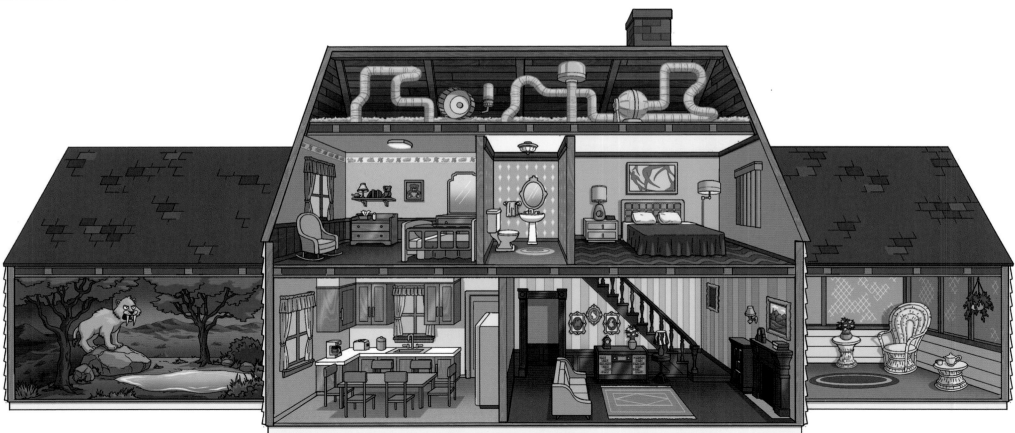

The Griffin house is often redressed, reconceived or destroyed in order to serve a joke or story point.

QUAGMIRE

JOE

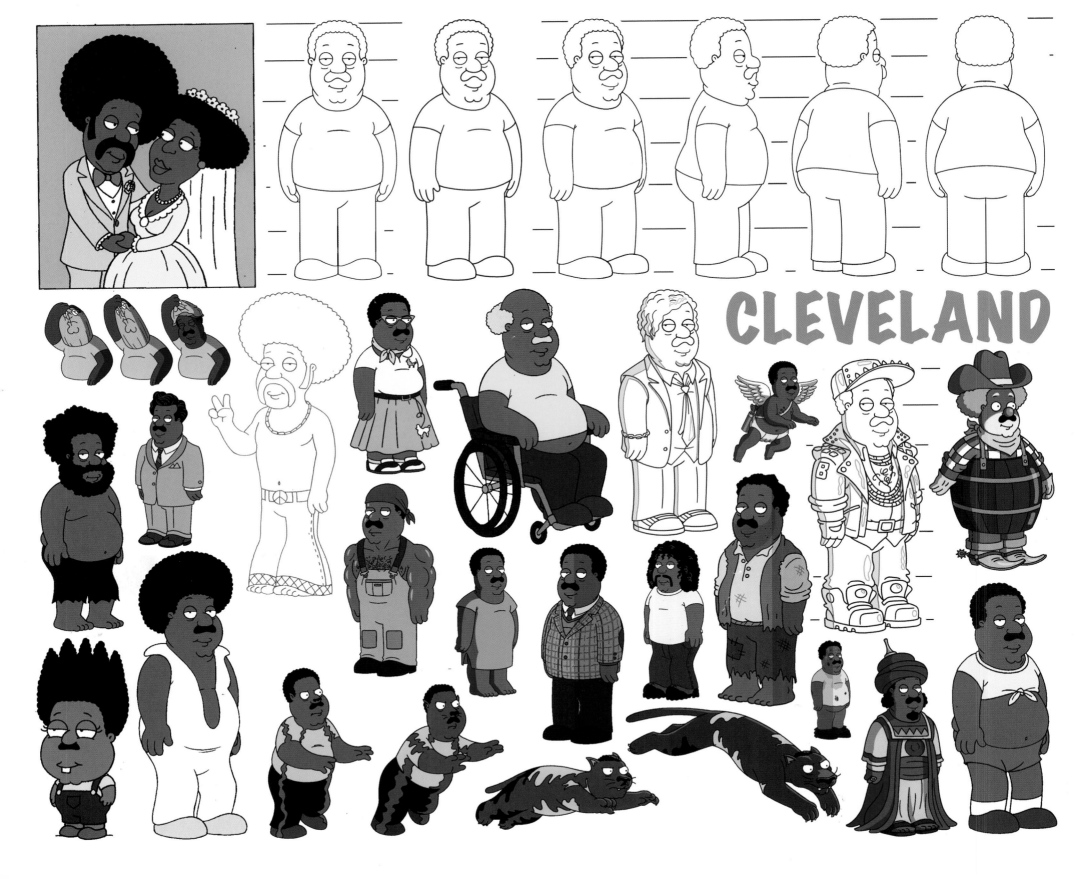

CLEVELAND

...AND EVERYONE ELSE!

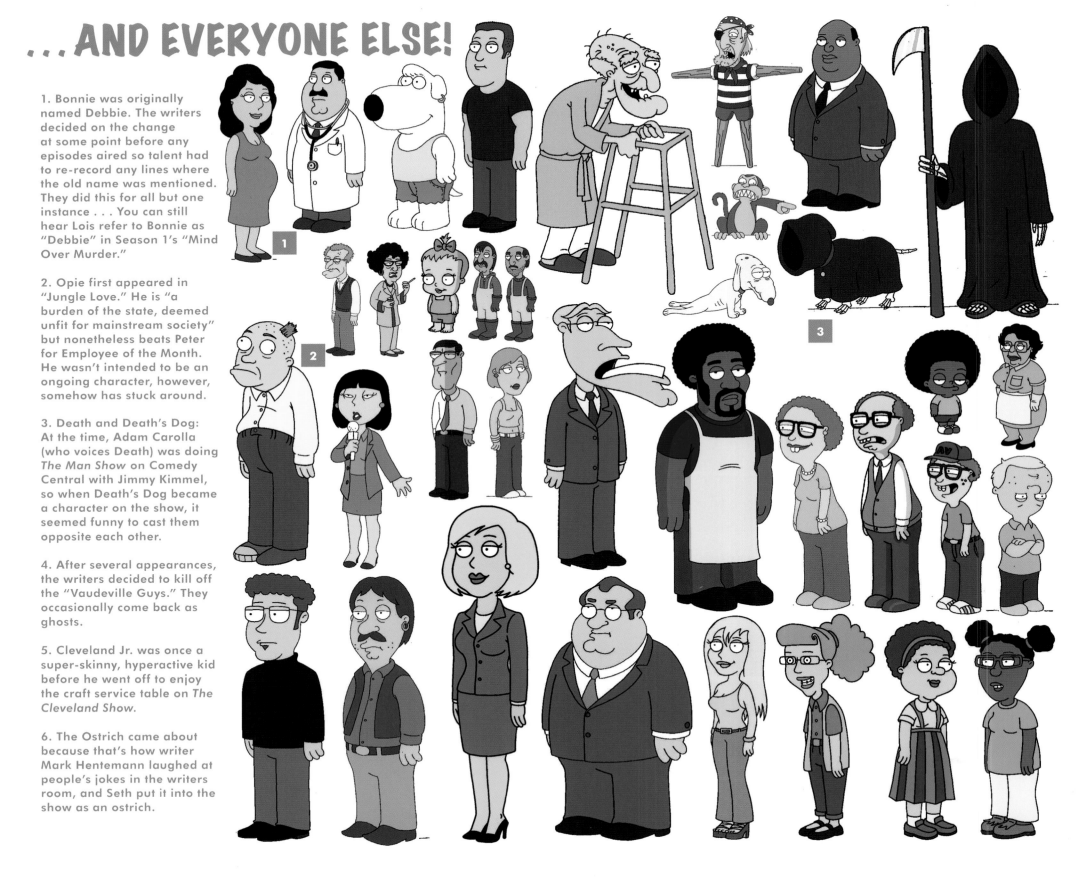

1. Bonnie was originally named Debbie. The writers decided on the change at some point before any episodes aired so talent had to re-record any lines where the old name was mentioned. They did this for all but one instance . . . You can still hear Lois refer to Bonnie as "Debbie" in Season 1's "Mind Over Murder."

2. Opie first appeared in "Jungle Love." He is "a burden of the state, deemed unfit for mainstream society" but nonetheless beats Peter for Employee of the Month. He wasn't intended to be an ongoing character, however, somehow has stuck around.

3. Death and Death's Dog: At the time, Adam Carolla (who voices Death) was doing *The Man Show* on Comedy Central with Jimmy Kimmel, so when Death's Dog became a character on the show, it seemed funny to cast them opposite each other.

4. After several appearances, the writers decided to kill off the "Vaudeville Guys." They occasionally come back as ghosts.

5. Cleveland Jr. was once a super-skinny, hyperactive kid before he went off to enjoy the craft service table on *The Cleveland Show.*

6. The Ostrich came about because that's how writer Mark Hentemann laughed at people's jokes in the writers room, and Seth put it into the show as an ostrich.

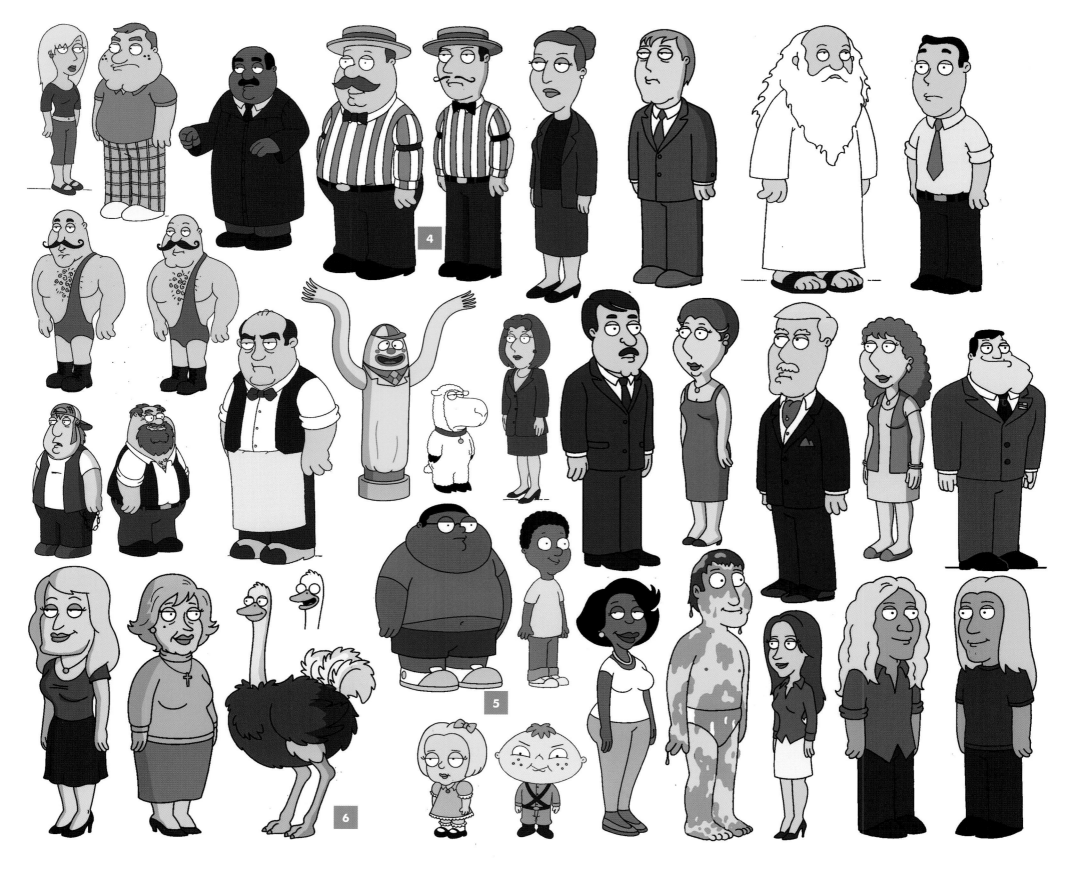

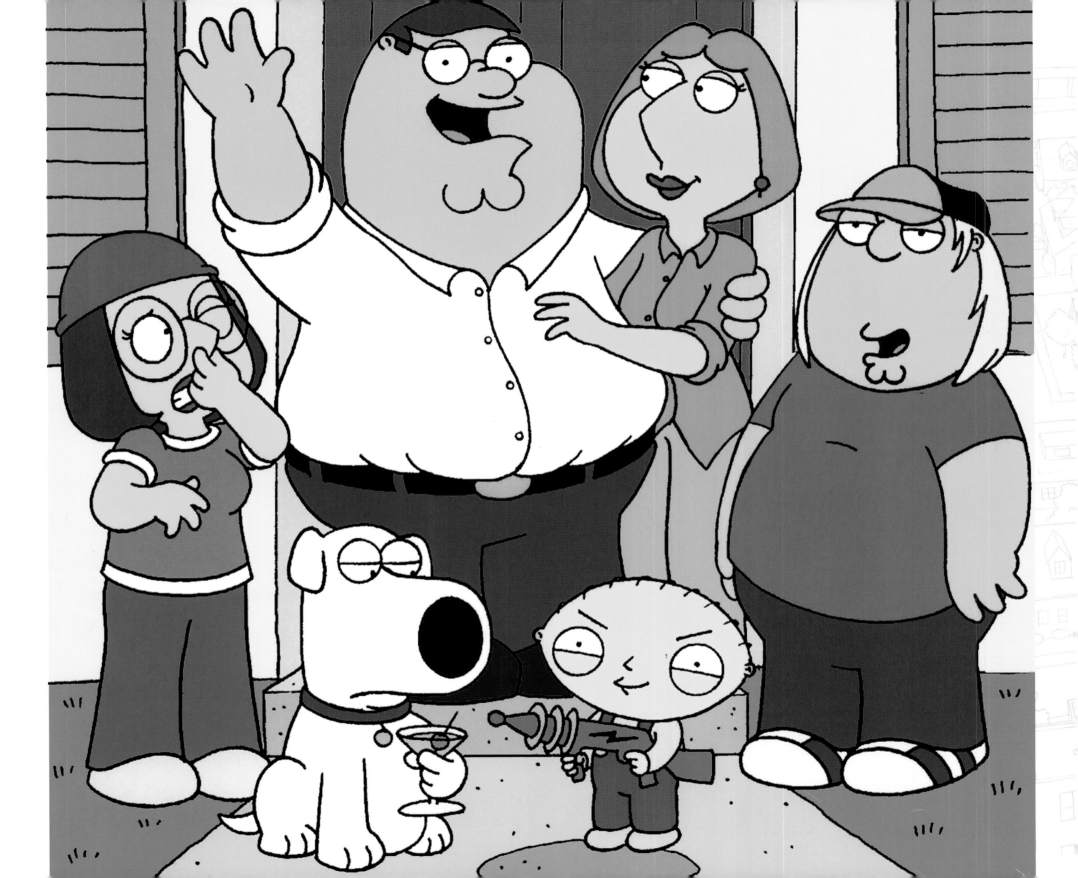

THE FAMILY IS BORN

In the summer of 1998, Walter Murphy got a call from his agent. Murphy, a successful TV and movie composer who also had scored big with the '70s novelty hit "A Fifth of Beethoven," a disco-style spoof of Beethoven's Fifth Symphony, learned that a young fellow named Seth MacFarlane needed some music for the series he had in the works. Murphy sent over a CD sampler. MacFarlane brought him in for a meeting.

"This was before there was even one frame of animation," Murphy says. "He gave me the lyrics to the *Family Guy* theme and asked if I could write a tune to those lyrics. I said, 'I'll give it a shot.' Then I asked what the main title of the show was going to look like."

Out poured MacFarlane's vision, as Murphy recalls it: "The two main characters would come on the stage, like Archie and Edith, and sit at the piano and start to sing, and each of the other members of the family would join in. Then the back wall would fly up to reveal a Broadway stage with everyone in tails. Then the camera trucks from above like a Busby Berkeley shot."

Murphy said OK, went home and wrote the tune.

"I gave it a kind of Broadway-esque arrangement," Murphy says, "because I thought that was what Seth was going after. When I played it for him, he said, 'Can you do it swing style?' So I did another mockup arrangement in a swing fashion. He said, 'I love it. Let's do it.'"

But Fox hadn't budgeted for an orchestra.

"We ended up doing it at my house with one trumpet player playing four parts, a friend playing sax five times and a trombone player playing four times. They each came in one morning, one after another."

Murphy played everything else—drums, bass, piano, guitar and strings—all using a keyboard. Then several background singers came in. It was finished in a day.

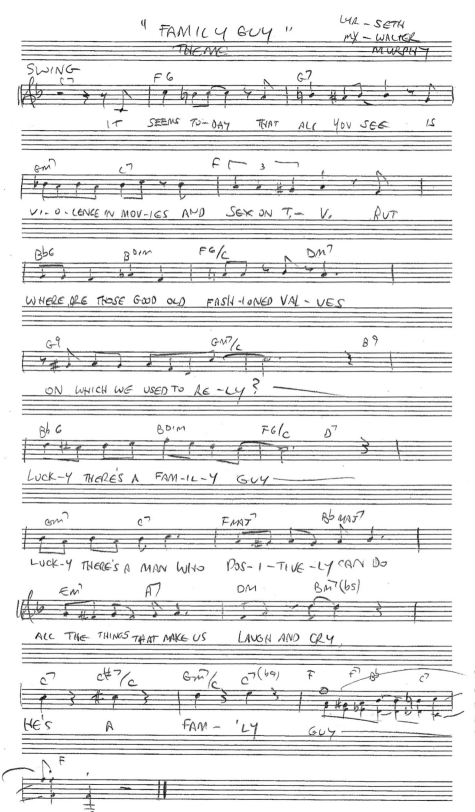

Walter Murphy's original handwritten sheet music for the *Family Guy* main title theme song.

"Seth took my tracks and recorded his part and the other actors'. Then I mixed everything together."

The lyrics are credited to MacFarlane and David Zuckerman, who had just been enlisted as fellow executive producer.

"Truth be told, the lyrics are probably 90 percent Seth's," says Zuckerman. "The line that I wrote was 'On which we used to rely.' The line it replaced was kind of awkward. Seth was very generous to give me shared credit."

But Zuckerman made a major contribution to the main title's visual. It was he who had remembered a campy 1970s soup commercial starring Hollywood musical veteran Ann Miller.

"She was in the kitchen singing about the soup," says Zuckerman, "and then the kitchen set broke away, she tore off her apron and she was wearing a show-girl unitard surrounded by other dancers as a huge can of Campbell's soup rose out of the floor. Since *Family Guy* was going to spoof pop culture, I thought this would be fun for the credits."

Once *Family Guy* went into regular production, it was able to spring for a 60-plus-piece orchestra to perform each episode's lush score. "That was at Seth's insistence," says Murphy, "because he loves a live score rather than an electronic accompaniment, which is what is mostly done on TV these days for budgetary reasons."

But although the lead vocals were soon re-recorded (in part, to clarify that Stewie sings "laugh and cry," *not* "effin' cry," as some fans even now still insist), and although the animation was enhanced in 2010 to accommodate the show's new widescreen, high-res format, MacFarlane has never seen fit

to use the orchestra that's at his beck and call to re-record the opening theme. When Murphy proposes redoing it, MacFarlane says no, he likes it the way it is.

"That's a man who knows what he wants and knows when he has it," says Murphy. "So what you hear on the air every week is kind of the Budgetville Philharmonic I did at home decades ago."

The off-screen beginning of *Family Guy* might be marked with a meeting MacFarlane and Zuckerman took early in the summer of 1998 with a pair of important executives, Gary Newman and Dana Walden, who jointly ran the Twentieth Century Fox Television studio.

From that first brush with the 24-year-old MacFarlane, Newman remembers him as "exuberant and goofy-looking, with thick Coke-bottle glasses and a Mr. Spock haircut."

"He was an extremely smart, entertaining guy who was wearing a T-shirt that said something ironic," adds Walden. "He wouldn't have looked out of place at Comic-Con. He was a much different-looking Seth than the movie-star Seth MacFarlane who walks into our offices now."

Fifteen years later, Newman and Walden would be promoted to run the entire Fox Television Group, an empire that also includes the Fox Broadcasting network. But back then, their sole domain was the studio, which produces shows for the Fox network as well as other outlets (such as ABC, for which it produces *Modern Family*). Both execs were wowed by MacFarlane's seven-minute *Family*

Guy presentation, a rough prototype of what the series could be that he had single-handedly written, drawn and voiced. Now Fox was set to start production on *Family Guy* for real, with a 13-episode commitment.

"The plan was to premiere the first episode after the Super Bowl," says Newman.

But that was less than eight months off! A typical animated series—one already up and running, with writers, cast members, animators and everyone else already in the groove—takes more than a year from start to finish. How could anyone do this, especially a 24-year-old beginner?

MacFarlane said he could.

THE WRITE START

At that point, *Family Guy* not only didn't have the requisite squad of writers, it didn't even have its own writers room. The newly mobilized writers would be billeted in office space still occupied by Zuckerman at the headquarters of *King of the Hill*, the Fox animated series where he had been a producer.

"Seth had a vision and he had a voice, but he didn't have the experience to run a show," says Zuckerman. "At that point, I was on my third season at *King of the Hill* and I was one of the candidates that Fox put forward to make a show out of *Family Guy*."

Zuckerman, whose earlier credits included *The Fresh Prince of Bel-Air*, had his roots in traditional live-action sitcoms. Although *King*

Seth MacFarlane poses with character standees for an early publicity photo.

of the Hill was animated, in telling its story of Texas propane salesman Hank Hill and his middle-class family "its mission was to be as grounded and real as possible. I was not an animation guy. I wasn't even a particular fan of *The Simpsons*—I thought it was OK.

"My contribution was helping Seth learn the craft of storytelling. What he taught *me* was to open up my mind to his sensibility and sense of humor. *That's* what the network had bought. It was my job to help him realize all that in the show—to support it and make it better."

Finding writers—and it had to be done *fast*—proved a vexing challenge. This was June, and the hiring frenzy for fall series was over and done with. What Zuckerman and MacFarlane faced now was akin to a high-schooler landing a date the night before the prom.

"All that were left were the stragglers, the guys who didn't have the sexy credits," says Zuckerman.

"We were left with this rogue's gallery of people to choose from," says MacFarlane. "But they turned out to be incredibly funny, incredibly smart, incredibly thoughtful writers, many of whom are still with us today. So we really ended up lucking out."

One of them was Chris Sheridan, who wasn't an "animation guy" any more than Zuckerman was.

"I wasn't a *Simpsons* fan," says Sheridan. "I was on what I thought was a different track." In fact, he had expected to sign on as a writer for the coming 1998–99 season of the live-action NBC sitcom *Veronica's Closet*. By June, when he learned to his dismay he had been passed over, few other openings were left.

GETTING IN TOON

Family Guy was a wide-open lane.

"A *cartoon*? My career's over!" he remembers despairing. No wonder his level of "whatever" nonchalance when he met with MacFarlane and Zuckerman: "I was so relaxed, I got the job," he says.

By 2000, *Veronica's Closet* had fizzled out.

"There I had been," says Sheridan, "thinking I'm supposed to be on *Veronica's Closet*, which was obviously going to be a big, long-lasting hit—and instead, I'm on this stupid cartoon which is going to die immediately. And the opposite happened! It taught me a valuable lesson."

Danny Smith had been a sitcom writer for a decade when, in 1997, he landed a job on a promising new ABC comedy called *Soul Man*, created by Matt Williams (*Home Improvement*) and starring one of his comic favorites, Dan Aykroyd. Even better, it was going to be filmed in New York and Smith was looking to get out of L.A.

During its freshman season, *Soul Man* seemed to be destined for a nice, long run. Smith was happy.

Then, in May, unexpected news came down: *Soul Man* wouldn't be returning for season 2.

"I called my agent: 'What am I gonna do?'

"He said, 'There are just two jobs available. One is a sitcom with kids that is filming in Chicago.'

"I said, 'That sounds terrible. What's the other one?'

"'The other one is a cartoon that a 24-year-old kid did the presentation for on his kitchen table at night when he was working at Hanna-Barbera.' And I said, 'That's *it*? Is this the end of my *career*?'"

Choosing what he saw as the lesser of two also-rans, Smith flew to L.A. to meet with Zuckerman and MacFarlane.

"When I checked into the hotel," he recalls, "there was an envelope waiting for me with a VHS tape. It was Seth's *Family Guy* presentation. And I couldn't believe it: In spite of myself, I was

cracking up. I liked the dog, and I *really* liked that baby!"

But next day at the meeting, Smith's misgivings resurfaced.

"When I walked into the room there was this guy with a weird crew cut and a blue-and-red-striped rugby shirt like the kids used to wear on that PBS show *Zoom*. I was 38 years old and I've got a job interview with this kid?

"But right away he recognized my Rhode Island accent and asked what town I'm from [for the record: Smithfield], and we just hit it off. He said, 'You start tomorrow.' And on and off I've been working for him ever since."

A few months before Danny Smith's interview, Rich Appel threw a going-away party for his five-year-old son at a Manhattan bowling center. The family was about to move to Los Angeles, where Appel, then a writer for *The Simpsons*, was relocating to be on the show's home turf.

There were lots of youngsters at the party with their respective parents or caregivers. These included an au pair named Rachael whom Appel knew from previous kids' social events.

Over the racket of tumbling pins, the young woman greeted Appel by saying, "You're the dad who writes for *The Simpsons*, aren't you?" She went on to tell him that her twentysomething brother had just sold an animated show to Fox and was hiring. "Could I give him your name to call?"

Here Appel was: a former writer for *The Harvard Lampoon* turned assistant U.S. attorney for the United States District Court for the Southern District of New York, who

Three-year-old Seth outside the MacFarlanes' log cabin in Kent, Connecticut.

Seth and his sister, Rachael, outside the rectory at Kent School on the first day of school in 1986. The MacFarlane family lived there while dad Ron finished building their timber-frame house on the other side of the Housatonic River.

Seth worked on the *Family Guy* pilot for Fox in his first apartment near CBS Studios in Los Angeles.

then had relapsed into comedy writing ("As a lawyer, I was known for my sense of humor; as a comedy writer I'm known for my legal skills," he jokes), and who now had a sweet gig on the biggest cartoon hit in 40 years. And here *she* was, suggesting he might want to take a flyer with an unknown youngster trying to launch a show that might not last a second week!

"Are you *kidding*?" Appel thought to himself. "But because I liked Rachael, I said, 'Of *course*,' and gave her my number. But I remember thinking, 'How could she *possibly* think that show is going to amount to anything?'"

Flash forward to 2007, by which time

Appel had moved over from *The Simpsons* to write for another cartoon hit, a show called *Family Guy.*

"I walk past the recording booth in our building and I see this young woman, and we both do a double take. I said, 'What are *you* doing here?' She said, 'I'm a member of the *American Dad!* cast.'"

"You're Rachael *MacFarlane*," said Appel, suddenly making the connection to their years-ago chat about her brother and the long-shot series he was staffing up.

"He never called me," Appel told her with a laugh. "Next time, would you just tell *me* to call *him*?"

Years before *Family Guy* was a thing, future writer and cast member Mike Henry was chums with MacFarlane.

Henry's brother, Patrick, was a housemate with MacFarlane at the Rhode Island School of Design in the early '90s, so he would pay them a visit from time to time.

MacFarlane was a film major there with a focus in animation.

"He was this random savant," Henry says. "Someone incredibly sharp who just sees things on a different plane. He had these big, thick glasses and he was kind of pale. And just so damn funny."

Henry had his eye on a career in comedy

Above: Seth performing in a local community theater production of *The Vaudeville Show* when he was in eighth grade.
Below: The MacFarlane family in front of the Tyler House when his parents joined the faculty of South Kent School in 1980: Seth with his mom, Perry; sister, Rachael; dad, Ron; and dogs, Murphy and Taylor.

and was already making short films. This he did all the more intently after a couple of years' detour after college at an advertising agency, an experience that supercharged his passion for spoofing the world of advertising he had learned to despise.

By 1998 he was living in New York with hopes of selling commercial parodies to *Saturday Night Live* when he got a call from MacFarlane bearing big news.

"He said he'd sold *Family Guy* and asked if I wanted to move to L.A. and create characters for it and write jokes," Henry recalls. "I was a little apprehensive until he told me how much it paid. And then I was on the next plane."

AN EARLY RISER

Practically from the moment he was born in Kent, Connecticut, MacFarlane had demonstrated artistic skills and passion—and a love of animation.

According to his sister, "First thing Saturday mornings, he would get up and go downstairs with his big comforter and curl up in front of the television watching cartoons."

"When he was less than two years old," says his father, Ron MacFarlane, "we'd watch him holding a pencil or a crayon and just drawing lines and scribbles. Then, while he was watching cartoons on television, he began drawing Fred Flintstone or Woody Woodpecker."

Ron, a retired schoolteacher who still terms himself "an unreconstructed hippie" and who was there at Woodstock (and in Season 9 of

Family Guy appears on-camera drolly narrating "Road to the North Pole"), recalls working at the food market owned by his father-in-law between teaching jobs. There, little Seth would sit on the counter and draw Yogi Bears on the grocery sacks. "There are people in Kent who still have those bags," he says.

Young Seth even took early TV instruction from Bob Ross, the Afroed, wispy-voiced artist whose series, *The Joy of Painting*, on each episode took viewers step-by-step through the process of creating a masterpiece, complete with its "happy little clouds and trees."

Along with his sister, Rachael, Seth also performed in local stage productions. He displayed a gift for singing and funny voices. He took piano lessons.

He loved Broadway musicals and decades-old pop standards. As a young child, he spent hours listening to Big Band music on his grandfather's collection of 78s.

Both parents supported their kids' activities. But Ron says Seth's mother is the parent to credit for his comic style. (Seth himself has declared that "some of the foulest jokes that I ever heard came from my mother," who had chosen his middle name, Woodbury, as an homage not to some reigning hero, but to the town drunk.)

"She had a rockin' sense of humor," Ron says of his late wife, Ann Perry Sager, who died in 2010.

When he was about nine, Seth began producing a comic strip for the local paper, for which he was paid five dollars apiece. One strip pictured a character in church kneeling at the altar and taking the Communion wine as he asks, "Can I have fries with that?" It created a minor stir in town.

The school where Ron taught had a Super 8 movie camera he used to film the kids he coached in sports. But when the school acquired a newer model, he turned Seth loose with the old one.

The camera had a setting for shooting one frame at a time, so Seth, then just seven or eight, set to work to create his first cartoon, with the "sound track" provided by a cassette recorder that had to be synced with the Super 8 projector. (Needless to say, Seth did all the voices.)

"Regrettably," says Ron, "that film is lost to history."

But that was just the start.

Some 15 years later, MacFarlane was working on his *Family Guy* audition, the pilot presentation that Fox had signed him to do, which he did in solitude at his kitchen table in his West Hollywood apartment during a feverish few months.

How many drawings did he churn out?

"You know the box a Keurig coffee maker comes in? There were certainly enough drawings to fill at least three of those boxes," he says.

IN THE WEE HOURS

He worked all day at Hanna-Barbera, where he was an animator and writer for such kids' cartoon shows as *Cow and Chicken* and *Johnny Bravo*. Then he spent nights and weekends on this all-important tryout. He got little sleep, especially the time someone tried to break into his none-too-posh ground-floor apartment.

"I woke up in the middle of the night, and there was a guy prying the screen off my window," MacFarlane says. "For some reason, I ran into the kitchen and grabbed two pots I had bought and never used, and ran back into the bedroom and banged them together as hard as I could right in front of the guy's face. He took off. It was the only time I ever used those pots."

He had scored back at art school with his 10-minute student cartoon *The Life of Larry*, a proto–*Family Guy* short subject hosted by a live-action, cigar-puffing Seth MacFarlane. This he retooled into *Larry & Steve*, a more slapstick man-and-talking-dog caper aired by Cartoon Network in 1997 as part of its "What a Cartoon!" series.

"Tonally, *Larry & Steve* was very much a departure from what I wanted to do," he says. "When it came time to pitch *Family Guy* I wanted to preserve some of the essence of what these characters were, but in a way that would be suited to a prime-time audience. So I had to reconceive it all."

The Family Guy himself, Peter Griffin, "was loosely based on a security guard who worked at the Rhode Island School of Design. He was extremely good-natured, extremely lovable,

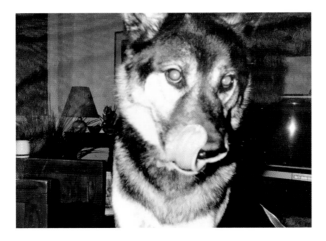

THE ORIGINAL BRIAN: The MacFarlane family dog Brian was a husky-malamute mix. Every night around 5 P.M. he would start howling until he was finally served his wine in a plastic wine glass, which he would sip very slowly. He lived to be about 16.

extremely well-intentioned. But he had zero self-editing mechanisms. The stuff that would come out of this guy's mouth would make your jaw drop. But you knew that he wasn't necessarily aware of what he was saying, so the lack of intent made it somewhat forgivable. And that is sort of the essence of Peter."

According to Zuckerman, the character of Brian would require a little tweaking.

"There was some question as to whether Brian should actually do dog things. Seth's initial vision of Brian was: He's just a guy. But then we made him a guy who's still a dog." It proved to be an inspired cross-breed.

For all of Brian's sophisticated humanness, he still barks at cats, buries tennis balls in the yard and not only pants in hot weather, but can tell you why ("I don't have any sweat glands").

"With Stewie, I took a sort of Mel Blanc/ Daws Butler approach to voiceovers," MacFarlane says, citing two cartoon-voice virtuosos. "You start with a real character actor, then go from there" (as he would later do by borrowing the unique style of comic actor Paul Lynde for the voice he devised for the swishy extraterrestrial alien, Roger, on *American Dad!*). Other than his haughty British airs, Stewie has nothing in common with Henry Higgins. "But that was a great springboard for conceiving my own original character."

Not only is Stewie arguably the most distinctive character on *Family Guy,* his design—a pipsqueak with a head shaped like a football—is no less singular.

"With characters that I provide the voices for, the voice always comes first," says MacFarlane. "Then I'll build the character design around what the voice sounds like the character *should* look like.

"That was the case with Peter and Brian, and that was the case with Stewie. I did about 50 different drawings with some bizarre twists—different head shapes and whatnot—and, for some reason, *that* head design and *that* facial design looked like what the voice *sounded* like to me. There's no logical reason. It was a purely visceral, gut decision: I thought, 'This looks like who that voice should be coming out of.'"

KILLER INSTINCTS

The voice that seemed perfect coming out of teenage son Chris led to an overhaul of who Chris was meant to be.

"He was originally conceived as a dumb surfer guy, and that was what my drawing reflected," says MacFarlane. "But that was an instance where the voice actor came in and completely transformed the nature of the character."

When Seth Green read for the role, he rejected a "cool dude" approach. Instead, he channelled the quavering, borderline-deranged voice of serial killer Jame

"Buffalo Bill" Gumb as played by Ted Levine in the horror classic *The Silence of the Lambs.*

"We were all laughing in the room," MacFarlane recalls, "and I was thinking, 'This is completely different from what I had in mind—but it's a lot funnier.'"

Thinking back to that audition, Green says, "I just took a chance and tried something very silly."

It happened that Green and a pal loved to play a can-you-top-this game where each of them would mimic the psychopathic Buffalo Bill as he might exist in an everyday setting, such as working the drive-through at a Jack in the Box.

"I probably got the job because what I did sounded so different from what anybody else was trying," he says. "But I never expected to get it."

A future writer-producer as well as actor, Green, then 24, was already a showbiz veteran whose acting credits included *Buffy the Vampire Slayer* and the film *Radio Days,* playing Woody Allen's character in childhood.

He describes Chris "as really simple, in that he's got very simple needs. Easily entertained. Easily satisfied. I think he's complex, but I don't think he's complicated. There are people who spend their whole lives worried about the world and what they can do about it. Chris doesn't do any of that. He's not going to wake up one day and say, 'Oh, man, how do I save the world?' He's going to wake up and say, 'Oh! What is that in my belly button?'"

TEEN ANGST

Mila Kunis took over the role of daughter Meg after the first season.

A cast member on the sitcom *That '70s Show,* she had never seen *Family Guy* when she auditioned.

"They hired me as I am. They said, 'Be a 15-year-old,' and I said, 'Perfect. I'm 15.' It was pretty easy. It was just *my* voice. And it was a really fun supplementary job. I would run over during my lunchtime at *That '70s Show* and record a *Family Guy* episode, then go back and continue *'70s.*

"I think everybody can identify with Meg," Kunis says. "I can't imagine that somebody in this world is so secure that they never have a moment of doubt. Meg lives in that perpetual moment. I think she's incredibly relatable."

Along with settling on voices and the actors who would furnish them, the look of the characters had to be refined from how they looked in MacFarlane's demo.

"We fine-tuned Peter's and Lois' skin tones," says Peter Shin, who, as co–executive producer, remains in charge of the show's animation and other visual elements. "Seth would say, 'I would like Peter's pants to be green.' But what *kind* of green are we gonna choose? Meg's beanie had been bright pink. We toned it down a little bit. And Seth made the choice to change Lois' hair from blond to a shade of burnt orange."

"*I* made a lot of suggestions that were wisely discarded," says Zuckerman. "I remember really being put off by the change to orange for Lois' hair and arguing strenuously that it should be a much more realistic color. Seth politely disregarded that suggestion. Like I said, animation wasn't my strong suit."

"When Seth approved the final designs," says Shin, "I prepared this very detailed manual on how to draw the characters. Because we have over 200 artists I needed to have some sort of manual so they all draw similarly. I made this character model booklet specifying not just how each of them should walk, but also the size of their eyes, the size of the pupils, how they blink and how many frames a blink should take. It's *all* spelled out."

Meanwhile, MacFarlane brought a specific design to the writing.

"Seth created this very clear template from the very first episode," says writer and executive producer Steve Callaghan, who joined *Family Guy* as a writers' assistant in its first season after graduating from the Department of Public Policy at the UCLA School of Public Affairs.

"It had the flashbacks and the cutaways,

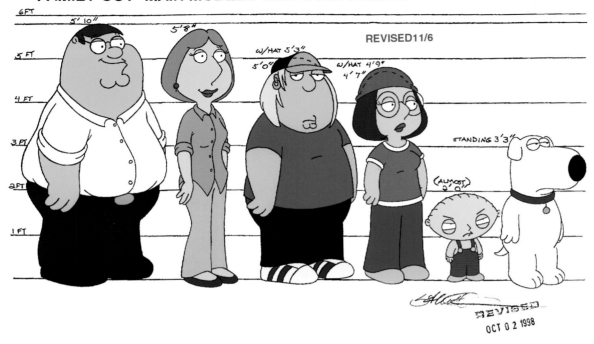

FAMILY GUY- MAIN MODELS SIZE COMPARISON

REVISED 8/27 #2

REVISED 11/6

6 FT

5' 10"

5 FT

5'8"

W/HAT 5'3"

4 FT

5'0"

W/HAT 4'9"

4'7"

3 FT

STANDING 3'3"

2 FT

(ALMOST)
2' 0"

1 FT

REVISED
OCT 0 2 1998

Family Guy main model color lineup from 1998. In this version, Peter and Lois have eyebrows, Chris has an earring and Meg's shoes are tan. These details were later revised.

almost a pastiche style of storytelling that allowed the writers to bring in so many styles of comedy, but still would feel like a cohesive whole," he says. "That meant the show would have the capacity—not only within the same episode, but within the same scene—to do a joke that is really smart and clever, followed by something really lowbrow: a shit joke just ahead of a joke about Benjamin Disraeli."

The cleverest among the gags, embedded almost self-indulgently in the flow, earned the term "ten-percenter" or "five-percenter" or even "one-percenter."

"We knew not many viewers would get it,"

says Callaghan, "but we knew those who *do* would absolutely *love* it—you feel it's something special just for *you.*"

TIGHT SQUEEZE

The show's first weeks were spent in cramped, makeshift quarters.

"There were 14 or 15 of us writers in my office," says Zuckerman. "*King of the Hill* was in one of those high-rise towers in Century

City which were intended for, you know, *law* offices. So the AC was shut off promptly at midnight in the whole building. We worked far beyond that. And since it was one of those hermetically sealed buildings, the windows didn't open. Fourteen or 15 guys in one office! It smelled like *man*—man and Chinese food, or whatever else it was we had ordered that night. It was not at all glamorous."

In writing the series' first episode, credited to MacFarlane, he and his newfound band of fellow writers borrowed from and expanded upon his demo pilot—"We took everything from it that we could," says Sheridan.

Repurposed material included a comic reference to sitcom classic *The Brady Bunch,* Peter's defective porn tape and the implant in his brain (as in the brain of every power-bill-paying father) that alerts him when the kids are messing with the thermostat. Stewie's futile schemes to kill Lois are retained, including a pistol hidden in his sandwich and aimed at her that misfires.

In a cutaway bit originally used way back in *The Life of Larry,* Peter mortifies his family by chuckling at Tom Hanks, whom he recognizes from the comedy *Big* ("Anything that comes out of that guy's mouth," Peter chortles, "you know it's going to be a stitch"), while they're at the movies watching Hanks' gripping AIDS drama *Philadelphia.*

And, as in the demo pilot, Peter is caught sleeping on the job after his night out drinking with his chums.

"You're fired!" his boss roars.

"Ah, jeez," sighs Peter. "For how *long?*"

FAMILY GUY

"Death has a Shadow"

Show # 72301-0001/1ACX01

Written by
Seth MacFarlane

Directed by
Peter Shin

Act 1

FINAL STORYBOARD

9/25/98

| FILM ROMAN | FAMILY GUY | SHOW#72301-00 | ACT_____ | PAGE_____ |

| Scene | | Panel | | BG |

ATTENTION : KOREAN STUDIO

← THIS FIELDING IS THE **T.V.** CUT OFF FIELD. PLEASE LAY OUT EACH SCENE BIGGER TO COMPENSATE FOR CUT OFF.

NOTE THAT ALL CHARACTERS ARE **OFF** MODEL
(PLEASE FOLLOW CHARACTER DESIGNS)
(IN THE MODEL PACK PRECISELY.)

Trans.

감사합니다. Peter Shin
— 신상진 —

| FILM ROMAN | FAMILY GUY | SHOW#72301-00*01* | ACT *1* | PAGE *1* |

| Scene *1* | | Panel *1 A* | | BG | | Scene *2* | | Panel *1 B* | | BG |

PUT ON MODEL
COLD OPEN
EXT./ESTAB. GRIFFINS' HOUSE - DAY
Dialogue

Action/Elx 4⁵
PUT ON MODEL
INT. GRIFFINS' LIVING ROOM - SAME
PETER, CHRIS, LOIS (with STEWIE on her lap), MEG and BRIAN sit on and around the sofa watching television.
Dialogue

Storyboards from *Family Guy*'s pilot episode, "Death Has a Shadow," written by Seth MacFarlane and directed by Peter Shin. Some storyboard panels were originally drawn by MacFarlane for his pilot. The Quagmire design was a later addition, replacing another character from the earlier draft.

Scene 101 cont — Panel 25A — BG
Action/Efx: Pan over / At here Peter Devil appears over his left shoulder.
Trans: FX shake

Panel 25?
Dialogue: Peter-Devil / Peter-lie to her! It's okay to lie to a woman... they're not people... like us

Scene 101 cont — Panel 26A — BG
Action/Efx: Pete looks down shakes head (cycle exists for head turns)
Dialogue: Peter: AH, I dunno —

Scene 101 cont — Panel 27A — BG
Action/Efx: Peter looks down as shakes his head.

Scene — Panel 27B — BG
Action/Efx: Fast truck out to right. As Peter looks over his right shoulder. No one's here.
REVISED

Scene 101 cont — Panel 28A — BG
Action/Efx: Peter turns to R-hand as pointing to the other direction.
Dialogue: Peter reacts / "Hey, where's the other guy?"

Scene 101A — Panel 28B — BG — CUT
Action/Efx: EX2 Traffic Jam. Truck in / A little blue Angel sits in his car, honking his horn
Dialogue: SFX: <honking horn>
Trans: KOREA: PLEASE USE REGION GUIDE FOR PETER AND THE CAR

Scene — Panel 28B — BG
Action/Efx: On Peter Angel, in the car, shouting at...
Dialogue: Peter Angel (Tiny Voice) "Come on,"

Action/Efx: He leans forward raising his fist.
Dialogue: "You bastards!"

Action/Efx: (illegible)
Dialogue: Peter Angel cont. "I'm late for work"

REVISED
Action/Efx: He grabs a coffee mug that was sitting next to him.

Action/Efx: He takes a sip.

Action/Efx: He spits coffee on his white robe.

Action/Efx: He gestures.
Dialogue: P. Angel (Tiny voice) "Oh, oh, coffee is perfect."

FAMILY GUY
EPISODE # 72301-0001
TITLE: "DEATH HAS A SHADOW"
SCENE #
SPECIAL POSE & COSTUME
DESCRIPTION: PETER ANGEL

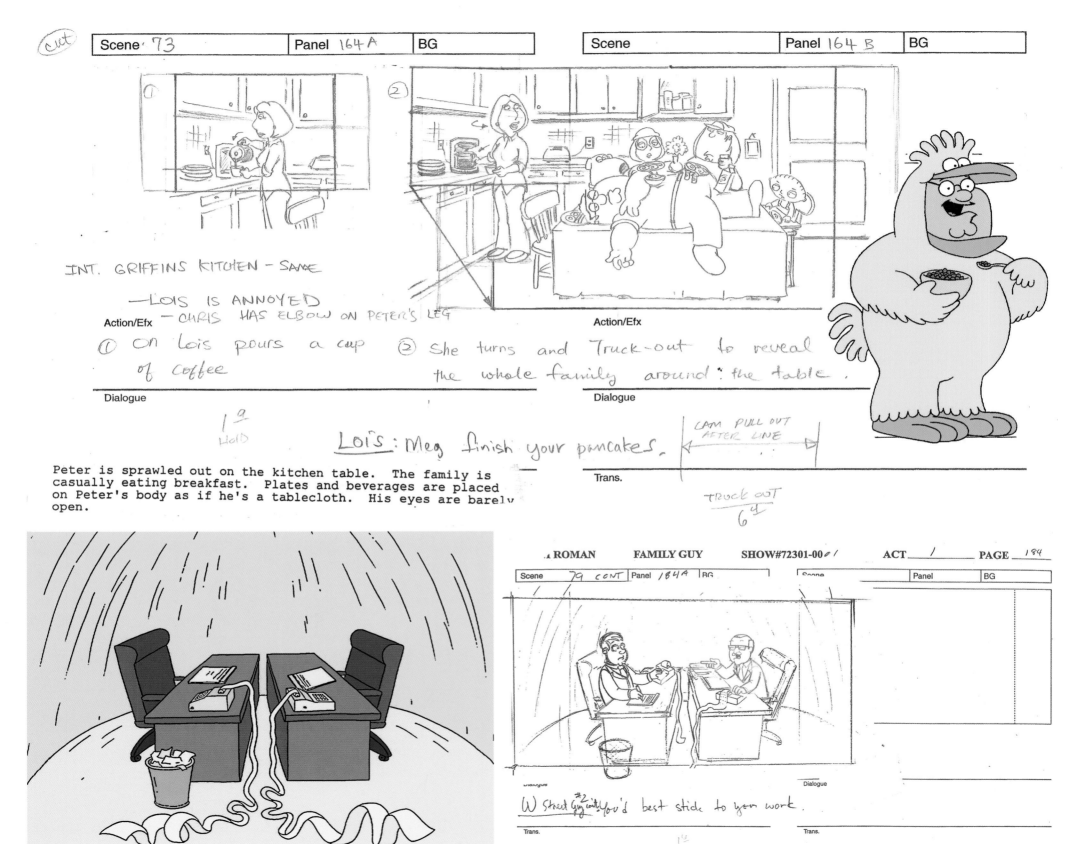

Scene 73 | Panel 164A | BG | Scene | Panel 164 B | BG

INT. GRIFFINS KITCHEN - SAME

—LOIS IS ANNOYED
—CHRIS HAS ELBOW ON PETER'S LEG

Action/Efx

① On Lois pours a cup of coffee

② She turns and Truck-out to reveal the whole family around the table.

Action/Efx

Dialogue

1ª
Hold

LOIS: Meg finish your pancakes.

CAM PULL OUT AFTER LINE

Dialogue

Trans.

TRUCK OUT
6ª

Peter is sprawled out on the kitchen table. The family is casually eating breakfast. Plates and beverages are placed on Peter's body as if he's a tablecloth. His eyes are barely open.

ROMAN **FAMILY GUY** SHOW#72301-00 01 ACT 1 PAGE 184

Scene 79 CONT | Panel 184A | BG | Scene | Panel | BG

Dialogue

W Street Guy #2 cont: You'd best stick to your work.

Dialogue

Trans. | Trans.

HAPPY-GO-LUCKY TOYS, INC.

Scene 241	Panel 11 m/A	BG

Action/Efx

Dialogue
Brian: Oh.

Trans.

Scene	Panel 11 B	BG

Action/Efx

Dialogue
come on

Trans.

Scene 241 cont'd	Panel 12 A	BG

Action/Efx Wide — on Brian puts the book
next to him

Dialogue
Brian (cont'd):
...if every woman dumped her husband just for

Trans.

Scene	Panel 12 B	BG

Action/Efx He starts to get on the bed.

Dialogue
crashing a blimp into the Super Bowl,

Trans.

Scene 241 cont'd	Panel 13 A	BG

Action/Efx He lays down on the bed

Dialogue
Brian (cont'd):
no one'd be married.

Trans.

HATCHING FRESH IDEAS

But there was plenty of room in the new pilot for new material.

Zuckerman recalls one new quick-hit bit of silliness that initially the Fox bosses wanted to cut: The Kool-Aid Man (a giant, smiling Kool-Aid-filled pitcher with arms and legs) makes an ill-timed entrance into the courtroom where Peter is on trial, bursting through the wall and bellowing his signature catchphrase, "Oh, *yeahhhh!*"

The execs just didn't get it, says Zuckerman. "They knew it was a TV-commercial reference, but thought it so broke the reality of the scene it would turn people off to the show."

On the other hand, there was at least one solid piece of advice from the powers-that-be.

"Fox called and said to make *Family Guy* specific to a region," says Danny Smith. "Seth and I had been sharing a lot of Rhode Island stories, so the writers made up a town in Rhode Island we could make fun of."

They christened the Griffins' hometown Quahog—the Narragansett Indian word for "clam" and thus the name of a certain hard-shell mollusk well-known to any Rhode Islander. (And the inspiration, of course, for Peter's local hangout, the Drunken Clam.)

That way, the writers reasoned, if Rhode Island natives hated the show, no one could get offended: "It's an *imaginary* town. But instead, people in Rhode Island *want* Quahog to be the stand-in for their town," Smith marvels. "They come to me and say, 'It's really North Providence, isn't it?' or 'It's Cranston or Matunuck, isn't it?' And my answer is always: 'Yes! It *is*.'"

Each episode that was created allowed more characters to be introduced.

City cop Joe and his wife, Bonnie, moved next door to the Griffins in episode 5, "A Hero Sits Next Door." Peter received him with an initial mix of scorn for his disabled condition and resentment that, even from a wheelchair, he could still best Peter at most things (including Peter's company softball game). "My whole family worships the ground that guy can't walk on," Peter grumps.

"Joe is a guy's guy, a guy who tries a little too hard at times, a guy with a little bit of an attitude," says Patrick Warburton, who voices him. "All it takes is just a few little pieces like that and you feel like you've got a foundation to lay your voice on."

Although his paralysis makes him the butt of many jokes (including his problems in both the bathroom and the bedroom), the square-jawed, bulging-biceps Joe is undeniably more "manly" than drinking buddies Peter, Cleveland

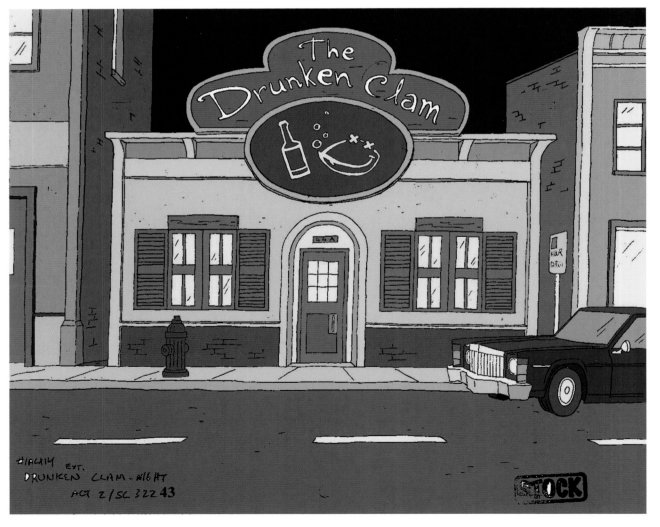

or Quagmire, however cruelly they (and the show's storylines) make sport of his infirmity.

"To me it's a deeply sensitive issue, actually," says Warburton, an able-bodied actor with numerous sitcom and voiceover credits. "A viewer who has that lot in life could find the character offensive, and I'd hate for that to be the case.

"But I've met guys in wheelchairs who say, 'I love that show, he's my favorite character.' That makes me feel good."

Quagmire and Cleveland had been established as Peter's Drunken Clam barmates the previous week.

Mike Henry says Cleveland was born when he pitched the voice in the writers room.

"It was the voice of a guy I had been playing basketball with a couple of weeks before, back home in Richmond, Virginia," says Henry. "It was just a chance encounter at a pickup game with this super laid-back guy who had a nothing's-too-big-of-a-deal sort of outlook. I thought a character with his chill temperament would be a great complement to the frenetic rhythm of the show.

"The question was, would Fox let me voice the character, since I was white? They said, sure. So Cleveland was born.

"I would never have him do something stereotypically 'black' just for a cheap laugh," Henry says. "He's a good person, operating from a place of love and respect, and a little bit more thoughtful than anyone else on the show. He takes a minute to respond. Sometimes it's completely off the mark, but he's coming from his own good place."

Rounding out the trio is Quagmire, voiced by MacFarlane. He's now identified by his overbite, fetishes (he can get aroused just from watching the DirecTV help video) and an attitude toward the opposite sex that makes the Rat Pack look like feminists.

"But for a while we didn't know how to make him funny," says writer Mark Hentemann. "Then someone pitched a joke where Quagmire comes out of the bathroom in just a robe to find a naked woman in his bed who says, 'Glenn, honey, I have a question for you: What do you do for a living?' and he says, 'Hey, I have a question for you, too: Why are you still here?' That got a big laugh at the table." Giggity!

"The nice thing about being part of a show at the very beginning is, you can really have an effect on shaping the characters and making them more three-dimensional," says Sheridan.

Unexpected dimensions were revealed in episode 4 in the form of Lois' hotcha figure. This came as a surprise to the audience, who, even at that early stage, had grown accustomed to Lois' slacks-and-blouse attire, which offers little hint of her body.

"There was that episode in Season 1 where she was a lounge singer. I think that's where we pushed it a little," says Peter Shin. *To say the least.* Bored with humdrum housewife chores, Lois transforms herself into a sizzling chanteuse in the Griffins' makeshift basement cocktail lounge, where her onstage costumes include a clingy evening gown and provocative short shorts.

"In the beginning we didn't have an intention to make her sexy," Shin says. "But over the seasons, whenever there was an opportunity to

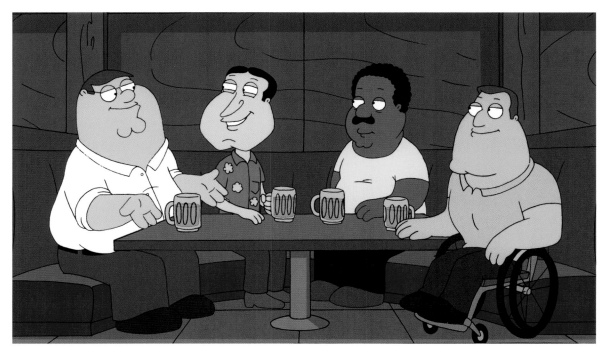

show her—well, she was definitely more curvy than we initially intended."

"But at first, we didn't really know who Lois was," says Sheridan, who would contribute an important element of her background.

FILLING OUT LOIS

When the writers were breaking the story that would open the second season, the germ of an idea from Sheridan had the Griffins inheriting a mansion in ritzy Newport, Rhode Island.

"I asked myself what could I borrow from my own life?" Answer: His father grew up on a farm in Connecticut, and his mother grew up a New York City debutante. "Taking that dynamic, we gave Lois a backstory where her parents had money."

So in "Peter, Peter, Caviar Eater," written by Sheridan, viewers learned that Lois is the rebellious rich-girl daughter of terminally snobby Carter and Barbara Pewterschmidt.

A flashback shows Lois in her bikini-clad teens as she meets and inexplicably falls for Peter, a porky working-class pool boy at the town's tony country club. Much to the horror of her parents, she and Peter would wed.

"We were very conscious of making her more of an ally than an adversary of Peter in their marriage," says Sheridan. "We thought that, in the beginning, her love for Peter would help excuse some of his shenanigans: If *she* loves him, the viewer should love him, too."

Making Lois a more, well, full-bodied character also allowed the show to benefit

Publicity photo featuring Alex Borstein with an early design of Lois, wearing a red shirt and blue pants. Colors would later change to her iconic green and tan.

more from the skills of Alex Borstein, who voices her.

"We weren't giving Alex enough to do," says Zuckerman. "At first, it was always, 'Peter, we're a *family.*' Every eighth word was 'family.' Alex is so funny and so talented, we got tired of hearing Lois always saying, 'family, family, family.' We wanted to give her some quirks."

Borstein wanted that, too. She says MacFarlane "brought his own bizarre perspective to Brian and Stewie and Peter, while I think the rest of the family was there to fill out the vision of the Griffins. But initially *they* didn't have as much detail."

Borstein first met MacFarlane when she tried out for the role.

"Seth showed me the drawings for the

character and I did a bit of a voice that I had been doing for a live stage show at ACME Comedy Theatre in Los Angeles." She describes the voice as "basically a rip-off of a cousin of mine on Long Island—but let's make sure she never finds out.

"We both liked giving her an East Coast flavor without being super-specific about where her accent was from. Seth giggled and said that he liked the voice. Then he had me speed it up tremendously and we tinkered with it until we found something that we both liked. I remember thinking how great it was to be collaborating with someone who worked straight from his gut. He liked what he liked and that was it."

Borstein, who until *Family Guy* was best known as a regular on the Fox sketch-comedy series *Mad TV*, helped bring Lois to life not only with her performance but also, during early seasons, as a member of the writing staff.

"When I was in the recording booth giving Lois a voice I was able to play with some of those details a bit," says Borstein. "I improvised some, and made her a bit filthy, a bit gritty.

"That's how I actually started writing for the show. One of the other writers, Chris Sheridan, would often come to the recordings, and he was the one who asked if I would ever consider writing for the show. He thought that I might bring something a little different to the page for Lois, as well as for the other characters. He mentioned it to Seth, who quickly agreed, and that's how it all came to pass."

A golden opportunity presented itself to establish a certain element of kinkiness in Lois' nature, and in her marriage, in the second-season episode "Let's Go to the Hop."

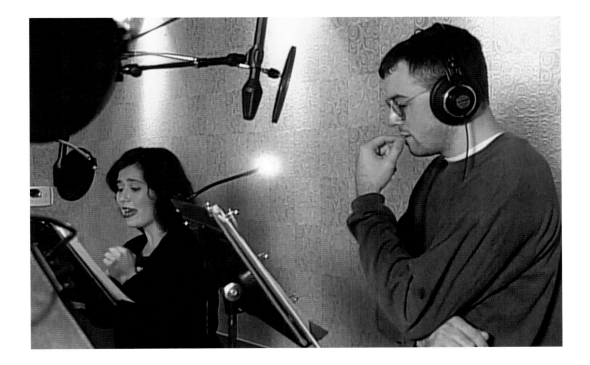

Above: Alex Borstein and Seth MacFarlane in a 1998 *Family Guy* recording session.
Below: Scene from the episode "Let's Go to the Hop," written by Mike Barker & Matt Weitzman, and directed by Glen Hill.

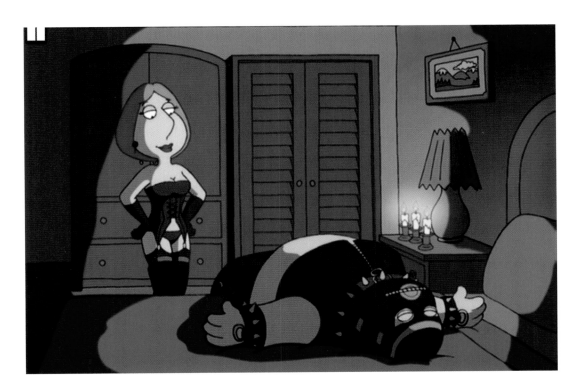

"We were writing a scene that was all exposition," Zuckerman says. "It was the kind of scene that Seth hated, and rightly so, where the characters were just talking and it was really hard to get any jokes in."

The scene found Lois and Peter getting ready for bed while expressing routine parental worries about the local drug scene.

"Then we had this idea: What if they just start putting on S&M gear while they're having this conversation! Suddenly the scene was sooo much more interesting, and funny."

Bingo! For a minute and a half, Lois and Peter matter-of-factly change from street clothes into, no, not pajamas, but their whips-and-bondage attire while they carry on their conversation about drugs in the school:

> LOIS: *How could this happen? I thought we lived in such a nice small town.*
> PETER: *There's no such thing anymore. Things are a lot different than when we were kids.*

"Seth and Alex played it straight," says Zuckerman, "and there were no jokes."

Yet the scene is hilarious.

"It's up to us as parents to be a part of the solution," sums up Peter, who, before he zips shut his leather hood, adds, "I'll go talk to the principal tomorrow."

"The safety word is 'banana,'" Lois says before she slugs him.

Mark Hentemann would join the *Family Guy* writing staff shortly after its premiere. He had started out as a greeting card writer and

One of the show's first musical numbers, "Road to Rhode Island," written by Gary Janetti and directed by Dan Povenmire.

illustrator in the Alternative Humor department at American Greetings. That led to a writing job on *Late Show with David Letterman,* where he stayed for about a year.

"I left an institution that was very specific in what worked, and where you had to navigate the 50,000 jokes they'd already done," he says, "whereas *Family Guy* was something we were trying to figure out as we went along. We were inventing things.

"We would structure a story that hopefully made sense, but we were willing to take these tangents—we wanted it to be joke-driven, too, with extended, surreal, Monty Python–type stuff. I noticed that the edgier we were, the bigger laughs we were getting at table reads and screenings. That was such a smart move, for Seth to make it edgy. It helped differentiate us from *The Simpsons.*"

"Seth had such a clear vision for the show, and such an expansive knowledge of so many kinds of comedy and music," says Gary Janetti, who would forge Stewie and Brian into a perfect yet previously unimagined twosome

with the second season's "Road to Rhode Island."

"He had a very ambitious way of looking at the world and what we could do in our universe, the places we could go. It was very freeing," says Janetti. "Sometimes you have to cross the boundaries to find out where the boundary is. The boundary on that show was always a lot further than you might expect it to be on other shows, and there were times when we went over it. But more often than not, we pushed the boundaries out further for what you could laugh at and get away with. It felt like we were coming up with something that was new and anarchic."

At the same time, the goal was to not just make the characters funny, but also, in the midst of the anarchy, imbue them with some semblance of humanity.

"That was what I was pushing for a lot," Zuckerman says. "I wouldn't call the show 'heartwarming,' but I think you do see that Peter cares about his family, and that, even though he's a complete idiot, his heart is in the

right place. And that was what a lot of the work was focused on in the beginning, to make sure Peter wasn't just a one-dimensional character—that he wasn't just a *cartoon.*"

PROVING GROUNDS

The show had a lot to prove, and so did MacFarlane.

One of his many challenges: to shine in the eyes of his fellow writers.

"Because Seth was so young, it was hard at first to relax and trust his instinct on things," says Smith. "He was very poised about what he thought would work or wouldn't work. He was never an asshole about it, and he was never indignant, but he was very, very certain about what he wanted, and he would dig in and fight for his instincts. Always.

"But among those of us who had experience, at first there was a lot of feeling in the room

Seth Green, Seth MacFarlane and Alex Borstein at the "Peter, Peter, Caviar Eater" table read in 1998.

that this kid didn't know what he was doing. And whether we were arrogant or simply trying to be helpful, some of us felt like we were going to try to shepherd this young boy toward what we know television *is*. So he had to overcome even the people who were supposedly trying to help him."

Borstein likens her feelings today for MacFarlane to "an old, favorite pair of jeans—comfortable and easy and always dependable. That being said, he makes my ass look flat and my thighs look like blue chorizos."

But she marvels that, at the birth of her relationship with him, MacFarlane was "this incredible mix of raw innocence while also feeling like the oldest soul in the building. He was half confidence and half puddle of insecurity, kind of like a seeing-eye dog who shits everywhere."

"The fact is," says MacFarlane, "I *didn't* know what I was doing. It's a strange position to be in, because you have to be open-minded and willing to learn from people who are more experienced than you are, and there's enormous value in that. But at the same you're expected to preserve the unique tone and vision that sold your show in the first place. It was a really delicate balance.

"It was the same as when I went into *Ted*, my first movie: There was so much about the moviemaking process I didn't know. I had to learn that stuff as I went and at the same time project to the crew that I had a handle on things and knew exactly what I wanted, so those people working 14-hour days felt like there was a method to the madness.

"You have to be open to learning from people who have been doing this longer than you have, but at the same time you have to make people think that you're an expert. It's two goals that directly contradict each other. But both are important."

Needless to say, MacFarlane won over his writers.

Two examples prove the point.

EXAMPLE NO. 1: When the writers were breaking the story that would become "A Very Special Family Guy Freakin' Christmas," which Danny Smith would write to air in the third season, they were wrestling with the scene where the very drunk Joe, Cleveland and Quagmire were joyriding around town with Peter driving. In the passenger seat, Quagmire, showing off, keeps flinging open his door and hanging out.

Smith recalls, "We were writing that scene when Seth got this quiet little smirk on his face and said, 'Quagmire hangs out of the car and hits his head on a dog.'

"We said, 'A *dog*? No! He hits a pole or a mailbox.'

"Seth said, 'No, he hits his head on a *dog*.'

"And everyone is going, 'That's stupid! You don't hit your head on a *dog*.' And we fought about it. But Seth stood his ground, and it was very late at night." If only from fatigue, the room eventually yielded.

Three months later, Smith screened the VHS animatic of the episode at home, and let his nephew and a friend, both 12 years old, sneak a peek.

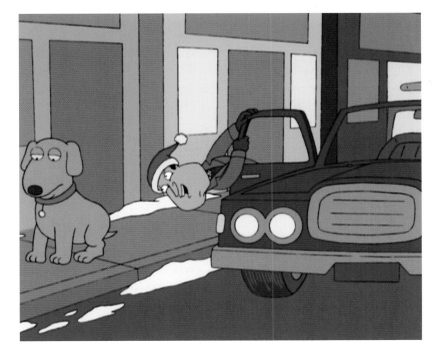

series gained one of its most hilarious and memorable characters." Until West's death in June 2017 at age 88, the actor who had scored instant stardom a half-century earlier as TV's Batman had been voicing Quahog's mayor, and been Quahog's mayor, on more than one hundred episodes.

"He never failed to knock it out of the park," says Callaghan. "But if it had just been Adam West playing the mayor, that somehow wouldn't have been as funny. The absurdity of never commenting on the fact that Adam West is, for some inexplicable reason, the mayor of this town—and never even mentioning Batman or anything like that—is what made it so fantastic. There is a huge number of TV viewers who now only know Adam West as the mayor of Quahog, and I know that Adam was always extremely grateful for the important role that *Family Guy* played in his career."

"I put in the cassette, and for the first eight or ten minutes it's all *my* jokes. The kids are sitting there stone-faced. Then here comes Quagmire leaning out of the car, and he hits his head on a dog."

The dog, just standing on the sidewalk until Quagmire's head collides with him, then careens through the air with a yelp before vanishing into the distance. The whole gag lasts little more than a second.

"But watching it, the two 12-year-olds go *crazy*: 'He hit his head on a *dog!*' They were just about barfing up a lung they were laughing so hard. And I'm thinking: 'Seth is connected with his audience and I'm *not*. I better pay attention to what he likes.'"

EXAMPLE NO. 2: The Season Two episode "Fifteen Minutes of Shame" was to be written by Steve Callaghan and would open with the Griffins attending Quahog's annual "Clam Day." The town needed to establish a mayor to preside over the festivities, and MacFarlane suggested Adam West. According to Callaghan, "All the writers said, 'That would be great if Adam West plays the mayor!' And Seth said, 'No, he doesn't *play* the mayor. He *is* the mayor.'

"We were all looking at each other and thinking this was such a weird idea. We had so many questions. We didn't get it. But Seth insisted. And he was completely right. The result of that brilliant instinct was that the

LESSONS LEARNED

"The way you survive as a sitcom writer is to write for whoever show it is," says Smith. "You have to find that voice and write to that voice. Little by little I started to get Seth's voice. And to trust him.

"We learned a lot from him," he adds. "Since most of us in the room were sitcom writers, all we cared about were the jokes and stories. Until then, I had never heard the terms 'walk cycle' or 'mouth shapes.'"

Sometimes the stories and gags the writers pitched, and MacFarlane quashed, would

have relied on a live-action performer to put across. Recall how Bea Arthur triggers gales of sustained laughter on *The Golden Girls* with nothing more than a disapproving look.

"Seth would say, 'You can't do nuance. It doesn't come across in animation,'" says Smith. "So we had to adjust the way we wrote for these characters."

At the same time, animation opened up countless new possibilities for the writers, as Smith and his comrades also learned: "Peter could get so excited that his head turned into a helium balloon and exploded! I couldn't do *that* on *Head of the Class*."

But that was just the beginning. In short order, *Family Guy* also established a consistent visual style and rhythm.

TAKING A LONG VIEW

"More than most shows, I think it's really *authored*," says executive producer Kara Vallow, who, after being told she couldn't play baseball or be a jockey, decided to study art and animation at New York's School of Visual Arts before heading west and landing a job at Hanna-Barbera, where she first worked with MacFarlane.

"When he was at *Family Guy* day-to-day he dictated and curated everything: Every drawing, every piece of music, every word and the way the words were going to be said, and then how they were edited," Vallow says. "He has an ability to see the end product at the beginning. That's an incredible skill with animation

because the end is so far down the line, with so many steps. To *know* how it's going to look, how it's going to sound, a year before it's done, is amazing."

"There were so many times where we'd be sitting in the writers room and Seth would do something vocally with one of the characters," says Hentemann. "He would pitch a joke in Stewie's voice, and there would be no precedent for it in who Stewie's character was, it was just something Seth felt at that moment. But it would provide another shade, an unexpected shade, of Stewie's character. And that was great."

"Oftentimes, if you pitched a joke that was visual that Seth liked, he would just draw it right away on a random scrap of paper," says Cherry Chevapravatdumrong, who would join the *Family Guy* writing team in 2005. "When that happened, you knew it was going on TV. It was real-time feedback. It was awesome."

Sheridan recalls an instance of MacFarlane's total involvement at the sound mix for episode 2. During a scene that would last just a few seconds, Peter, out with his family in the country for a picnic, waves a red blanket to spread on the ground. A bull unexpectedly bursts in from the left and plows Peter out of frame off to the right. The bull's collision with Peter is accompanied by a "thud."

"Seth asked the engineer, 'Can you make that thud a little bit louder?' He did. It was funnier," says Sheridan.

"So Seth asked, 'How about a little bit louder?' Then: 'A little bit louder.' Then: 'Just a little bit more.' The engineer gives him a look. But it's even *funnier*.

"Then Seth says,'You know what? Turn it *all* the way up.'

"The engineer says, 'I can't do that. It's already in the red.'

"Seth replies, 'Who *cares* if it's in the red?'

"So he did it, and it was hysterical. Turns out, the *louder* it is, the *funnier* it is, and all Seth cared about was how funny it was. And he was right."

Episode by episode, the mythology of *Family Guy* and its community grew more and more robust.

"Soon it came time to name the high school," says Smith, who wrote "Chitty Chitty Death Bang," the third episode. "In Rhode Island, pretty much every building is named for Roger Williams, who is a Colonial figure. But someone in the room wondered if there's anybody *else* from Rhode Island who's famous. I said, 'James Woods.' I wasn't even trying to be funny, but everybody in the room laughed. For whatever reason, everybody thought that was really funny. And the high school got its name."

Soon *Family Guy* also got its own home, over in the San Fernando Valley.

"We were the only non-porn production north of the 101, I believe," says Zuckerman. "We found this great building on Laurel Canyon Boulevard. We got the top two floors, with the animators downstairs and the writers on the top floor. Seth and I each had our own bathroom. I really felt like I had made it.

"But the hours were absolutely brutal. An early night for us would be midnight. Going till 2 wasn't uncommon. Sometimes we went until 6 or 7 in the morning, then came back in at 10."

"We were locked in a room from 10 A.M. until 2 or 3 in the morning most nights," says

Borstein, "and it was a bit insane. We ordered pizza after pizza as we searched for better ways to say 'boner' or 'shitass.' But the room was filled with some of the funniest and smartest people I had ever met and it was an amazing feeling to make any of them laugh."

"We would have such long discussions about the most minute points of a story or a joke," says Zuckerman. "Once we spent maybe two hours trying to parse the difference between 'time machine' and 'time *manipulation* machine.'

"Around 3 or 4 in the morning and everyone's just loopy, somebody will pitch an idea that's insane and then everyone starts building on it, and you go, 'Yes, *yes!*' But as I'm typing it in, I would be thinking in the back of my head, 'God, I *hope* this is still funny when I read it in the cold light of day.'"

From the first, a hallmark of *Family Guy* has been its treasury of for-all-ages historical and pop culture references that reach back generations. Some would even stump MacFarlane, however well-versed he was at his tender age. But in those instances, he had a backup system.

"If Seth didn't understand a reference or didn't trust a joke being pitched," says Zuckerman, "he would call his parents."

In the writers' discussion of "Chitty Chitty Death Bang," which would find Meg falling prey to a cult and almost joining in a mass suicide, the subject of Jonestown (with its 1978 "revolutionary suicide" under cult leader Jim Jones) naturally arose.

"Seth had never heard of Jonestown," says Zuckerman. "Everybody else in the room was like, 'Jonestown *is* a thing.' But Seth called his parents."

Oddly, neither of his parents was hip to this epic tragedy either.

"So Seth was pretty sure nobody would get the joke. But it wasn't just a joke, it was how we wrapped up the episode's B-story." If MacFarlane didn't buy the argument that a mass suicide led by a mad prophet was rooted in contemporary real life, he wouldn't have felt comfortable putting Meg in an absurd version of this catastrophe.

"And it would have been so much work to come up with something else," says Zuckerman. "I remember we spent a *lot* of time talking about Jonestown and how that was a real thing. Seth finally came around on that one."

That summer of '98 Seth's sister, Rachael, took a trip out west with a friend to visit him and take in Los Angeles.

He generously handed over his Toyota Tercel for the several weeks they were visiting. But the freedom his car gave them to do the town came with a price. Seth needed a ride after each long workday: "He would call us around 2 or 3 in the morning and say, 'I'm ready to come home.'

"I've never met anybody with a work ethic like his," says Rachael. "He didn't seem

stressed. He was just very, very busy doing what needed to be done. I've never seen anything like his ability to hyper-focus on the task at hand."

Rachael and her friend found that out anew when they decided to tidy up his apartment.

"In the process, we collected all his empty paper-towel tubes. There were so many of them all over the place, we decided we would do something with them. So we built a log cabin and left it in the center of the floor, thinking it was the most hilarious thing. But Seth was so focused on his work he didn't even notice it. Not a comment. We left it there for days!"

For the remaining months of 1998, the writers, like the rest of the *Family Guy* team, worked in isolation from a watching world since the series hadn't premiered yet.

Then, on the last day of January 1999—two weeks after the debut of Eddie Murphy's *The PJs* and little more than a month before the Matt Groening-spawned *Futurama* seemed to harken a renaissance of prime-time cartoon fare—*Family Guy* debuted.

"RISKY, RUDE, HILARIOUS"

The New York Times gave it a rave, hailing the show as "risky, rude, hilarious," and adding that, "Whatever its similarities to other shows, *Family Guy* feels wholly original. . . . Nothing is out of bounds as this series gleefully undermines family sitcom values."

While *The New York Times* got it, it left some others cold, notably *Entertainment Weekly*,

which branded it "*The Simpsons* as conceived by a singularly sophomoric mind that lacks any reference point beyond other TV shows."

Never mind the naysayers. After having fast-tracked that first episode, *Family Guy* now had to scramble to be ready with six more when the show returned in April on a weekly basis.

When those episodes aired, the audience applauded. *Family Guy* actually managed to attract a larger number of viewers than the show preceding it, an accomplishment almost unheard of by such a new series.

But then the show got some bad news. In a display of what Hentemann calls "overconfidence," Fox decided that, come fall, it would evict *Family Guy* from its Sunday berth to make room for *Futurama*. *Family Guy* would be carted off to Thursday to face a killers' row that included NBC's hit sitcom *Frasier* as well as UPN's *WWF Smackdown*, which was really big with young men, the same much-coveted audience that *Family Guy* had had to itself on Sundays. Meanwhile, it would be awkwardly lodged on Fox between *World's Wildest Police Videos* and a new comedy, *Action*, that was fated to be dead on arrival.

Zuckerman recalls getting the network call advising him and his partner of this schedule change.

"Seth was half upset and half laughing at me," says Zuckerman, "because I was on the phone saying, 'We're giving you this *precious gift* and you've *squandered* it!'" He laughs at his chutzpah. "Who was *I* to talk to a network president like that!"

In retrospect, Dana Walden, then running the studio with Gary Newman, says she didn't disagree. The network, she says, "didn't understand the asset they had in this show."

After just two airings that September, *Family Guy* was put on ice until it came back for a single telecast three months later.

That episode was "Da Boom," which aired with perfect timeliness on December 26, just five days before the new millennium would arrive, bringing with it, many feared (though their fears would prove unfounded), a technological apocalypse.

"With all the clamor and worry about Y2K,

we did an episode to address all that panic," says writer Matt Weitzman.

But more important than its millennial relevance was something far more meaningful: That episode introduced the Giant Chicken.

In the episode, a man in a chicken suit offers Peter a coupon to a restaurant.

Peter declines. "I'm sorry, pal, I don't take coupons from giant chickens. Not after last time."

We FLASH BACK to Peter in a market, presenting a coupon to the cashier, given to him by "that nice chicken outside."

It transpires that the coupon has expired and Peter, enraged, lunges at the chicken—an actual human-size chicken this time—through the store's plate-glass window.

And it goes from there, with an epic knockdown-drag-out battle between man and fowl that grows exponentially in destruction.

This diversion—completely unrelated to the episode's story—lasts a riotous and ridiculously long ninety seconds.

"It's one of those turns that happens in *Family Guy* that you would never expect and that people came to love," Weitzman says.

Other pieces of foolishness would join the Chicken fights in the show's repertoire of recurring funny business.

A character—usually Peter—would hurt his knee while running, then bring the entire show to a halt by collapsing to the ground, wincing and groaning in pain ad infinitum.

The front of Cleveland's house would collapse for one reason or another, leaving a naked Cleveland in his second-floor bathtub tumbling to the ground.

The Evil Monkey would lurk in Chris' bedroom closet, routinely terrifying him.

Even country-and-western legend Conway Twitty (1933–93) would be called to duty for a number of posthumous cameos. Live-action clips of Twitty in performance were employed to buy time for Peter when a situation went awry. Notably, in the episode "The Juice is Loose!," Lois arrives home to find Peter partying with his pals and oblivious to the

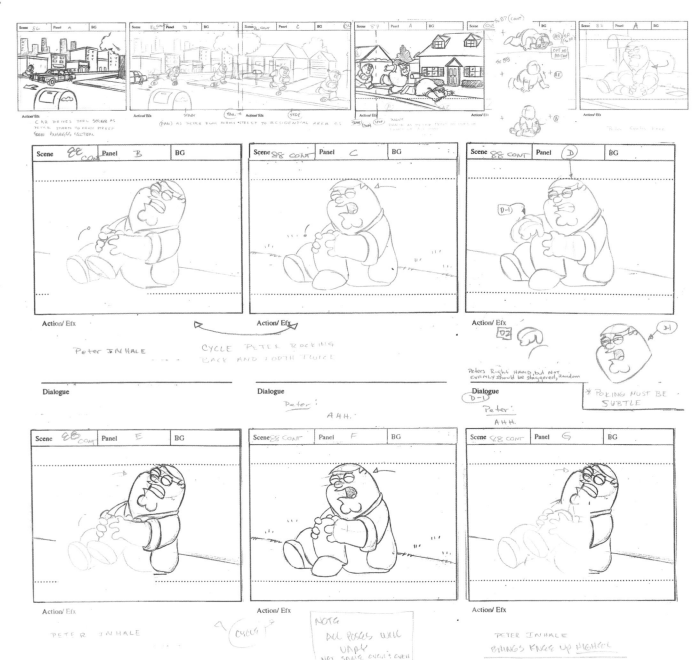

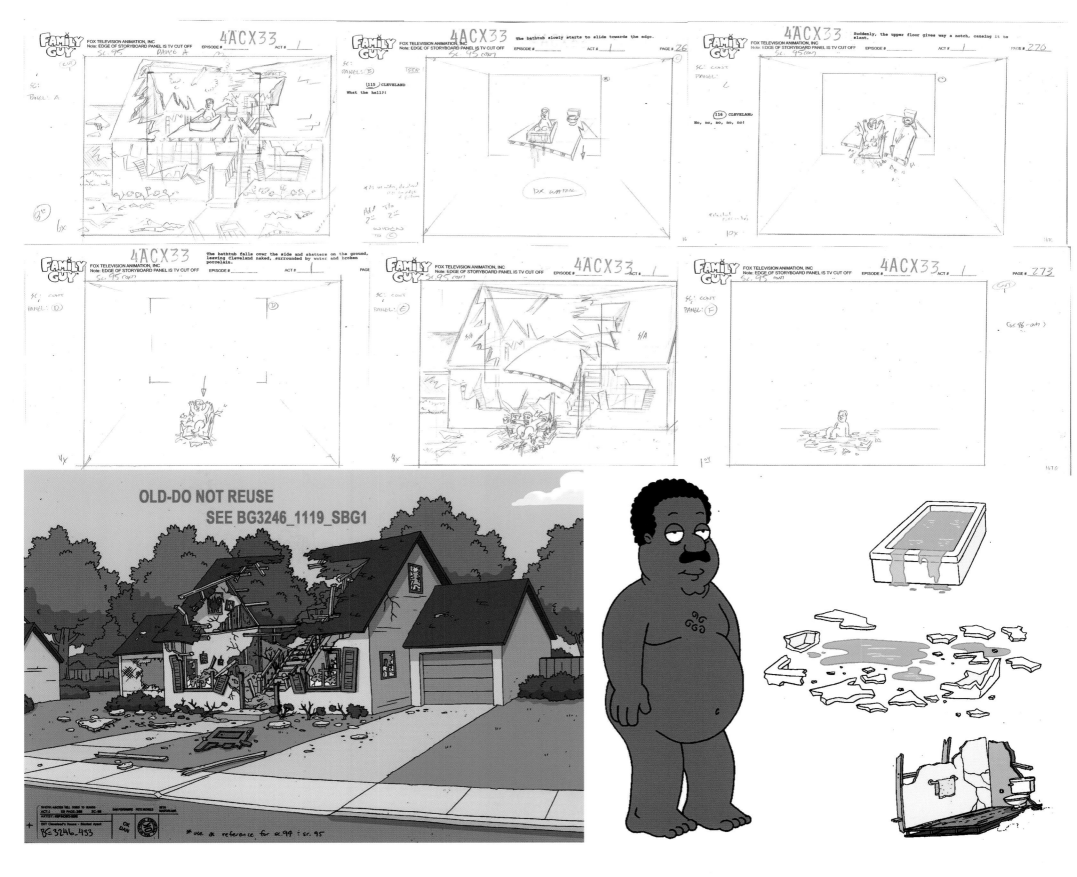

fact that Stewie, left in his care, is out on the roof.

"Yikes!" says Peter as he confronts Lois' wrath. "Looks like I need a distraction." Then, facing the audience, he says, "Ladies and gentlemen, Mr. Conway Twitty," whereupon Twitty and his band perform a nearly three-minute-long song in what becomes an exercise in pushing *Family Guy* viewers' patience to the breaking point.

But perhaps no recurring bit would rival the Chicken's appearances for sheer ambition. Subsequent fight sequences would grow in spectacle and collateral damage, as well as in duration—to as much as five full minutes.

In one brawl, the Chicken is decapitated by an airplane propeller (in tribute to *Raiders of the Lost Ark*). In another, Peter is broiled by a blowtorch. In yet another, they pound each other in zero gravity in outer space.

And in yet another, they interrupt their slugfest when they both realize they can't recall what they are fighting about. They make peace and make plans to get together, along with their wives, for dinner at a nice restaurant. There, all is well until the check arrives: Peter and the Chicken both insist on picking up the tab. With that, the battle resumes, more intense than ever.

For years, Chris Griffin was terrified of the Evil Monkey living in his closet. Production images and episodic stills from "Hannah Banana," written by Cherry Chevapravatdumrong and directed by John Holmquist.

"Any *Family Guy* chicken fight (Peter vs. the Giant Chicken, or anyone else) is an opportunity for our artists to come up with mayhem for a long period of time," says co-executive producer Peter Shin. "From the writer's original script, artists expand from there, pitching additional sequences that they think would be good for battle between Peter and the Giant Chicken." And often that can be too much of a good thing. Shin explains, "A fight at the animatic stage can sometimes be more than double the length of what it ends up being in the show. We've had a ten minute fight that had to be cut down to three."

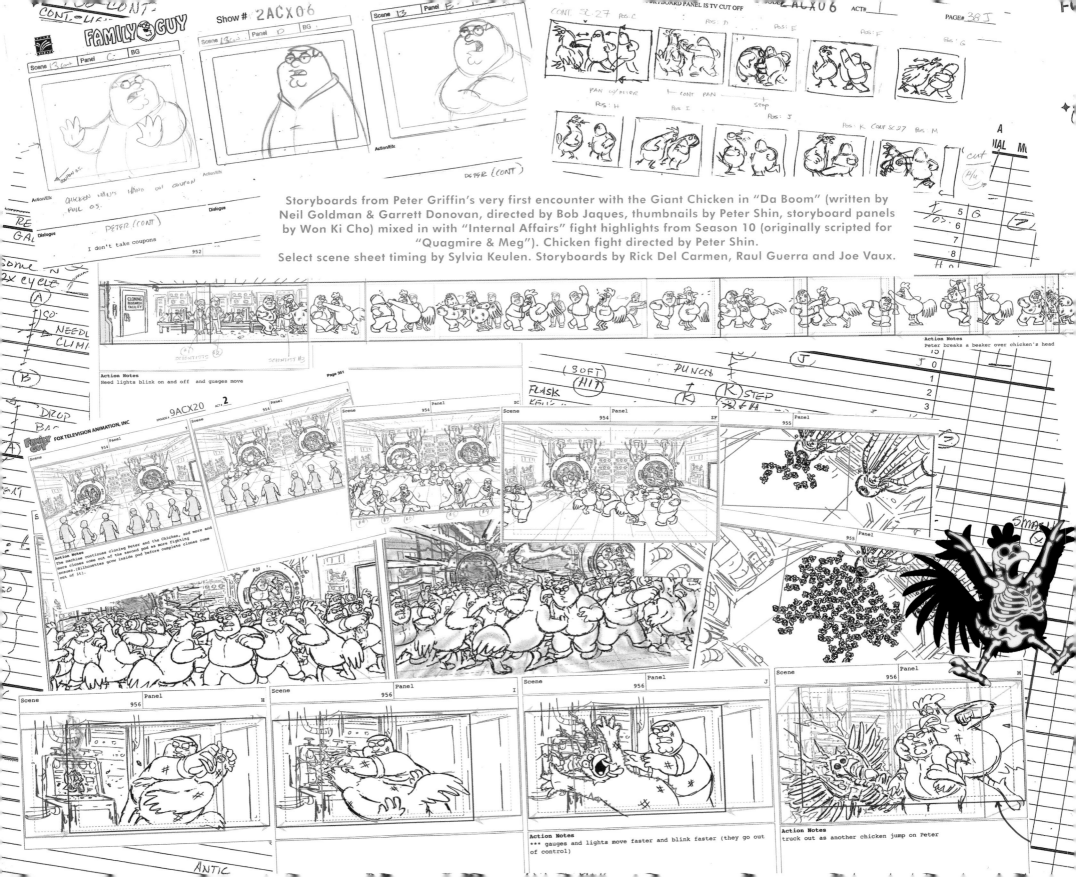

Storyboards from Peter Griffin's very first encounter with the Giant Chicken in "Da Boom" (written by Neil Goldman & Garrett Donovan, directed by Bob Jaques, thumbnails by Peter Shin, storyboard panels by Won Ki Cho) mixed in with "Internal Affairs" fight highlights from Season 10 (originally scripted for "Quagmire & Meg"). Chicken fight directed by Peter Shin.
Select scene sheet timing by Sylvia Keulen. Storyboards by Rick Del Carmen, Raul Guerra and Joe Vaux.

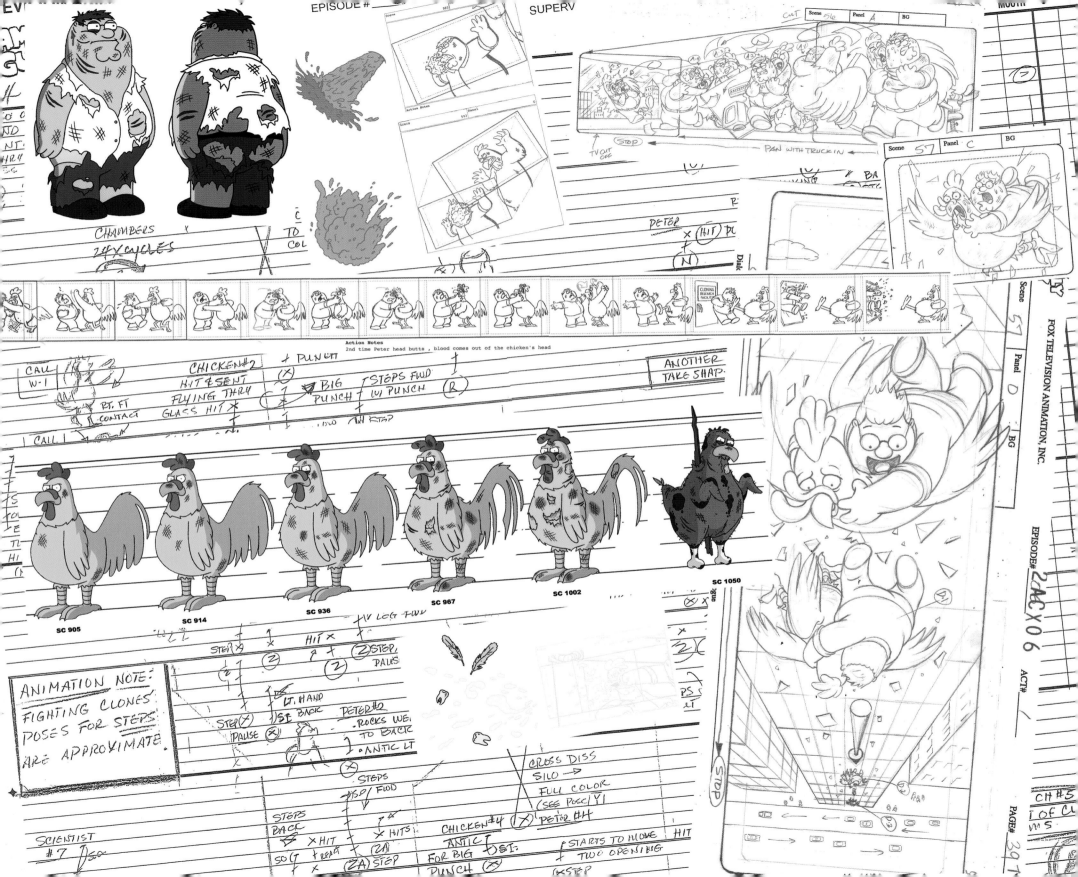

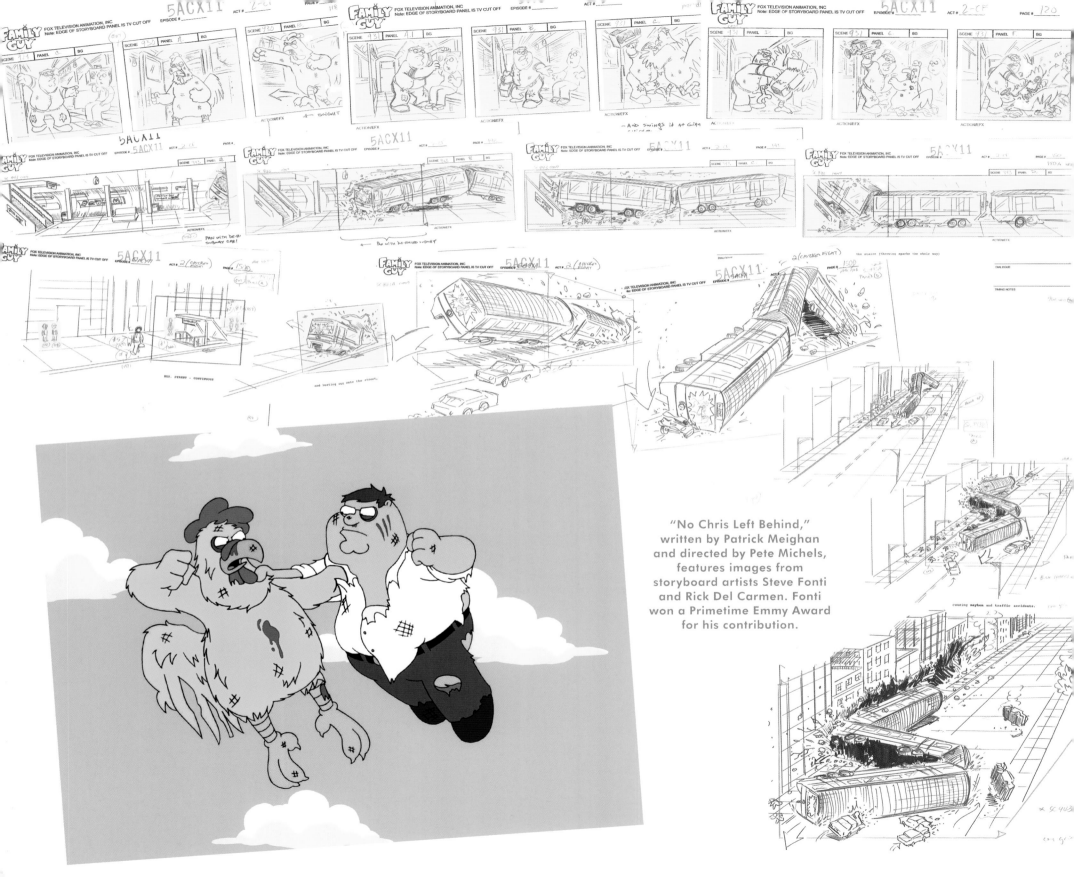

"No Chris Left Behind," written by Patrick Meighan and directed by Pete Michels, features images from storyboard artists Steve Fonti and Rick Del Carmen. Fonti won a Primetime Emmy Award for his contribution.

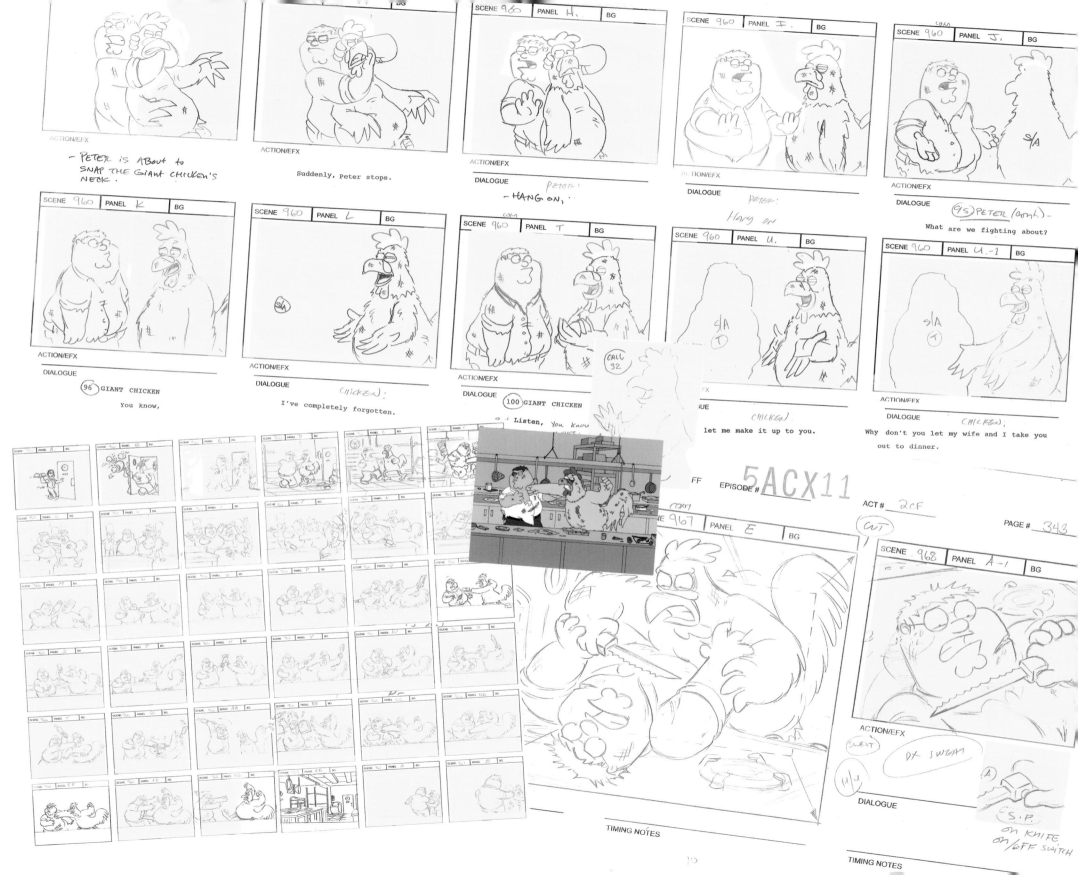

ACTION/EFX

- PETER IS ABOUT TO
SNAP THE GIANT CHICKEN'S
NECK.

ACTION/EFX

Suddenly, Peter stops.

SCENE 960 PANEL H. BG

ACTION/EFX

DIALOGUE PETER:

- HANG ON,

SCENE 960 PANEL I. BG

ACTION/EFX

DIALOGUE PETER:

Hang on

SCENE 960 PANEL J. BG

ACTION/EFX

DIALOGUE (95) PETER (cont.) -

What are we fighting about?

SCENE 960 PANEL K BG

ACTION/EFX

DIALOGUE

(96) GIANT CHICKEN

You know,

SCENE 960 PANEL L BG

ACTION/EFX

DIALOGUE CHICKEN:

I've completely forgotten.

SCENE 960 PANEL T BG

ACTION/EFX

DIALOGUE (100) GIANT CHICKEN

Listen, you know

SCENE 960 PANEL U. BG

ACTION/EFX

DIALOGUE CHICKEN:

let me make it up to you.

SCENE 960 PANEL U.-1 BG

ACTION/EFX

DIALOGUE CHICKEN:

Why don't you let my wife and I take you
out to dinner.

EPISODE # 5ACX11 ACT # 2CF

CUT PAGE # 343

SCENE 967 PANEL E BG

SCENE 968 PANEL A-1 BG

ACTION/EFX

SWEAT DX SWEAT

M/U A

DIALOGUE

S.P.
ON KNIFE
ON/OFF SWITCH

TIMING NOTES

TIMING NOTES

CALL
32

GONE AGAIN

After the one-off airing of "Da Boom," *Family Guy* vanished again until March 2000, when it returned on yet another new night, Tuesday, to finish out the season getting walloped by ABC's must-see quiz show, *Who Wants to Be a Millionaire.*

When Fox's upcoming 2000–2001 season was announced that May, *Family Guy* was missing from the lineup. And although then Fox network president Gail Berman was quoted a few weeks later saying, "The company remains optimistic about the future of *Family Guy*," she added, "To be fair, it hasn't been reordered yet either."

But then it was. The show received an order from Berman for 13 episodes.

In July 2001, after a year's absence from the Fox airwaves, *Family Guy* returned for what was billed as its third season. Ratings were still dismal. No wonder. It was buried on Wednesdays facing ABC's *Spin City* and NBC's *The West Wing*. Then in November, the show found itself relegated back to Thursdays, where it again vied with *WWE SmackDown* for young male viewers while also battling NBC's hot sitcom *Friends* and CBS's new smash-hit reality competition, *Survivor.*

GOING FOR BROKE

"We knew *some* people liked our show," says Sheridan, "but there was a point where we started losing hope, and we said, 'Let's stop

Hard to Let Go

While I packed up the materials intended for archive into boxes after Fox cancelled the show in 2002, I was told not to bother, that "Fox is out of the television animation business." Fortunately, Seth and I decided to split the boxes of materials and store them in our respective garages. *Just in case.*

Seth told me that his biggest regret about the cancellations was that he still "had so many stories he wanted to tell with the characters," which was so quintessentially Seth. It wasn't the money, it wasn't the power of running your own show. It was that this creation of his *was not finished*.

During the cancellation interval, a few things happened. Seth and I both went to work on other projects, but we would talk about ways in which to keep the *Family Guy* characters alive in the world. I was producing a show for MTV at the time, and one of the executives really loved *Family Guy* and we met a few times about a Brian and Stewie spin off. We also mounted a "Stewie for Governor" campaign, with Stewie running against Arnold Schwarzenegger. At the same time, Fox allowed Cartoon Network to air old episodes in exchange for their promoting the DVDs that Fox was actually having a difficult time getting shelf space for at retailers—a miscalculation that seems inconceivable in retrospect. Fox released those DVDs in 2003. That was my first recollection that something weird was happening with the show. Seth and I would go to these *Family Guy* DVD promotional events shrewdly held in bars around college campuses. One night, we drove up to a bar near UCLA and there was a line around the block for what we assumed was something happening in the club next door. They were there to see Seth. They were collegiate young men with disposable income standing in line around the block for a cancelled cartoon series. They acted like Seth was the Beatles.

One year later, I got a call from our production executive at Fox, Marci Proietto, she told me not to tell Seth, but that they were going to order thirty-five new episodes of *Family Guy*. I called Seth as soon as I hung up with her.

—Executive Producer Kara Vallow

making this for anyone but ourselves. Let's just do whatever we want, no matter how weird it is. Let's make ourselves laugh and go down in a ball of flames.'"

They did and it did. Again, it was cancelled (its final new episode would air the following February).

"I remember being sad but not overly distressed," MacFarlane says, "because Gail Berman fought really hard to keep the show around for as long as she could, despite the fact that ratings weren't great.

"It was a cancellation but not a firing," he adds. "Twentieth was very clear that they wanted to remain in business with me. So it wasn't like I was being kicked to the curb."

MacFarlane wrote a pilot script for a new show. It failed to get a series pickup. Then he joined *The Pitts*, a sitcom the studio produced that was on the air already but struggling. There he worked with writers Alec Sulkin and Wellesley Wild.

"By then, my career had been ass-backwards," MacFarlane says. "Generally you're supposed to work on other people's shows, get some experience, work your way up, and then, when you have a handle on it, create your own show. I did that all backwards. So it was a valuable experience to be finally working on someone else's show."

But soon *The Pitts* was cancelled. MacFarlane teamed up with fellow *Family Guy* alumni Mike Barker and Matt Weitzman to develop a new cartoon series, *American Dad!*

"We created it as a response to our frustration with the [President George W.] Bush era," he says. But the series, which features the family and home life of CIA agent and conservative Republican flag-waver Stan Smith, also represented "our way back onto the prime-time animated landscape, since we thought *Family Guy* was gone for good."

American Dad! would premiere on February 6, 2005, following Super Bowl XXXIX (and with Rachael MacFarlane voicing one of the lead roles). It aired on Fox until moving in 2014 to TBS, where it remains.

Even so, back when *Family Guy* went down for the second and seemingly final time, MacFarlane couldn't quite let go.

"He was so sad when it was cancelled," Rachael insists. "I remember him saying, 'I'm not ready for these characters to die yet. They have so much more to say.'"

A potential savior was waiting in the form of a cable channel based way off in Atlanta.

Cartoon Network mostly catered to youngsters, but it was experimenting with a weekly late-night programming block aptly branded Adult Swim.

"We already knew Seth from his days at Hanna-Barbera," says Mike Lazzo, a Cartoon Network exec who was spearheading the Adult Swim venture. "We had stayed in touch and we were big fans of *Family Guy*."

Indeed, Lazzo and his team had been tuned in the night *Family Guy* premiered.

"We were all mildly disappointed with the pilot," he concedes. "But then the Kool-Aid Guy crashes through the courtroom wall." That is, the gag that had given Fox execs such pause. It destroyed Lazzo and his colleagues, and won them over to the show overall: "Ultimately *that* was what the show became!"

Then, within a few months in early 2003, four consequential things happened.

THING NO. 1: Twentieth Century Fox Television offered the 50 existing *Family Guy* episodes to Cartoon Network for airing on Adult Swim. Normally, a cancelled series with fewer than 100 episodes and a less-than-stellar ratings record doesn't spark much resale interest. But the episodes were offered at a fire-sale price, and, once Cartoon Network's Standards and Practices Department could be talked into giving its approval, Lazzo jumped.

In April 2003, *Family Guy* premiered on Adult Swim, where it was an immediate hit. By year's end it was the top-ranked show on cable among adults and young men, and in the young-men demo it was beating broadcast juggernauts *Late Show with David Letterman* and *The Tonight Show with Jay Leno* in head-to-head competition.

"Our Adult Swim block exploded," says Lazzo, "and *Family Guy* has never been off our air since."

THING NO. 2: Fox's Home Entertainment division was just starting to gain traction with the relatively newfangled DVD format. Flimsy, analog-fuzzy cassettes had reigned for two decades, but sales of cassettes preloaded with movies or TV programs were mostly made available not to viewers but to rental outlets (from where they could be borrowed for a day or three, then returned with the admonition to the renter to "Be kind, please rewind" for the next customer, or be subject to a fee).

By the early 2000s, the more elegant, handier (and digitally razor-sharp) DVDs were beginning to shine as a format viewers wanted to own, not just rent, as they built a home library of favorite shows. Thus was the so-called "sell-through" business model for video stirring. And then in April 2003, Fox

Volume 3 DVD packaging. Concept sketch by Greg Colton. Final art by Julius Preite, Sharon Ross and Kevin Segna.

Peter pitches Fox's next big hit show to studio executives Gary Newman and Dana Walden, as seen in the episode "Inside Family Guy."

released a cache of 28 *Family Guy* episodes in a boxed set covering its first two seasons. Optimistically labeled "Volume One," it sold like gangbusters.

"The head of Home Entertainment said they couldn't keep them stocked in stores," Newman recalls.

With the success *Family Guy* was enjoying on Adult Swim, and the market potential for DVD home sales it was demonstrating, Walden and

Newman knew something big was going on with the show.

Then came **THING NO. 3:** Newman took his teenage son on a college trip to his alma mater, Yale University. While there, he was scheduled to speak to a class.

"So I give my 15 minutes of who I am and what I do," says Newman, "then open it up for questions. A bunch of arms shot up. Question after question was, 'Why would you cancel

Family Guy?' And I would tell them, '*I didn't cancel it. We produce it and support it!*' And I remember thinking, 'Wow, you rarely see this kind of passion for a show that never had spectacular ratings and then was cancelled.'"

So Newman had these three data points.

Actually, **FOUR:** "Seth used to visit me regularly, presumably just to say hi," Newman says. "But what it was all about really was him saying, 'Can't we bring *Family Guy* back?'"

Never-say-die MacFarlane was still lobbying, still hot to trot.

Meanwhile, Lazzo at Adult Swim was hungry for new *Family Guy* episodes.

After *The Pitts* was axed by Fox in April 2003, MacFarlane and Sulkin continued to hang out, even heading out some nights for a round of karaoke.

During that period, MacFarlane told Sulkin, "they're talking about bringing *Family Guy* back." He invited Sulkin and writing partner Wild to come aboard if that happened.

"I was thinking, 'Yeah, *right*,'" says Sulkin.

David A. Goodman, who after the third *Family Guy* season had migrated to *Futurama,* then *Star Trek: Enterprise,* was also hearing from MacFarlane.

"Seth kept telling me the DVDs were coming

FAMILY GUY

"North By North Quahog"

Production #4ACX01

Written by
Seth MacFarlane

Directed by
Peter Shin

Created by
Seth MacFarlane

Executive Producers
David A. Goodman
Seth MacFarlane
Chris Sheridan

<u>AS BROADCAST</u>
May 1, 2005

<u>**COLD OPEN**</u>

EXT./ESTAB. GRIFFINS' HOUSE - DAY

INT. GRIFFINS' LIVING ROOM - SAME

CHYRON: February, 2002.

PETER addresses the FAMILY.

> PETER
>
> Everybody, I've got bad news. We've
> been cancelled.

> LOIS
>
> Oh, no, Peter. How could they do
> that?

> PETER
>
> Well, unfortunately Lois, there's just
> no more room on the schedule. We've
> just got to accept the fact that Fox
> has to make room for terrific shows
> like Dark Angel, Titus, Undeclared,
> Action, That 80's Show, Wonderfalls,
> Fastlane, Andy Richter Controls the
> Universe, Skin, Girls Club, Cracking
> Up, The Pitts, Firefly, Get Real,
> FreakyLinks, Wanda at Large, Costello,
> The Lone Gunmen, A Minute with Stan
> Hooper, Normal Ohio, Pasadena, Harsh
> Realm, Keen Eddie, The Street,
> American Embassy, Cedric the
> Entertainer, The Tick, Luis, and Greg
> the Bunny.

> LOIS
>
> Is there no hope?

> PETER
>
> Well, I suppose if all those shows go
> down the tubes, we might have a shot.

<u>**END OF COLD OPEN**</u>

out and the studio was thinking about bringing the show back," says Goodman.

Even before the show was cancelled, a tuckered-out Zuckerman had decided to leave the show (though, as every *Family Guy* viewer knows, he would retain a "developed by" co-credit with MacFarlane on each episode). He needed to be replaced.

"Seth told me, 'If it comes back, I want you to run it with me,'" says Goodman. "I didn't say so, but I'm like, '*This* show isn't coming back.'"

Gary Janetti, who by then was working on the NBC hit *Will & Grace*, recalls a day when he saw a kid pedal past him on a bike. Much to his surprise, he saw the kid was wearing a Stewie T-shirt.

"I think something is changing with this show,' Janetti told himself. "It's out in the world in a way that it never was before. I think the show *is* going to come back."

"In an odd, backward kind of way, the show grew most in its popularity during that period when it was not in production or on Fox," notes Callaghan.

PUSHING THE SHOW AND HIS LUCK

Months passed. Walden and Newman had a standing weekly meeting with their boss, Sandy Grushow, who, as chairman of the Fox Television Entertainment Group, oversaw both the network and the studio.

"Each time we would go into the meeting, Gary would talk about the success *Family Guy* was having on Adult Swim, and how how well it was doing on DVDs," says Walden. "He would encourage Sandy to order the show back onto the network."

Each time, Grushow would say no. And no. And then, again, no.

It got to the point where Grushow, exasperated, told Newman, "If you ask me one more time about this show I'm gonna fire you."

But Newman didn't let up and, finally, instead of telling him "You're fired," Grushow said yes.

"I told Sandy I could bring *Family Guy* back as a series for Cartoon [Network] and finance it off what Cartoon could pay us, along with DVD sales, with no financial risk," Newman recalls.

"Fine!" said Grushow. "As long as you stop *talking* about it."

There was one more wrinkle to the deal. Newman had gotten the go-ahead to produce new episodes of *Family Guy* for Adult Swim, not the Fox network. But what he built into the deal, and Lazzo agreed to, was a limited-time option for Fox to decide it wanted to put *Family Guy* back on its own air, in which case Fox would be granted first dibs on the new episodes. Adult Swim could air them shortly after that.

Even with the income from DVD sales expected to fill the gap between production costs and what Cartoon Network could afford to pay, the deal, announced in March 2004, was a bold one at the time: A big-budget broadcast-network-level TV show was resuming production without a commitment from a broadcast network—just a niche cable network itching to keep the show alive.

"But I really believed that eventually Fox was gonna want it, too," Walden says. (Fox did, and in May made it official, announcing that *Family Guy* would be returning to its schedule, yet again, the following year.)

Mila Kunis learned that *Family Guy* was coming back from her TV, where, on a news crawl at the bottom of the screen, she read: "*Family Guy* gets picked up two years after it was cancelled."

"I was like, 'It *did?*' Then 40 minutes later I get a call: 'Hey, *Family Guy* got picked up.' And I was like, 'I *heard!*'"

The fourth season of *Family Guy* premiered on May 1, 2005, joining *American Dad!* on Fox's Sunday slate.

"So here I was with *American Dad!*, and then *Family Guy* was coming back, and I said, 'Oh, shit,'" recalls MacFarlane. "I never really wanted to be running two animated shows at the same time. I was a little freaked out.

"I made an attempt early on to run back and forth between the two writers rooms. But I got tired of that real quick. I decided I was going to focus my efforts on the rebuilding of *Family Guy*." (Even so, he has continued to do voices for *American Dad!* characters Stan and Roger.)

"We were working on the show for a full year," says Callaghan, "crossing our fingers and hoping that anyone would care or even remember the show."

"For us, it was like Lazarus rising from the dead," says Sulkin, who along with his partner Wild, had signed on. "It was an awesome time to be on the show. It felt like we were bulletproof. They tried to kill us, the fans said no, and to their credit Fox brought us back."

"When it came back," says Sulkin, "we had about 50 episodes under our belt and we had done the Montreal Comedy Festival," where, in July 2004, the troupe made its first-ever "*Family Guy* Live" stage appearance. "The crowd reaction was *un*believable. We felt like the Beatles! That, along with the new 35-episode order, gave us a lot of confidence."

The returning episode, "North by North Quahog," was written by MacFarlane, and opens with a memorably sassy scene that puts the tumultuous history of *Family Guy*, at least up to that point, in wry perspective.

For once, Peter was right. And, not for the first time, so was Seth MacFarlane.

FOX EXECUTIVE OFFICE - SPRING OF 2004

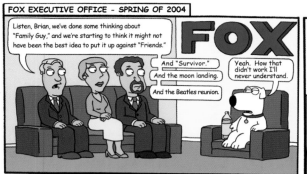

Listen, Brian, we've done some thinking about "Family Guy," and we're starting to think it might not have been the best idea to put it up against "Friends."

And "Survivor."

And the moon landing.

And the Beatles reunion.

Yeah. How that didn't work I'll never understand.

FOX

We saw those "Family Guy" DVD numbers and the ratings on Cartoon Network. And now I totally "get" you and that funny little baby.

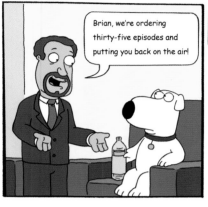

Brian, we're ordering thirty-five episodes and putting you back on the air!

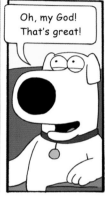

Oh, my God! That's great!

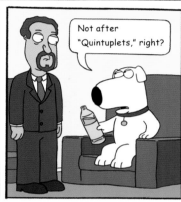

Not after "Quintuplets," right?

FAMILY GUY WRITERS ROOM - A FEW WEEKS LATER

Hehehehehe.....

What if we do an episode where Peter finds out he's legally retarded?

Or... What if he decides to get into the Guinness Book of World Records by eating more nickels than anyone's ever eaten before, and goes blind from nickel poisoning?

HAHA! HAHAHA!

Steve, that's perfect.

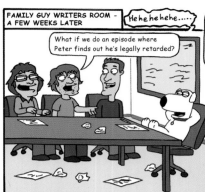

Just for that, I'm buying you a sundae.

SNAP

ICE CREAM

So, who else is gonna earn themselves a sundae?

FAMILY GUY CONFERENCE ROOM - SUMMER OF 2004

Hey, everybody, I'd like to thank you all for coming to the reading of the first episode for "Family Guy" Season Four.

And especially the Evil Monkey for taking time out of his busy schedule of flinging poop.

(CHUCKLES) Just kidding, Evil, you look great.

BRIAN'S OFFICE - WINTER OF 2005

You think this shot makes my snout look kind of big?

You're a dog.

Good point.

Hey, if I gave you like fifty bucks, do you think you could draw Lois in one of those see-through nightie things?

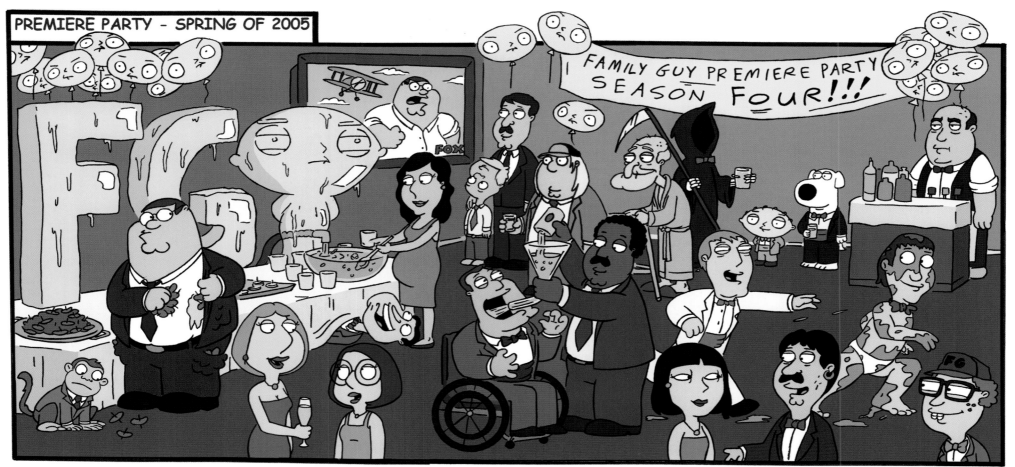

PREMIERE PARTY - SPRING OF 2005

FAMILY GUY PREMIERE PARTY SEASON FOUR!!!

It's good to be back.

And don't forget to watch us on Sundays at 9:00PM on FOX!

What else are you gonna watch? "Strong Medicine" on Lifetime?

Oh, actually, that sounds pretty good.

Comic from July 2005 *Esquire* magazine, includes caricatures of writers Wellesley Wild, Alec Sulkin, Steve Callaghan, David A. Goodman, Mark Hentemann, Tom Devanney, Danny Smith, Chris Sheridan and supervising director Peter Shin.

Art by Greg Colton and Peter Shin. Linework by Aldin Baroza. Color by Sandra Calleros.

HOW IT'S DONE

We may all think we know how a cartoon show happens. Someone writes a funny script. Some other writers lend a hand to make the script funnier. The characters' dialogue is recorded by actors the audience will never see. Then a lot of artists do preliminary drawings, and a lot more artists, maybe in a foreign land, do a lot more drawings that, flashing one after another, make those individual drawings look like they're moving. Animated, even.

Seems pretty cut-and-dried.

It's not. So let's take a look at the workflow for a typical *Family Guy* episode—and the looooong start-to-finish time span.

Why does it take so freakin' long?

"Animation is nothing if not details," says producer Shannon Smith.

Her portfolio of production tasks at *Family Guy*, which she joined in 2004, includes scheduling and supervising what in effect is a year-round cartoon assembly line. At any time, upwards of 40 episodes are in the works, each a couple of weeks behind the one ahead of it in the process.

"My theory has always been that the assembly-line process is a good thing," says Kara Vallow, whose broader domain includes *American Dad!* as well as *Family Guy.* "Having a very specific production plan in place at the beginning lets the creative be more grounded and it makes for a better creative product at the end."

"My line producer and I were recently accused of running a 'sausage factory' and not in the hilarious sense. Personally, I embrace the 'factory system' where the end product isn't a sausage but something unique and as perfect as it can be. The actual process of animation, the steps, *is* a pipeline. Animation production requires so much time, so many people and has so many moving parts that there needs to be a 'system'

Opposite: Original art from *Family Guy* director Joseph Lee created for a Fox gallery exhibition.
Above: Multihyphenate Seth MacFarlane working hard on the show. Crew drawing by Peter Shin. Special appearances by Kara Vallow (budget), David A. Goodman (script), Shannon Smith (schedule) and Peter Shin (animation).

where you discipline the execution process—where the environment is calm and controlled without hysteria and the headless chicken thing that seems endemic to so many productions. When the process is ordered, you allow the artists and the writers to generate their best work. The idea that only out of chaos comes the genius is barbaric. We have the system down."

Weeks 1-4:
Writing the Script

For this, we're in the writers room, where an idea for a story can catch fire without warning.

"You've got five or six people throwing out 'What if *this* happens?,' 'What if *that* happens?'" says Chris Sheridan, often one of those people. "Then an idea takes on a life of its own, and we know we have something."

A story like: Lois learns that Peter has been donating sperm for years. Which means his sperm have impregnated a lot of women. Then all his many grown-up offspring unexpectedly show up at his house.

"I remembered a story a friend had told me about how, just to make extra money in college, he donated sperm," Sheridan says. "He didn't think anything of it. And then one day he went back again and they said, 'You can't do it anymore. You have too many kids already.'

"He told me that's when it got really real, like, 'This isn't just beer money.' And that's where our story started."

The episode, which would be titled "A House Full of Peters" and would air in Season 15,

The episode "Inside Family Guy" takes the viewer inside the writers room. Here we see caricatures of a few of the shows' writers. *(From left to right:)* Travis Bowe, Cherry Chevapravatdumrong, Patrick Meighan, Danny Smith, Peter Griffin, Steve Callaghan, Rich Appel, Mike Desilets and Andrew Goldberg.

An early version of "Dog Bites Bear" from the initial writing phase of the episode.

was written by Sheridan, but not before the story was submitted to the typical (and very collaborative) writing process. First, a small group of writers will "break" the story into "beats" that conform to a three-act half-hour structure, with a dramatic "turn" before each mini-intermission for commercials.

"You put all the beats on a whiteboard," says Sheridan, "and when it all lays out, a showrunner comes in and hears it and gives input. Then the writer will go off and write an outline"—about 10 single-spaced pages.

Another step in the process: the "gag pass."

"The writer of the episode will sit with other writers," says Sheridan, "and they'll go scene by scene as they randomly pitch ideas for funny things that could happen along the way."

Many writers will be involved in a script that will be credited to just one of them.

"When you write an episode, you're the one who writes the first draft, but we all work on everything together," says Cherry Chevapravatdumrong. "So you can feel pride of authorship in a gag that you pitched and wrote that ends up in somebody else's script. And the gags are moved around all the time. Something you wrote in your first draft that was cut for time could end up in another script two years later."

The communal monkeyshines of the writers room ("It's a room with an odd combination of silliness and professionalism. We all take our jobs incredibly seriously, even if that job is creating absurdity," says Steve Callaghan.) are felt in every episode. But right now, the designated writer of this episode-in-progress is facing solitude and a no-nonsense deadline: In two weeks, a 50-page script is due.

But that's not the only script in the pipeline.

Working Out Family Stuff

Writing scripts for *Family Guy* can be funny and fun. Occasionally, it can also prove therapeutic, as Danny Smith recalls when he wrote "Holy Crap" for the second season.

In the story, Peter's devoutly Catholic and brutally judgmental father moves into the Griffin home, where he spares no effort berating everyone for their every perceived sin.

This treatment is particularly painful for Peter, who had always sought in vain to gain his father's approval.

"If you're in a job where you can work out some of your own 'stuff,' that's great," says Smith. "My 'stuff' was being what I've called a recovering Catholic. In a Catholic upbringing it's all about what you didn't do: You're born into original sin. I remember being eight years old and thinking, 'What could I have possibly done to deserve going to hell?' So I had some issues.

"In the episode, Peter wanted to prove to his dad that he was a good guy, and the length he went to was to kidnap the pope and bring him back to their house to meet his dad. But that *still* wasn't enough."

The distinguished character actor Charles Durning was cast to voice Peter's fault-finding father.

"That was a great thrill for me," Smith says. "There he was in the recording booth, looking like every one of my Irish uncles. He's holding the script and he says, 'Alright, you little bastard. I want to know who it was?'

"And I go, 'What do you mean?'

"He says, 'Was it your mother? Your father? The priests? The nuns?'

"'It was kind of *all* of them,' I told him. And he nodded. He recognized the issues I was working through!"

Working Retroactively

A secret of *Family Guy* plotting: Act I is sometimes a display of misdirection. That is, it may offer little hint to the narrative that will unfold in Acts II and III.

It should come as no surprise, then, that when the writers settle on a story idea, they must next work backward to figure how, in the first act, the story can be set up in the most obscure way.

Take the seventh-season episode "Family Gay" (written by Rich Appel and directed by Brian Iles), for instance. The basic idea: Peter learns he can make money by participating in a battery of drug tests, one of which calls for injecting him with the "gay gene."

This was a premise rife with comic possibilities, including a major punch line late in the episode: The drug would wear off while Peter is having sex with another man. "We initially animated the sequence so that we stayed tight on Peter's face, which, as the drug wore off, moved from an expression of ecstasy to one of confusion to one of shock. All of those expressions were deemed too explicit for broadcast, so we just heard him scream offscreen," says Appel.

Fine. But this plan begged the question: Why did Peter need the money in the first place?

The answer they came up with: He bought a brain-damaged horse with the plan to race it and get rich. But on race day, the addled horse gallops off the track, trampling spectators and destroying property. Peter needs money fast to repair all the damage. That becomes the "turn" at the end of Act I, leading the way to the "real" story.

Alec Sulkin, along with co-showrunner Rich Appel, has to keep track of what all the other 15 writers are doing, and all the episodes in progress.

"At any given time," says Sulkin, "there will be two writers working on their outlines, three writers out working on their first drafts, and we'll be breaking two or three stories at a time, and working on a table read or an animatic screening. It's a juggling act."

"Animation is never done," says writer Mark Hentemann. "It takes a year, but it's all staggered, so you start with a table read on Monday, then you have another one the next Monday, and the next, and it just keeps going. And each episode moves along that timeline to completion."

A version of the *Family Guy* cast and crew came to the screen in "Inside Family Guy," written by Andrew Goldberg and directed by Joe Vaux. Many of the characters seen here are modeled after real-life *Family Guy* writers, directors, producers and crew members.

Weeks 5–6:
Words Come to Life

After another round of rewrites and polishing by the writers, the script moves to the table read stage, which is the first out-loud performance by the episode's actors (or the writers who may sub for them). In fact, it's really the first time that anyone outside of the writers room is hearing or seeing the completed script.

Representatives from the studio and network, as well as most of the *Family Guy* cast and crew, will gather in the show's offices for the cold read of the episode. Throughout the table read, writers and producers quickly jot notes about which jokes seem to be working, which jokes are clearly not working, which portions of the script can be trimmed down, and where any

unexpected story problems may be rearing their heads. These notes, along with feedback given by the studio and network, will guide the rewrite that follows until the writers and showrunners are happy with the script. At least, as it currently stands. There will be many more rewrites to come.

Recording sessions come next.

"I directed the first voice session for the *Family Guy* pilot," says Mike Henry. "We had everyone there in a semicircle that day. But we all immediately realized that it was a waste of everyone's time."

"It proved both difficult in scheduling trying to get everybody together at the same time, and also really inefficient," says Seth Green (Chris). "You might have a character with a single line of dialogue and that actor has to be there for

the five to seven hours it took to record all the actors as they went through the whole script."

Instead, every actor typically records his or her character's lines solo, and in some cases remotely, whether from a more convenient studio across town, across the country or even from abroad.

"You're not doing scenes," says Mila Kunis, who voices Meg from various recording studios when she's busy on location with other acting jobs. "You're just going line by line. You don't really know how the scene is going to be animated, so you don't always know your surroundings and the best way to project your voice.

"So when you're in the recording booth, you record each line several different ways, and then they kind of 'Frankenstein' it together to make your dialogue fit to whether the character

Pushing the Limits but Not Crossing the Line

Regular *Family Guy* viewers may assume that anything goes when it comes to writing and animating the show. In fact, each draft of every script, storyboard, animatic and color cut is carefully scrutinized by both the network's Legal Department and Standards & Practices Department (essentially, the network's censors). The former tries to keep *Family Guy* out of legal hot water while the latter lays down the rules on what sorts of material is or is not acceptable for broadcast.

"Some of the discussions we have with Standards, though serious and professional at the time, can seem amusing when you take a step back from them," says Executive Producer and former showrunner Steve Callaghan. "I recall one instance where the network objected to us using a particular term on the air, which resulted in an extended, weeks-long email chain, the subject line of which read, 'Butthole.' Those are the times when you just have to marvel at the fact that this is your *job*." In the end, the potentially offending word did end up airing on the FOX Network.

Other times the objection to a gag may not be able to be reduced to the use of a particular word and may be more open to interpretation. In the episode, "An App a Day," while Stewie and Brian confidently train for an upcoming doubles tennis tournament, Stewie excitedly says he already knows exactly where he's going to put their trophy. At that point, the scene cuts to a doctor's office, where two physicians examine an x-ray on a light board, seeming to show the trophy halfway inside Stewie's posterior. "That gag generated a good deal of discussion," Callaghan says, "I suggested to our Standards executive that the x-ray gives no indication from which end the trophy made its entry, and that as a baby, Stewie may have simply put the trophy in his mouth to suck on it—as babies do—and inadvertently swallowed it." The executive skeptically replied by asking why, then, wouldn't the narrow end of the trophy be pointing *down*. "At which point," recalls Callaghan, "I joked to her, 'Are we really having a conversation right now about the correct way to eat a trophy?!'" In the end, two different versions of the gag were produced: one for broadcast and one for the DVD version of the episode (a practice that has evolved over the years when the writers don't want to part with a line or gag entirely, even though it has been deemed unacceptable for broadcast).

is walking, or going out of a room, or entering a room."

"I love to be able to watch the show and still be surprised by the jokes," says Green. "When Chris has only one scene in an episode, there's 80 percent of the script I don't have to read. Then, when I watch the episode as it airs, I'm completely surprised and entertained, just as our audience is."

The recording can usually proceed at a brisk clip. By now, the actors know their characters backward and forward, and they trust that the writers have captured the right phrasing for a line to guarantee it will work within the overall scene.

These days, either Appel or Sulkin directs each session. Their purpose, says Appel, "is to explain the context of a given line, or to explain exactly what the writer's point was, to get the right attitude."

"Most of the jokes are not subject to a lot of interpretation," says Green. "They are written in a very specific way, with the intention of a very specific cadence or inflection that will yield a laugh."

But there's nothing rote about the performance, in Green's mind.

"I've always felt like the writers' willingness to delve so deep into the family dynamics gives each of us actors the ability to make it as real and as true as we can," he says. "I don't think of Chris as a cartoon character. I don't *play* him as a cartoon character."

Of course, when it comes to voices, MacFarlane is a whole cast of characters all by himself.

"He doesn't just do one character straight through," says Appel. "He goes through the script page by page. And only two or three times in an hour-long session will I reach for the mute button because he's read a line where I think he may have emphasized the wrong word, or *not* emphasized the right word. But before I can hit the button to tell him, he's gone back and redone it—because his ear is so attuned."

Patrick Warburton (Joe) acknowledges that, as a voice actor, "I am by no means a chameleon. There's something identifiable about my voice, which is both good and bad. But I do feel good about what I can bring to a character like Kronk [in the animated series *The Emperor's New School*] or Joe. You've got to make the audience hear the gears turning in a character's head with the voice you give him."

Along with its regulars, the cast includes many members of the writing staff who are drafted to fill supporting roles.

"Lucky us!" says Appel. "Many of us are frustrated performers and we love doing it.

"It's all thanks to Seth. When a writer would pitch a particular joke and everybody would bust out laughing, and it wasn't for a major character, he would say, 'You have to record that joke,' because he understood that the person who said it and made everybody laugh had said it exactly the right way."

For the talent, the voicing step is a leap into the unknown (or, at least, the uncertain). They are often blind to what the visuals and action will be that their voices will ultimately coexist with.

But at the same time, what they say and how they say it can serve the animators with important cues. The vocals lay a foundation for everything that follows: "When I'm recording, I know that if I give the animator a 'handle' or an emotion to connect with, it's going to enhance how they interpret the character," says Green.

The best performance of each line is chosen and edited by Dialogue Editor Patrick Clark.

Casting Call

A typical *Family Guy* episode enlists a bounty of guest stars. They may be voicing an animated version of themselves or creating some fictional character, but a careful look at the cast credits always reveals big names supplementing the regular voices.

"A beautiful thing about the show is, we can get A-list actors, musicians and celebrities," says Mike Henry, a writer on the show who also voices Cleveland and other characters. "As long as they can get to a studio anytime within a three-month window, they can record their lines for us. It's really cool that it can then be put together virtually."

The earliest of the hundreds who have piped up through the years include Erik Estrada in his role as Ponch from the long-ago action series *CHiPs* (appearing in the second episode) and country singing star Waylon Jennings (in the third).

A sampling of other bold-face names includes Candice Bergen, Hugh Laurie, Will Ferrell, Bob Barker, the bandmates from Kiss, Hugh Hefner, Patrick Stewart, Phyllis Diller, Johnny Depp, Liam Neeson and many more.

Carrie Fisher became a recurring player as Angela, Peter Griffin's cranky boss. Drew Barrymore did numerous turns as Brian's dimwit girlfriend, Jillian.

Patrick Duffy and Victoria Principal appeared on camera to spoof their Bobby-and-Pam shower scene from 1986 on the prime-time soap *Dallas*.

Late-night hosts Jay Leno, Craig Ferguson and Jimmy Fallon appeared on camera in pseudo clips from their monologues skewering Brian as the latest boyfriend of reality-TV star Lauren Conrad (who did a bang-up job making fun of herself in the same episode).

And perhaps no finer living actor, Sir Ian McKellen, co-starred as Stewie's child psychologist in a standout episode, "Send in Stewie, Please," in the series' 16th season.

Rich Appel, who as a co-showrunner directs the voice talent, says these guest stars have to strike a specific tone.

"It's not cartoony, it's not broad," he says. "It's like theater acting. I call it 'real-plus.'"

Sometimes a film actor needs a little extra guidance.

"They're used to being able to use their very expressive faces. So initially we may get a read that's almost sotto voce. You don't want to just say, 'Louder!' So I tell them, 'You're on a stage and you're playing to the twelfth row.'"

And as for the actor who gets carried away and overperforms?

"I say, 'Just be a little more conversational. Like we're talking right now.' They get it."

Mike Henry in the recording booth. Henry does the voices for Cleveland, Consuela, Herbert, Bruce the Performance Artist, the Greased-up Deaf Guy and many more.

Using ProTools editing software, he assembles in order the selected takes into what is called a "radio play." He paces the lines to make them sound like natural conversations, paying close attention to the comedic timing—often two frames (a tiny fraction of a second) can make the difference between a mild chuckle and a hearty guffaw.

Weeks 7–15:
Storyboards and Design

This is where the episode begins its leap from spoken words to imagery. And this is when the director steps into the picture.

While the title of director may conjure images of Erich von Stroheim on the set barking orders through his megaphone, or, more recently, a cinematic master like Steven Spielberg or J. J. Abrams, the job of director is different in animation.

"It's a big bag of tricks," says Greg Colton, who joined *Family Guy* in its third season. "You're like a traditional live-action director, but you're drawing the acting. You're like a cinematographer, since you're coming up with all the 'shots.' You're also an editor, because you're choosing the shots—cutting from this one to that one—at the storyboard level. And also an animator, since you need to know the process and lingo and tricks of traditional 2-D animation: 'moving the camera' on a 2-D drawing is much different than moving the camera around in 3-D space. All that, plus you have to know comedy."

Under the supervision of a director and an assistant director, a team of artists will set to work, transforming the script's text into storyboards—adding all the visual elements to the recorded radio play. Conveying an episode, whose screen time is roughly 21 minutes, will entail an average of 2,000 storyboard panels.

Each panel specifies a successive key moment in the story, from the expression on the characters' faces to how they are staged to the framing of the shot.

Says co-executive producer Peter Shin, "For a simple action like lifting a cup, we would do just two drawings: the character grabbing the cup and then putting it to his mouth. But the more complicated the action, the more drawings we do."

It's a connect-the-dots exercise, with some actions or interludes requiring more dots (that is, panels) than others.

Consider just a snippet from a musical scene in the 15th season episode "Bookie of the Year," where Brian and Stewie open an Italian restaurant with Frank Sinatra Jr.: For the seven seconds it takes just for them to sing several lyrics, two dozen drawings are required to plot it out.

In the seventh season episode "Road to Germany," which Colton directed, "the script said 'a visually extensive airplane battle ensues,'" he recalls. "There was nothing else there. I'm not a fan of action and spectacle just for the sake of spectacle, so we came up with some visual storytelling during the battle, including sight gags like Mort's backpack getting shot up and, when he throws up into it, the throw-up pours out of its bullet holes."

"The script comes from the writers, but then we have to use that info to tell the story," says Shin, "and do it as comedically as possible."

"A House Full of Peters" inspired Peter Shin to design his directing team in the style of Peter Griffin. (*From left to right:*) Peter Shin, Brian Iles, Dominic Bianchi, Joe Vaux, Joseph Lee, John Holmquist, Steve Robertson, James Purdum, Greg Colton, Mike Kim, Jerry Langford and Julius Wu.

Board to Death

Turning a *Family Guy* episode from script into animation is no small task. Allotted a schedule of roughly six weeks per episode, directors and a small army of storyboard artists will transform the show's scripts into reams of detailed storyboard panels. Let's be clear—that's a *lot* of drawing, but drawing skills are only half the battle in this endeavor.

"I would say it's the process of visualizing the whole script, so it's like you're creating the episode in your head," says director Jerry Langford. "You've got to read through the script two or three times. Each time the visuals become more concrete and more developed."

Fellow director Steve Robertson broaches another vital aspect of preparation: "Figure out who your crew is and what they're good at; what's a challenge for them. You want to give people something that will excite them." For example, some artists prefer acting while others prefer broad action sequences. Playing to their strengths is essential for efficiency.

"I'll go through the script, figure out all the different locations," says Langford, "and then I'll have my team, which is usually three to four board artists, divvy up who's working on which sections. Because we tend to bounce around a lot with the show, a lot of cutaways, a lot of locations, sometimes it's a little bit tricky trying to balance the workload. I split it up as much as I can, so the artists don't have to rely upon one another for "Hey, I was working on this location we're both on, and I added *this* room. Oh, by the way, I hope it works with *your* stuff!" As much as it's separate, the better. That way everyone can go and do their thing without having to worry . . ."

Robertson agrees: "Page-wise, there may not be a lot [written in the script] but there could be a lot of animation required so you want to be aware of the difficulty level of each section and figure out how to break it apart for the crew so it's not overwhelming."

Once the teams are assigned their sections, it's time to check in with the writers and make sure everyone is on the same page. Pretty important for a show that sometimes features obscure references.

"All of the board artists, the director, the assistant director, will build up their notes related to things they've considered," says Langford, "and then we'll have a meeting with the writers where they'll bring up things we didn't even think of. Like, "by the way, we're going specifically for *this*," and I didn't even have a question

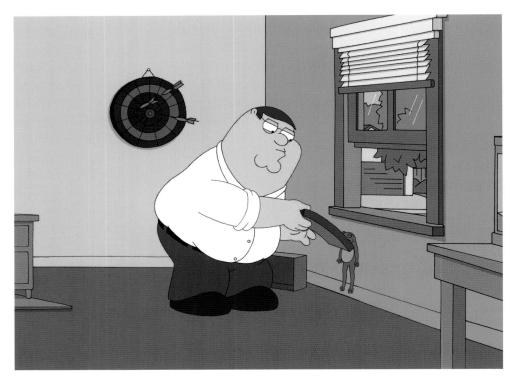

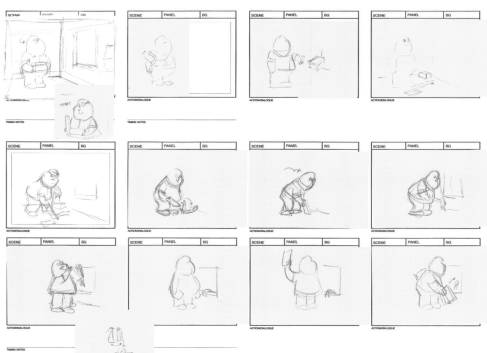

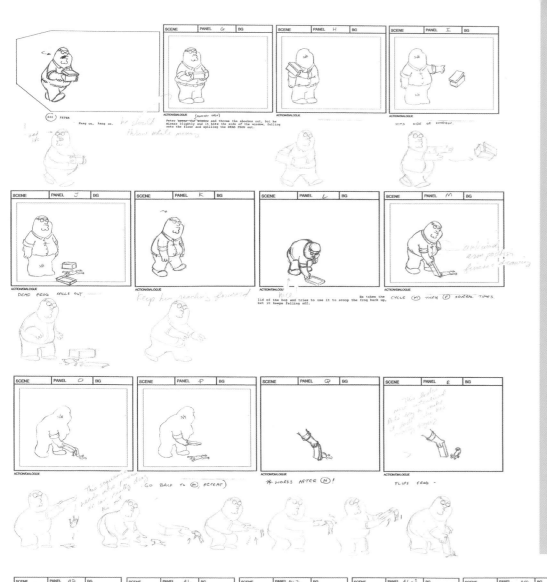

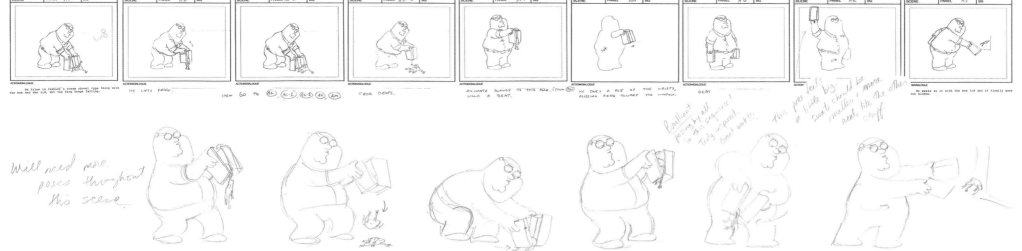

about that but I'm glad they said something because I would have gone in a different direction."

"The first week of production's very important to get that right because otherwise it could have ramifications for the rest of the show," says Robertson.

Drawing time! (Although very rough and loose drawing at first.)

"Everyone's working on thumbnails, which is really the most important step," notes Langford. "Even though it's very rough drawing, that becomes the blueprint, visually, for the whole episode. All the shots are figured out. What characters? What locations? What angles? How many shots? All that's worked out in the thumbnail phase."

"Sometimes it's nothing more than a single drawing showing where the characters are standing," says Brinson Thieme, one of *Family Guy's* storyboard artists. "While for more complicated scenes (such as fights, chases, etc.), we might break down the most basic actions so we can think about how the characters move through space and try to anticipate any problems."

"Then I'll go back and forth with the artists," continues Langford, "put on my notes and tweak and change things, try to springboard off their ideas to get it to the highest level we can take it to at that phase . . ."

Says Robertson: "The nice thing is that [an artist] will give you something and they could have a different take on what you originally thought and that's a good thing. If you hold on to things too tightly, it

"Long John Peter": Written by Wellesley Wild and directed by Dominic Polcino. Artwork by Polcino, Mark Covell and Peter Shin. Covell filmed Polcino acting this scene out—with a shoebox and a rubber lizard—to see how it would work in real life. Final board posing was later done by Julius Wu.

doesn't allow for the freedom of somebody adding something that never occurred to you that makes it better. And you've got to be careful that you don't change it just because it's not what you thought of in your head originally."

Once the show is loosely visualized, the team will pitch their efforts to one of the show's supervising directors who may offer suggestions to sharpen the episode further.

"Most of the time, they like to refine how a shot is composed," says Thieme, "but sometimes they'll also suggest a better way to set up a scene or different lines to cut on."

"That's a big milestone, getting through all the pitches, because that really becomes the skeleton of the whole episode," says Langford. From here, the crude thumbnails will be used as a basis for more detailed and refined final storyboards.

Langford continues: "At that point, we need designs figured out so that—we call it 'A-paneling' because the very first panel in the sequences is panel A, so what's the set-up for the beginning of this shot? That means the backgrounds need to look like the actual backgrounds and the characters that haven't been designed yet need to be drawn as they should be."

A-panels also "make sure everything connects in terms of continuity before we get too deep in the episode, and hopefully save us headaches in the long run," notes Thieme. And then it's on to the rough acting phase of the storyboards, when the board artists can start posing out the show's characters performing the script.

"By this point, we usually have an audio track of the voice actors performing their lines," says Thieme, "so we listen closely to it and try to imagine how the characters might act out these lines. We also have stage directions in the script to use, too—it might tell us what action the characters are performing while they speak their lines."

"That's the most subjective part of the process," says Langford, "because you can act out a line so many different ways.

Pablo Solis, Robertson's assistant director, points out *Family Guy*'s storyboard set-ups are kept simple to service the writing. "The staging is very clear. The characters are showcased more than the backgrounds or foreground elements or atmosphere. They say their lines, make sure you don't cover their faces when they're talking with hand gestures or do anything too fancy."

With an ever-present deadline, the well-worn animation industry mantra must be applied: there's no room to be precious with one's work. "Because often things do change along the way," says Langford. "There's no sense in investing super clean illustrations on something that is going to be revised."

"Everything's disposable," says Robertson. "If it's not funny, it's not funny. It doesn't matter how long it took."

"The jokes are the king on this show," Solis reminds us.

With the rough acting worked out, the completed storyboards are sent to the animatic department, where the boards are timed to previously recorded dialog and a rough cut of the episode can be assembled and shown to the crew.

"That's where the magic happens and it really begins to look like a proper cartoon," says Thieme.

"Hopefully it'll screen well, and everyone will love it," says Langford. "The things that people *don't* love get rewritten and the whole process starts again. A little mini-version of redoing the episode because all the new material needs to be re-thumbnailed, re-pitched, re-designed, etc."

Once the animatic is approved, the episode moves off in two directions: final design and timing, but for the directors and storyboard teams, the cycle simply begins anew. "Usually around that time, I'm starting my next episode," Langford says. "While timing and checking is going on, I'm doing thumbnails on the next script."

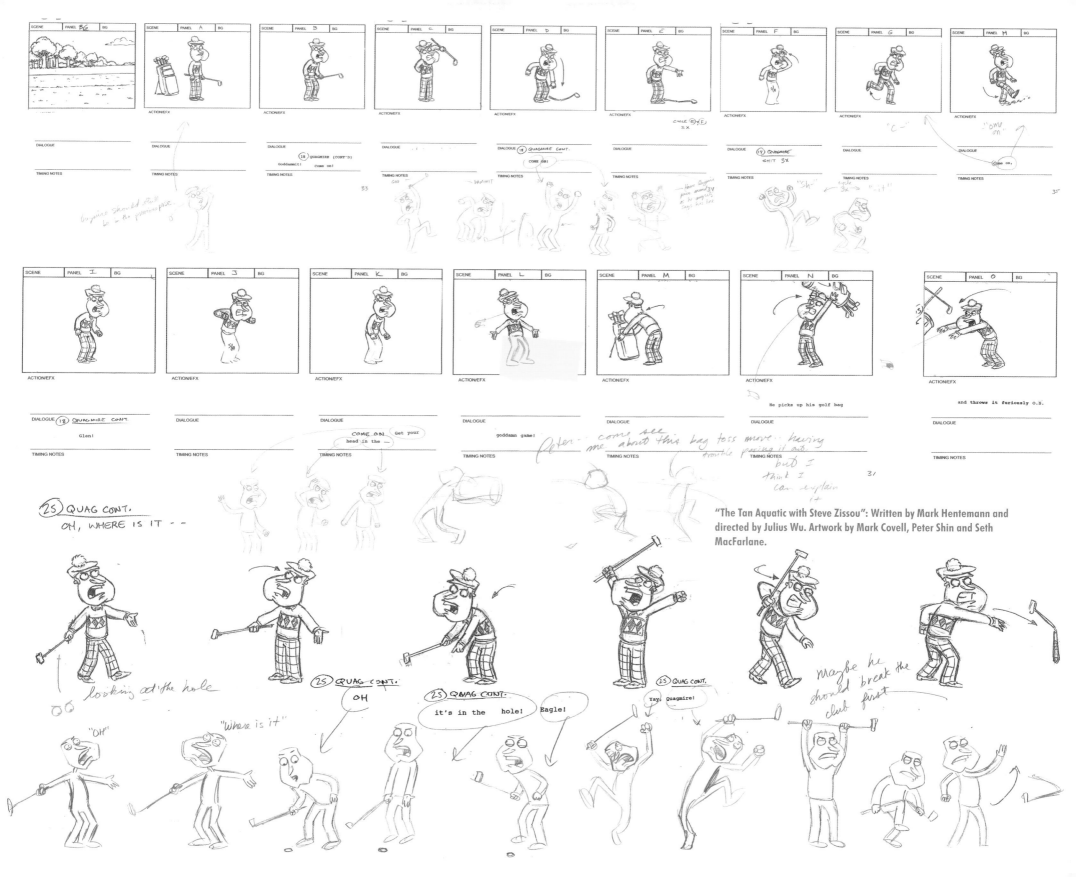

"The Tan Aquatic with Steve Zissou": Written by Mark Hentemann and directed by Julius Wu. Artwork by Mark Covell, Peter Shin and Seth MacFarlane.

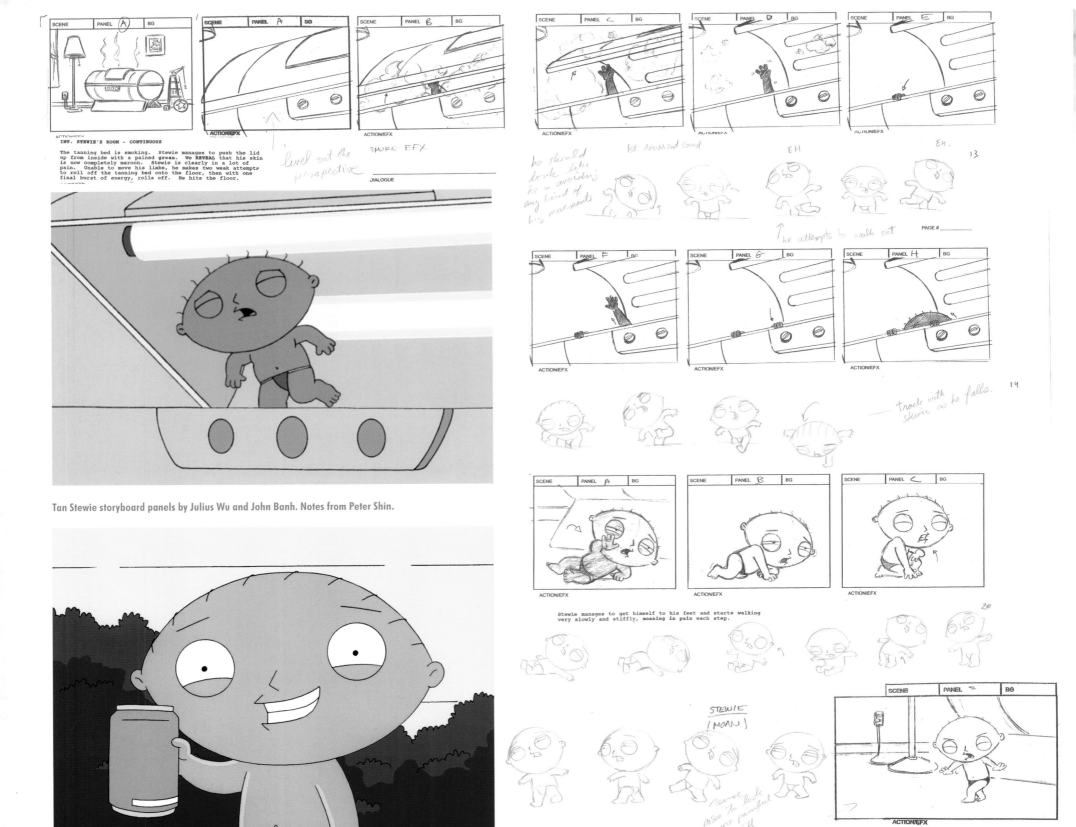

Tan Stewie storyboard panels by Julius Wu and John Banh. Notes from Peter Shin.

Keeping It Real

Even in the show's dizziest moments, the animation style of *Family Guy* sticks to a narrow path between cartoony and true-to-life. The action stays mindful of Newtonian physics and Earth's physical laws, even as liberties—*huge* liberties at times—are taken.

To accomplish this, its animation artists will sometimes do what visual artists have done forever: use real-life models for reference.

In the ninth season's "German Guy," Herbert, the elderly neighborhood pedophile, faces down an elderly Nazi in his living room for a battle to the death. The two combatants are feeble, palsied and dependent on a walker (in Herbert's case) and a cane (his Nazi nemesis) in this tortoise-paced brawl that lasts for four and a half minutes. The elaborately tentative moves of these wheezing codgers called for a pair of real-life stand-ins (directors Dominic Bianchi and Joe Vaux gamely volunteered) to tape the choreographed sequence as a reference aid.

Similarly, for a cutaway in Season 15's "How the Griffin Stole Christmas," the Little Drummer Boy begins his performance to honor the Christ child on a tiny drum strapped at his waist, then bursts into an explosive solo on a drum kit that would do Rush drummer Neil Peart proud. For this sequence, the drummer was videotaped playing the part to help animators capture the moves authentically.

Yet another classic sequence where a dose of realism reigns are the couch-moving scenes in the sixth season's *Star Wars* spoof, "Blue Harvest."

Peter (as Han Solo) is trapped with his comrades in a huge garbage crusher on the Death Star when he spies a couch buried in the rubble.

"Somebody threw out a whole couch, and it's in great shape," Peter says happily. "I know we have a dangerous job to do here, but I'm taking this couch!"

What follows is an uproarious scene lasting nearly a minute where Peter and Chris (as Luke Skywalker) wrestle with the couch to fit it through the tight cabin doorway. In a follow-up scene a few moments later, Peter and Brian (as Chewbacca) struggle to haul the couch across the Death Star flight deck and into their ship amid the stormtroopers' gunfire.

"The scenes had to be based on reality," says animation boss Peter Shin. "If we had drawn it like Looney Tunes, the couch would have been *stretchy,* and we didn't want that. And if we didn't make it look like it was heavy, the joke would fail. We had to strike a balance between super-realistic and too cartoony."

They did. But to capture this bit of reality, no real-life models were needed for reference. Everyone involved in animating *these* scenes could draw on ample muscle memory of moving heavy furniture.

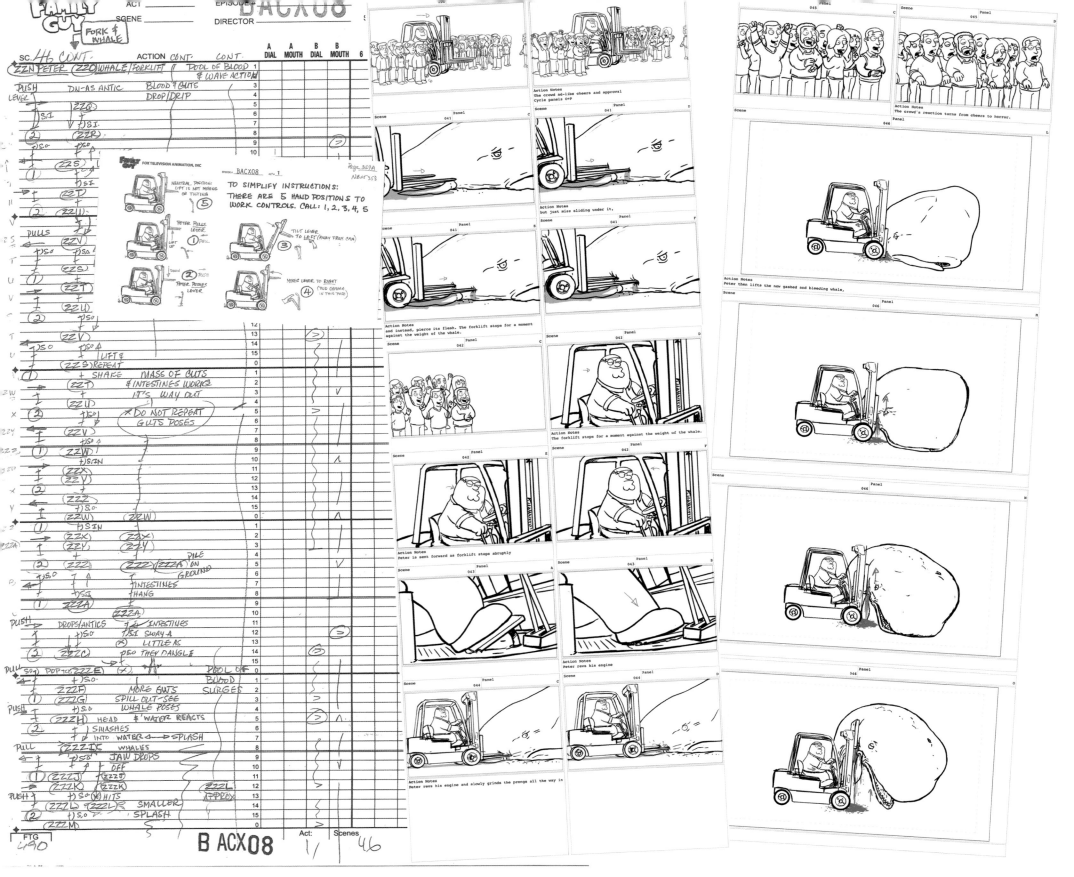

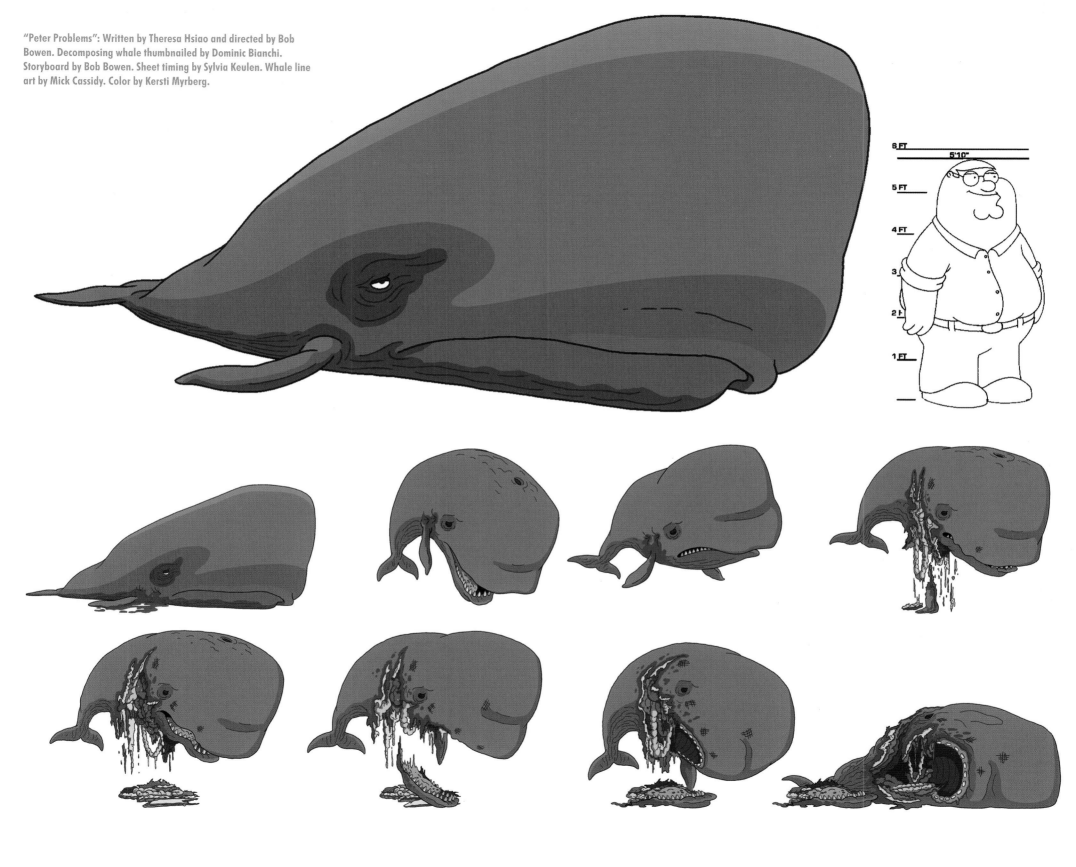

"Peter Problems": Written by Theresa Hsiao and directed by Bob Bowen. Decomposing whale thumbnailed by Dominic Bianchi. Storyboard by Bob Bowen. Sheet timing by Sylvia Keulen. Whale line art by Mick Cassidy. Color by Kersti Myrberg.

Character Design

Unlike the storyboard teams, who tend to focus on one show at a time, designers work on numerous episodes in different stages of production simultaneously.

"Part of our contribution to the process happens directly after the script is written," says Sharon Ross, a character designer for *Family Guy* since 2004. "That's when we alter the designs for the standard characters or design new incidental characters." At this early stage, there's plenty of collaboration with the directors to get the new designs just right.

"The next time we're involved is after the directors and the storyboard artists have drawn them in action," says Ross. "They might need new characters at that point—maybe even a stadium full of spectators—and usually more detailed aspects of a character such as a 'turnaround.' That's when we draw other views of a character in order to show the animators what they will look like from other angles. We also do more finished drawings of designs that are clean and hopefully easy to animate. We may need to do a mouth chart as well—drawings of the different mouth positions as characters speak.

Continues Ross: "We are also called upon to do characters in period costumes, like when Stewie and Brian play Sherlock Holmes and Watson. That can be both entertaining and educational doing the research necessary to make sure they fit into the proper time period."

When a show is lucky enough to run as long as *Family Guy,* do the designers ever run out of inspiration?

"We find ways to make even the most regular stuff interesting," says Ross, "and there's always a street-walking wolf in a miniskirt and tube top, or a silly-looking millennial, or Chris dressed as the Queen . . . or on a really good day, a member of Congress."

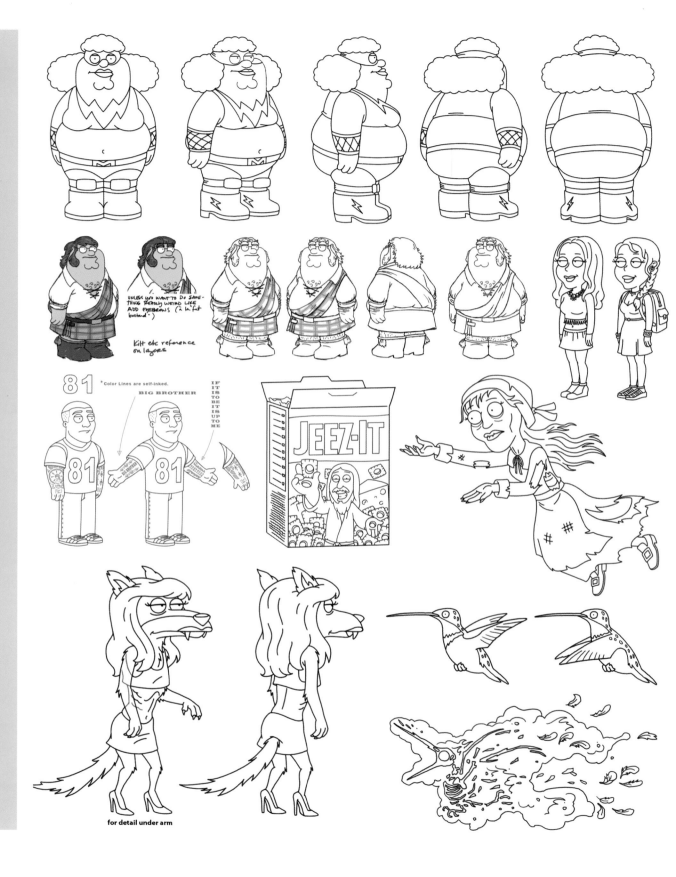

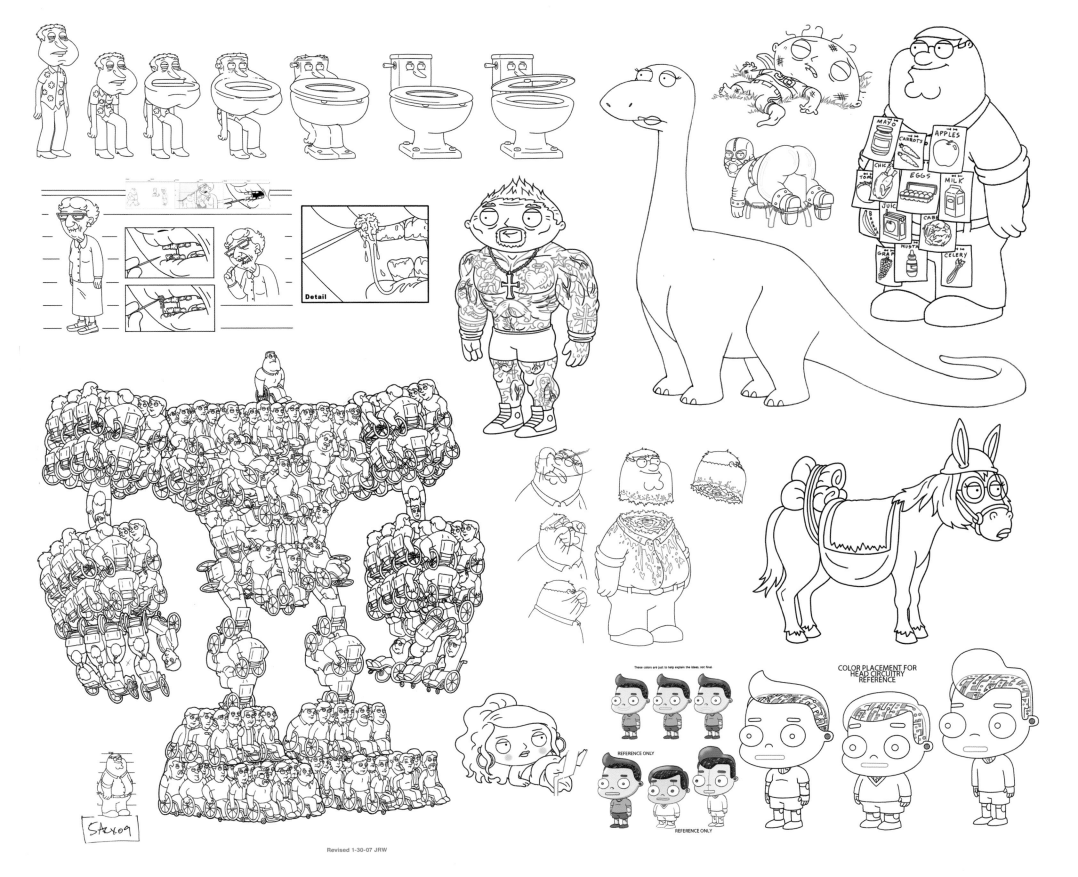

COLOR PLACEMENT FOR
HEAD CIRCUITRY
REFERENCE

These colors are just to help explain the ideas, not final.

REFERENCE ONLY

REFERENCE ONLY

SALX09

Prop Design

Elsewhere, *Family Guy*'s prop artist is busy designing every inanimate object for each new show. These designs require precise and fully functional renderings, usually from multiple angles, and sometimes for models that will be constructed in 3D.

"It can be as simple as an egg and as complex as vehicles and spaceships," explains Taesoo Kim, currently the show's single prop designer, making him nothing short of a miracle worker.

"Logo designs, incorporating text, special effects (explosions) are all part of my job. Anything that animates that our characters interact with."

For a show that regularly steps outside the box, that takes in anything from a half-eaten sandwich to Stewie's Big Wheel, all the way up to an Imperial Star Destroyer without stopping for breath.

There are some mainstays: "There's a lot of food," Kim notes.

Being a prop designer requires a very particular skill set. Says Kim: "I've done character design as well, but I do love designing cars, spaceships, gadgets. Mechanical stuff. Surprisingly, *Family Guy* is a lot more realistic than other shows I've worked on. The whole design style has changed. When I first joined the show I started off doing more simplistic designs but they asked for more detail. They love it and now I have to meet the expectations I've set. I like technical drawings so sometimes I add the extra details. Perhaps too many."

MOUTH OPEN

❶

❷ ❸

❹ ❺

56

56

Background Design

The background designers have the unenviable job of creating the environments for each new episode, which on average, calls for 76 designs per show. These drawings are used to provide detailed location reference for the overseas studio.

Of all the designers, the background artists have the most formidable amount of work. In animation vernacular, the term is *line-mileage*—the amount of linework required to complete each design. As *Family Guy*'s style has evolved over twenty years, the backgrounds have become more detailed—lavish, in some cases—and requiring a huge attention to detail. The prerequisites to perform a job of this magnitude?

"Research, hard work and teamwork," says Antonio Torres, one of the show's BG artists. "I look over the list and watch the animatic in order to familiarize myself with the overall storyline, which gives me a feel for the episode. Next, I set up a time to meet with the director to see what his vision is, and if any scenes have been changed or any cuts have taken place. Then, I figure out where the storyboard artist wants the vanishing point to be. This will set up the perspective for the scene. Some episodes require more research than others, but after all this is done, then I begin drawing."

"I believe that Background Designs are a secondary character which supports the primary characters," Torres adds. "This gives more believability, fun and excitement to the storyline. It often gives the episode its 'wow' factor. At the same time, a background design should be barely noticeable, never competing with the characters."

1418 sc-311

1606 sc-300

For Position
Only
See prop design

920 SC 15 EXT. DRUNKEN CLAM

FACX01_SC.675-A_INT. VINTAGE TOY STORE AISLE

YK

Color Design

Once designs for characters, props and backgrounds have been completed and approved, they move to the color department where a team of color artists assigns the colors and then paints every key element of each new episode.

"Based on what the writers indicate in the script and what the director indicates in the boards, we determine the color and lighting for each scene," says Kevin Hanley, one of *Family Guy*'s color artists. Capturing mood through color is also a vital part of these artists' tasks.

Hanley continues: "We digitally paint using Adobe Photoshop with a stock palate of colors we've established and real-world reference material to create both the Quahog universe and any other universe the characters travel to."

With *Family Guy*, a show more than happy to—quite literally—cross universes on a regular basis, this is no small task: "We've covered everything from films such as *The Shawshank Redemption, Star Wars* and *The Grand Budapest Hotel,* to time-travel scenarios set in period environments. The challenge is always maintaining a consistent look and feel that communicates *Family Guy* while clearly and accurately representing anything the Griffins may encounter."

While the storyboard artists are translating words into visuals, the script is scoured by a team of designers to create the cast, the props, and the settings for each new episode, all under the watchful eye of that episode's director.

Need to see Peter naked? Quagmire as a pizza? What about a giant maniacal robot constructed out of 200 people in wheelchairs? Ask the character designers, who have a hand in visualizing every animated cast member.

They must also adapt familiar faces from the real world to the *Family Guy* universe. Faces like those of Tom Cruise, Julia Roberts or Ryan Reynolds. "Celebrities are tough," says Mick Cassidy, a *Family Guy* character designer since 2004. "There's not a lot of line work with these characters and it's more than just making everyone three heads tall with ping-pong-ball eyes. The attention to detail is immense. One line out of place and it's all wrong."

The fourth season's ambitious "Patriot Games" episode featured football legend Tom Brady, along with a rousing "*Shipoopi*" musical number led by Peter as a New England Patriot teammate, in a sequence that also required the design of two squads of football players, cheerleaders and a stadium of cheering spectators.

Then in "Peter Problems" (Season 12), Cassidy faced a whale of a design problem. A comic interlude found Peter attempting—and failing—to save a beached whale with his forklift truck.

"It's a long sequence where he essentially disembowels and shreds the whale he's trying to help," notes Cassidy. "We had to draw a plethora of key poses in excruciating, realistic detail. We had to look up whale anatomy: What organs would fall out of the whale first? That sequence took up six weeks of my life."

Separately, prop designers create every inanimate object (that moves) in an episode, from a half-eaten sandwich to Stewie's Big Wheel trike to an Imperial star-destroyer.

And the background designers have the far-ranging task of conceiving the locations for every new episode. Whether it's Spooner Street, Paris, Los Angeles or the moon, a background designer is tasked with creating that environment.

To these drawings the color department, a team of artists working in Adobe Photoshop, assign the colors that will ultimately be applied to every person, piece of clothing, chest of drawers, tree or dinner plate—every design that has been drawn is now painted in color. There are no "natural" or default colors in animation; each one must be deliberately chosen, then specified in numerical terms. Consistency matters. You wouldn't want Lois' orange hair or Peter's signature green pants to vary from scene to scene or even episode to episode. (For the record, the unvarying red-green-blue formula that renders Peter's pants is: R-36, G-99, B-10.) Much care is taken to color style every element so that it works together and is visually appealing but not distracting.

Weeks 16–19:
The Animatic

Think of an animatic as a PowerPoint presentation if the presentation's images were a succession of black-pencil sketches. A team of animatic editors sync the thousands of storyboard panels with the audio radio play.

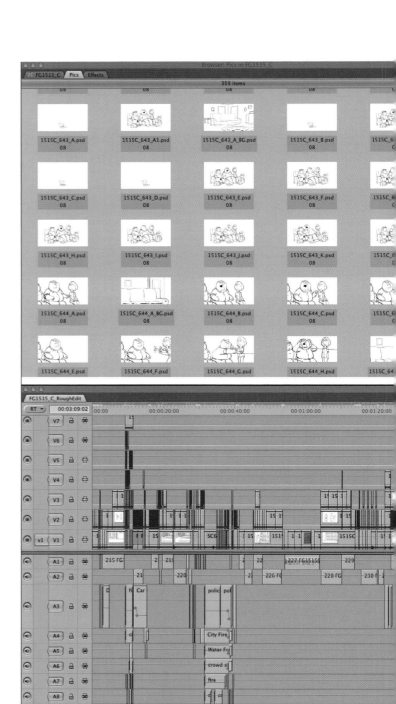

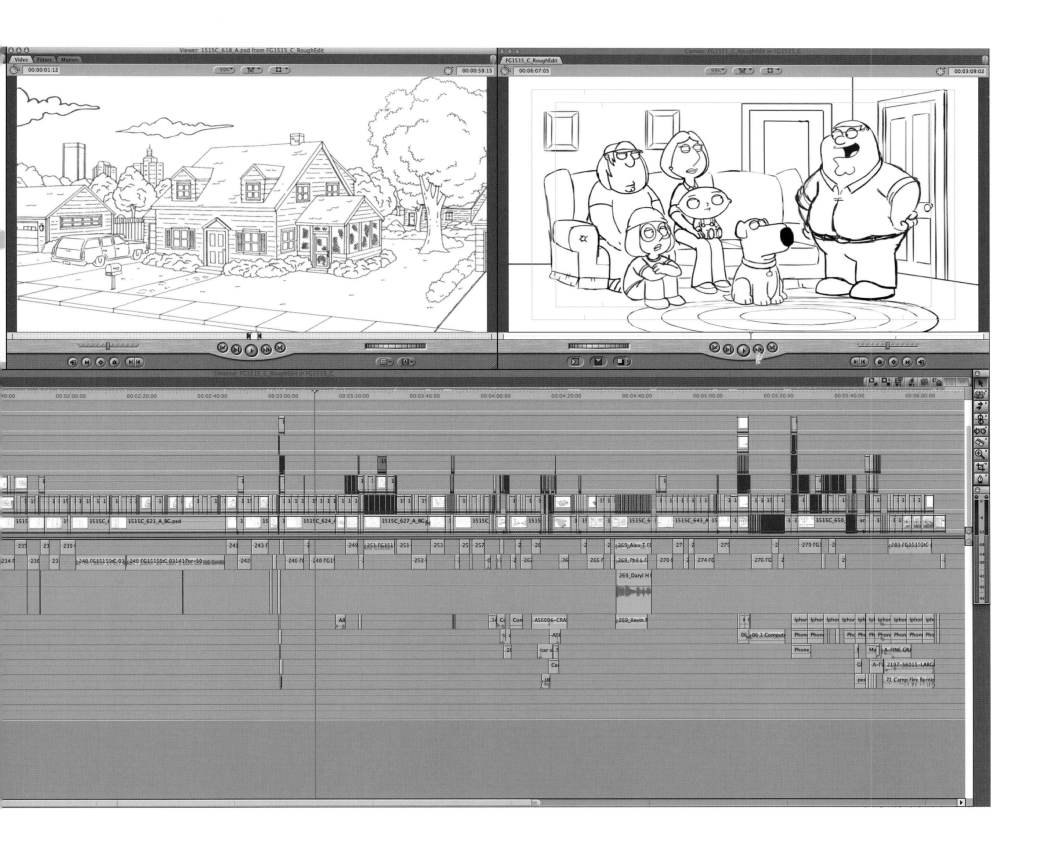

"It's like a dress rehearsal for the episode," says editor Sean Isroelit. "It's the first time the audio and pictures are together." The editors and director fine tune the timing of the jokes and add temporary music and sound effects to help the story and jokes play.

This words-and-pictures prototype is screened at the *Family Guy* offices for the whole gathered crew. Editor Monica Lee admits, "It's very satisfying to hear everyone laugh and get excited over a sequence that we've put a lot of effort into. Especially fights and musical numbers—they require a lot of extra attention in editing, but it's all worth it if it plays well."

Depending on how the episode is received in this preliminary form, the writers will do another set of rewrites on the script, while visual elements of the characters or staging may be sharpened or revamped by storyboard artists.

Weeks 20–24:
Timing

Then the meticulous process known as "timing" gets under way.

A stack of 11-by-17-inch exposure sheets will be prepared that, row by row, break the episode into its thousands of video frames. A filigree of notes, circles, arrows and thumbnail sketches ensure every detail

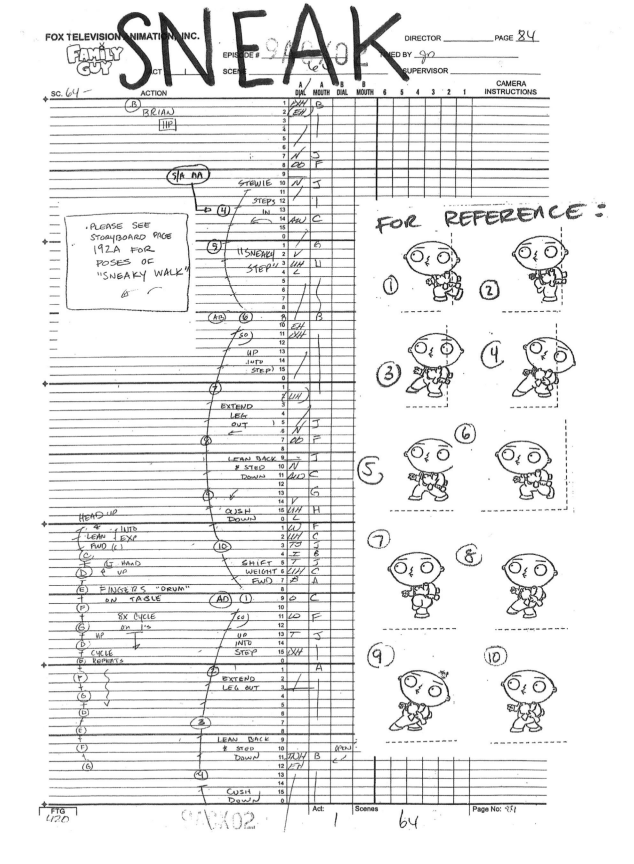

TIMING NOTES for FAMILY GUY

① CHOOSING RIGHT AMOUNT OF INBETWEENS.

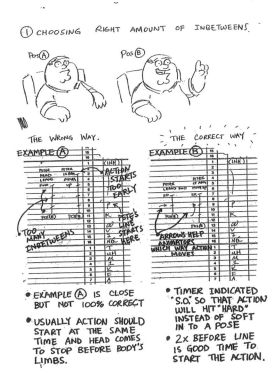

POS Ⓐ POS Ⓑ

NO

THE WRONG WAY.
EXAMPLE Ⓐ

THE CORRECT WAY
EXAMPLE Ⓑ

- EXAMPLE Ⓐ IS CLOSE BUT NOT 100% CORRECT

- USUALLY ACTION SHOULD START AT THE SAME TIME AND HEAD COMES TO STOP BEFORE BODY'S LIMBS.

- TIMER INDICATED "S.O." SO THAT ACTION WILL HIT "HARD" INSTEAD OF SOFT IN TO A POSE

- 2X BEFORE LINE IS GOOD TIME TO START THE ACTION.

a certain action should span five frames. Or maybe a ceiling fan on a storyboard panel would be keyed on the exposure sheet as "ceiling fan spins" with the number of frames for a full rotation specified.

Two of the columns on the exposure sheets reflect the work of two particularly arcane but vital specialists: the track reader and the lip assigner.

The track reader listens to the recorded dialogue, then transcribes it phonetically onto the exposure sheets. The sounds she labels, frame by frame, down a column designated "Dial" (as in sounds like EE, Y, OU, M, J, S), will guide the animators in understanding each sound a character is meant to make while speaking each syllable of dialogue.

of motion or appearance is nailed down by a team of animation timers. "Timing provides the blueprint for how things will move," explains timing supervisor Andi Klein. "A timer's job is to properly choreograph movement in order to sell the mood, tempo and sensibility of a scene. Timing is also crucial when it comes to the telling of a joke—especially on our show where comedic timing is everything."

Since the show's actual animation is done in South Korea, the exposure sheets are frame-by-frame instructions to the animators. At the proper moment a circled letter will indicate a corresponding storyboard panel whose illustrated actions will be quantified on the sheet by a certain number of hash marks—say, five, which would mean the duration of

Lip assigning builds on that phonetic labeling to interpret how that character is expected to *look*—that is, the character's distinctive mouth shapes—when uttering each particular sound (with the lip assigner's corresponding set of codes entered down the column designated "Mouth").

Week 25:
Checking

The past 24 weeks have led to this moment. All of the dialogue, designs, storyboards, exposure sheets and other notes and

Peter's Smile Expression Mouth Chart

A Use for B, M, P

B Use for sounds that are smaller A, E, H, I and sometimes UH sound

C Use for sounds that are middle range A, E, H, I and sometimes UH

D Use for sounds that are in the normal range A, E, H, I and sometimes UH

E Use for sounds Y, U, UH, OO, ER or R

F Use for sounds O, U, W, Y and OO

G Use for sound F and V

H Use for EL or L sound

J Use for sounds C, CH, D, G, J, K, N, Q, S, T, TH, X and Z

D+ Use for sounds in the high range A, E, H, I

D++ Use for extreme sounds (yelling etc) A, E, H, I

J+ Special mouth rarely used except for vocal efx or sounds deemed appropriate

Revised 11-16 JRW

directions have been compiled to enable the overseas animators to transform this data pool into a cartoon. This cache of information better be complete and clear. To make sure it is, one or more specialists spend a week checking over everything. Such a person, aptly enough, is called a "checker." "Checkers make sure that all the components are understandable for the studio to animate. We're like the conscience for the artists that keeps them from getting out of control," says checker Glenn Higa.

"The objective: When this all gets to Korea, they can just take it and go," says Shannon Smith.

Week 26:
Off It Goes

A team of production staff overseen by Brent Crowe, *Family Guy*'s animation producer, includes production managers, supervisors, coordinators and assistants who have been supporting and organizing the artists since the table read. This dedicated team carefully packages up the materials that have been prepared over the past five months, and FTP them to the show's animation house, Digital eMation in Seoul, South Korea. A backup set of materials is shipped "old-school," in a box. "It's exciting sending the show off," says story production manager Anne Michaud. "Everyone's worked really hard to get the show to this point. Now we pass the baton to our partners on the other side of the globe."

Weeks 27–40:
Animation

First step: Translators at the studio must translate all the materials into Korean.

Then the episode is broken into individual scenes and, with two overseas supervisors from the show working alongside a Korean team of artists numbering up to 230, the animation process begins.

These artists work at animation desks on sheets of paper. There's a strict division of labor and a regimented pecking order. Layout artist prepare layouts for every shot, translating the storyboard and designs into actual animation scene set-ups with a background and searate layers for the characters and props. An animator will draw the key poses of big actions. Then the scene goes to an "in-betweener," an assistant who draws the less consequential poses, filling in the action between the key poses. For instance, if Peter brings his arm from an extended reach over his head down to his side, one animator will handle the drawings of Peter's arm in the air, halfway through the arc, and down by his side. The in-betweener draws everything else.

Backgrounds, characters, even a particular character's mouth will each be drawn on a separate overlaying sheet.

Then all the drawings go to the scanning department. An average of 25,000 drawings for the episode will be scanned. Then a compositor puts all these elements together, shot frame by frame, all according to the dictates of the exposure sheets.

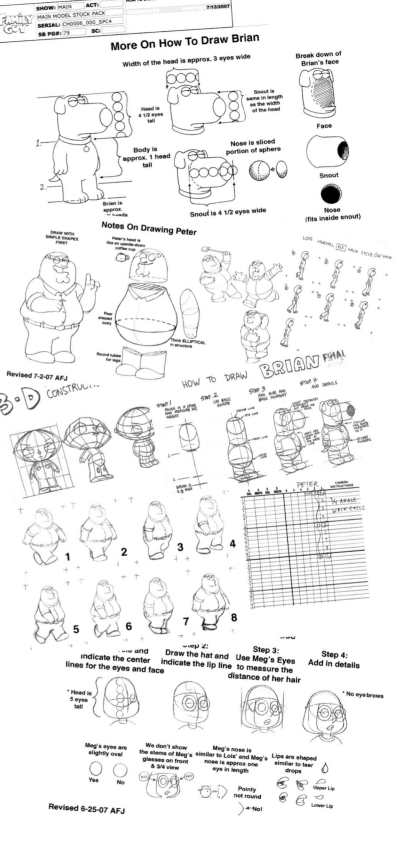

The Devil (and Peter) Are in the Details

If you're part of the huge animation team that brings *Family Guy* to life, here is one of many friendly reminders you might get from the *Family Guy* producers: a note on how to draw Peter Griffin's mouth closed.

Important: Even when conveying a neutral expression, Peter's closed mouth should *never* be drawn as a straight line. It should have a very slight, *very* subtle curve, according to Seth MacFarlane and *Family Guy* co-executive producer Peter Shin.

"Seth and Peter don't like it when it's a super-straight line," reports Shannon Smith, a producer on the show. "It's one of those things that, if it were drawn that way, someone sitting at home wouldn't think, 'That mouth looks too straight.' But it does make a difference."

It's just another expression of the show's attention to detail.

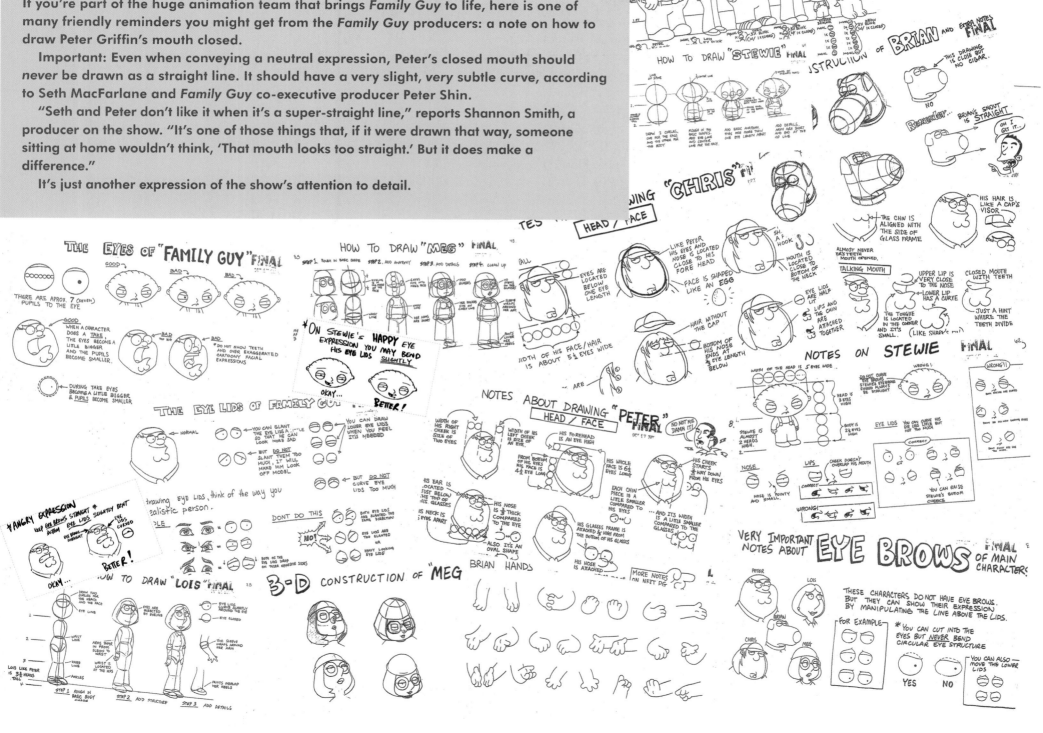

Also following those specifications, the Ink and Paint Department adds the color to each frame digitally.

Weeks 41–50:
Rewrites and Retakes

The completed first take of 32,000 individual frames is transmitted from the animation studio in Korea to the show's post facility in Burbank. There it is turned into clips, then digitized and sent on a drive back to the *Family Guy* offices. The clips are assembled and synched up with the audio track by one of our editors to create a rough cut. After a pre-timing and audio pass by supervising directors and producers, another screening—the so-called color screening—is held for the crew and assembled guests, similar to the animatic screening.

That's followed by one final rewrite by the show's writing staff, which then calls for a scaled-down version of the production process for any new or tweaked scenes, with retake directors working with revisionists to do the new boards. The retake department continues working on each episode through the entire 20-week post process, including after the lock and online—in one instance, up to two days before air.

"We do a lot of revising to the script and storyboards," says Shannon Smith. "As a group we watch screenings to see what's working and what isn't. We'll rewrite stuff at every phase of the process. Twenty to thirty percent of the show gets changed after an animatic screening, and five to ten percent after the color screening."

"Basically, the retake directors are doing the same thing [as directing]," says director Jerry Langford, a former *Family Guy* retakes director. "It's just more involved because the

episode is so much further along. It's more than new boards—it's new boards *and* having to re-submit to the overseas studio for a quick turnaround on the animation."

With 20 episodes per season, a team of four retakes directors can end up working on five episodes each. By mid-season, they juggle three episodes at a time: one in its infancy, one full bore and one close to air. A small team of dedicated production staff supports the directors prepping materials and communicating with overseas to ensure a quick turnaround.

"We're up against the clock at this point," adds Sarah Frost, one of the show's retakes directors. "The episode already has a fast-approaching airdate and we need to deliver. The average turn around for a scene could be as fast as a week versus maybe 20 weeks for the standard schedule."

And sometimes it takes a while to get things just right. "On a rare occasion there's a tricky

scene that requires a Take 8 (a scene that has been sent back and forth from the studio eight times)," says Frost, "and hats off to our overseas studio. Quite frequently they'll take the initiative to solve problems before we call them. I can't stress enough how animation is really a team effort. We strive to make everything look its best."

"It can be really satisfying because you can work on something one day, submit it and while you're sleeping, it's over in Korea getting worked on," says Langford. "It seems the show is being worked on 24 hours a day."

"It's enjoyable because we never encounter the same problem twice," adds Frost. "It can be an exciting beast to wrangle. We're a jack of all trades."

Even at this advanced stage, comedic inspiration may strike. Appel mentions a scene in an episode from Season 16, "The Unkindest Cut."

"Peter has a speedboat hitched to his station wagon and he's trying to back it down into the lake. It keeps swerving left, then right. It's so impossible for him to get it straight."

A close-to-final version of the scene made him laugh.

"But then supervising director Dominic Bianchi and director Jerry Langford said, 'Let us have another pass at this.' They added lots more poses and stop-starts and back-and-forths that made it so much funnier. It's 60 seconds of Peter failing and flailing at getting that stupid boat in the water."

Maybe it will take its place as a scene that's watched and rewatched as a comedy gem. There are many such classics in *Family Guy,* and few are more celebrated than a

Character design based on editor Mike Elias was used in the episode "And I'm Joyce Kinney."

prolonged piece of zaniness from "Long John Peter."

In that episode, Peter realizes he has unwittingly smothered a bullfrog he had kept in a shoebox as a pet. His frustrated attempts to dispose of the dead frog by tossing it out the window consume some 40 seconds of prolonged, hilarious, exasperating visual inventiveness.

"Seth, the editors, all the artists—we all reviewed it so many times before we finalized it," says Shin. "I'm sure *I've* seen it more than 100 times. Every frame was accounted for: Is it one frame too long, one frame too short? You're thinking in terms of 1/24th of a second. I don't think viewers realize how much of a review process goes into one of these sequences."

Weeks 51–56:
Lock and Spot

The final timing and pacing of the episode is overseen by the show's picture editor, Mike Elias. He works closely with the retake team and Peter Shin to make sure everything comes together for the final cut of the episode.

"Faster is funnier. Except when it's not," says Elias. And just because the picture is locked, it doesn't mean changes can't be made, even after episodes have been delivered to the network. Viral audio and videos have found their way into versions of *Family Guy* episodes that were only aired once. Whether it's an on-set rant by Christian Bale or a future president bragging about sexual conquests on an *Access Hollywood* bus, even an animation

program that takes over a year to produce can occasionally be timely. "Seth sometimes wants the fans to have more content for a one-time-air episode," says post producer Kim Fertman. "'And Then There Were Fewer,' 'Brian and Stewie,' and 'Send in Stewie, Please' all had extended versions. After the first airing, we cut them down for re-runs."

After the lock, a spotting session takes place where the composer, Walter Murphy, sound supervisor, Bob Newlan, and music editor, Stan Jones, make music cue and sound effect notations with the episode's showrunner

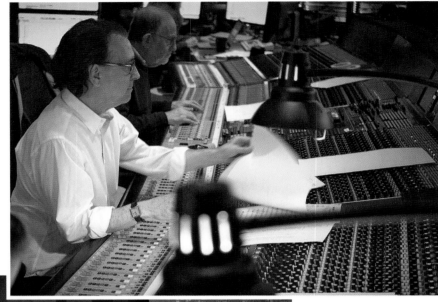

Composer Walter Murphy and engineer Armin Steiner in a scoring session on the Newman Scoring Stage on the Fox lot. A full orchestra is used to score each episode.

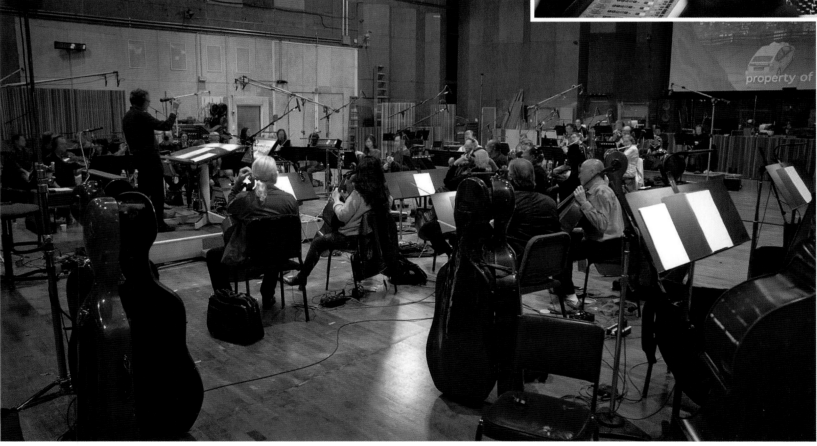

(Rich Appel or Alec Sulkin) and the editor, Mike Elias. During the next five weeks, new sound effects are added, plus any needed background dialogue, which is called "walla." Any murmuring, chattering, laughing or cheering is performed by a team of four or five walla actors, who serve the scene as the aural equivalent of extras.

Walter Murphy's contribution—the music—may already have been in the works for weeks if special material is called for in a scene.

"I get a script early on and look for the songs or musical jokes that will need to be animated," he says. "I need to do that and have singers demo the song, or have the voice actors sing it, so the animators can start to work."

But for routine scoring, he screens the nearly finished episode while consulting with the producers about where accompanying music should be placed during the spotting session.

"We spot the show by running it scene by scene. In one scene we might decide, 'OK, the music starts when they go in the house and ends when the door closes.'"

After writing the music, Murphy does a synth sampler. The producers listen and suggest final changes. Then the music—between 20 and 35 separate cues, some no more than a couple of seconds in length—is performed by a full orchestra on a scoring stage at the Twentieth Century Fox studio lot, where "I have these wonderful musicians playing my stuff. It's really cool."

Weeks 57–62: Online and Mix

After the locked picture has its new scenes fully animated and retakes completed, each episode is onlined at the post facility in Burbank. There the editorial timeline of lower resolution clips is replaced with the full resolution versions stored on high definition tapes. Titles and credits are added and any final retakes are called.

A copy of the onlined episode is sent to the show's audio facility in Hollywood where the music, dialogue and sound effects are mixed to the final picture. "Once or twice a season comes an episode that's a real challenge," says re-recording mixer Jim Fitzpatrick. "Previous episodes in that category were 'Road to the North Pole' (which won an Emmy in 2011 for Sound Mixing), the three Star Wars parodies, and any episode with a Chicken Fight. In this past season, the 'Three Directors' episode stood out above all others." In that episode the music, sound effects, and mixing matched the styles of Quentin Tarantino, Wes Anderson and Michael Bay. The latter section was even initially rejected by the network for being "too loud."

The showrunners watch through the episode a final time and make any mix notes they may have on sound levels, sound effect choice or even adjust or switch out a music cue.

After every aspect of the show is revised and approved, it is delivered to the network. A few days later it will be telecast.

This concludes a year-long-and-then-some process "of refining, of clarifying, of making a decision and moving on," says Appel. "You're only as good as the team that does most of the work and keys up each step for you. And there's a really fantastic team here, which is fortunate: The planes line up on the runway relentlessly, and they have to take off."

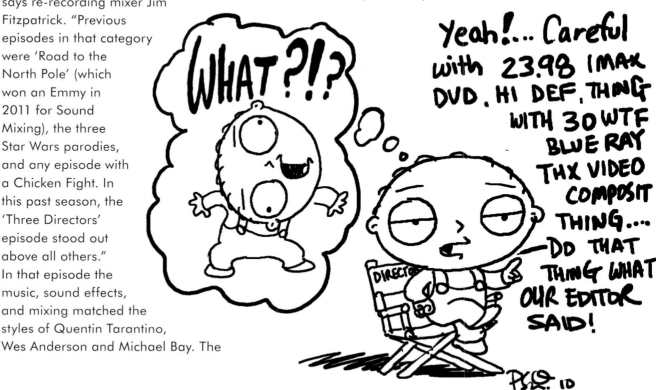

WACKY WAVING CUTAWAYS, GAGS AND MUSICAL NUMBERS

Here's Lois entering the house with a shopping bag.

"I just bought us some new sheets at Bed, Bath & Beyond," she tells Peter, who is planted on the living room couch.

"Ohhhh, boy," he says, looking concerned. "I hope you stayed away from that Beyond section."

And we *CUT TO* Peter as he pushes his shopping cart through swinging doors below a sign that says BEYOND. He trips, yowling, into an eerie netherworld. Weightlessly, he floats past one of those giant stone heads from Easter Island, a Rubik's Cube, a strand of 0's and 1's and a human fetus in the womb.

Then he spies a table display hovering nearby. He regains his composure.

"Ahhh, *here* are the coffee mugs," he says happily.

That, the Beyond-state of the show's many cutaways, is where *Family Guy* lives most farcically and with utmost abandon. Each cutaway brings the narrative to a screeching halt long enough for a piercing comment

on human vanities, social mores or pop culture (or sometimes for a gratuitous cheap shot). Peppered through each episode's tight 21-minute story line, these cutaways give *Family Guy* its distinct staccato rhythm.

Cutaways provide useful reality checks, as when Stewie calls out Batman on the folly of his thinking he can keep the existence of his Bat Cave hush-hush: "You can't expect to hire 60 workers to dig a cave under your house and then keep it a secret," Stewie scoffs. "I mean, those men *live* in this town."

No arguing with that.

And then there's Peter placing his refreshments order at the ballpark: "I'll take one terrible beer filled up way too high so I spill most of it, and a too-long hot dog in a too-short bun. Do you have mustard and relish?"

Snack-bar Attendant: "Yeah, it's right *there*, between the entrance and the exit to the bathroom."

With each cutaway, *Family Guy* takes refuge from reflexive correctness and the impulse to wilt at every trigger word. It claims a bizarro

safe space for itself where even a low blow is forgiven. Terminal cancer, Helen Keller's blindness, Richard Gere and his mythical gerbils—they are all fair game.

In the great Beyond of its cutaways, the show breaks free of any lingering constraints on its madcap narratives. A line of dialogue like "This is worse than the time . . ." or "I haven't felt so nervous since . . ." or "That reminds me of when . . ." cues a flashback or a comparative example or an imagined parallel event.

The cutaways generally fall into two categories.

The first category involves Peter and others from the world of Quahog:

CUT TO *Peter singing the lead in a Broadway musical version of the war film* Red Dawn.

CUT TO *Peter guest-hosting* Inside the Actors Studio *and hectoring his guest, Jeff Daniels, with stupid questions like: "Which is your favorite Care Bear?"*

CUT TO *Peter hanging out with the Charles Manson family and announcing he's invited to a party at actress Sharon Tate's house: "Now, you guys can come, but you gotta promise not to embarrass me."*

In the episode "Peter's Got Woods," Peter's feelings get hurt when Brian is consumed with a new girlfriend: "If that girl's more important to you than *me*," he sulks to Brian, "I guess I'll have to find a new best pal."

The next moment we find Peter at the slate-and-boulder home of Barney Rubble of *The Flintstones.*

"Boy, Barney, it's sure been great hanging out with you," Peter calls to him through the bathroom door. "You almost done in the john? 'Cause we're late for darts."

"All done, Peter," says Barney, seen seated in the gaping beak of a Stone Age pelican, which, in keeping with *The Flintstones'* practice of appropriating animals as household appliances, serves as the Rubbles' commode.

"You think *you've* got a crap job!" moans the pelican once Barney has removed himself, addressing us viewers with the scene's punchline.

Perhaps no cutaway ever made a more obscure pop-culture reference than when, in the Season 16 episode "Petey IV," Peter complains about family plans to visit Lois' hoity-toity parents—"I'm not allowed to touch anything in their house."

"Fine," says Lois, curtly telling him it's better if he stays home. "You always find a way to embarrass us at my parents'."

CUT TO a shot-for-shot re-creation of the circa-1980s commercial for a certain processed fruit-spread product. In this reimagining, it's *Family Guy* characters having brunch at a sophisticated restaurant. Unlike his fellow diners at the fancy table, who properly ask for "the Polaner All Fruit" or, more familiarly, "the All Fruit," Peter commits a shocking breach of protocol by blurting out a crude request for someone to pass him "the jelly."

From that scene we CUT TO Peter, standing in what seems to be a video-editing room, as he addresses the audience for this meta-moment:

"We're concerned that many of you *Family Guy* fans under 40 didn't get that reference," says Peter, and he's right: How many *Family Guy* viewers were even born when that commercial for Polaner All Fruit was airing

or, if they were, remember having seen it? To clear things up, Peter says, "I'm gonna take you through the actual commercial."

This he does, replaying and deconstructing that original, live-action 30-second spot.

"OK," Peter says when it's finished, "now you have the information that would have made that [cutaway] funny" had the viewer been familiar with the original commercial before seeing the spoof.

And with that, it's on with the episode.

The other common category of cutaways taps into an even *more* Beyond state: a world and characters removed from Quahog, historical or otherwise.

We find ourselves in a hospital room where the Pink Panther, that lovable cartoon character and longtime home-insulation pitchman, is gravely ill.

"What's *wrong* with him, doctor?" his distressed pink-panther wife asks.

"Well," replies the doctor, "it seems his lungs are completely filled with Owens Corning fiberglass insulation."

The next moment, the Pink Panther flatlines.

"Well, that's it," the doctor tells his widow, but adds consolingly, "Don't worry. He won't burn in hell, thanks to all that Owens Corning fiberglass insulation."

In the Emerald City farewell from *The Wizard of Oz*, Dorothy irks the Tin Man and the Cowardly Lion when she singles out the Scarecrow, telling him, "I think I'll miss *you* most of all."

"Sort of a weird comment," mutters the Lion indignantly, "right in front of *all* of us."

Setting up a cutaway in another episode, Peter and Lois are engaged in spontaneous canoodling in broad daylight in their front yard when they're interrupted by Chris and Meg.

"Kids, can we have some privacy, please?" Lois snaps.

"Yeah," Peter upbraids

them, "you're more annoying than that announcer on those TV commercials."

And we *CUT TO* a commercial delivered with the bluster and tommy-gun speed of a carnival barker: "Hi, I'm Al Harrington, president and CEO of Al Harrington's Wacky Waving Inflatable Arm-Flailing Tube Man Emporium and Warehouse! Thanks to a shipping error I am now currently overstocked on wacky waving inflatable arm-flailing tube men, and I am passing the savings on to *youuuuuu!*"

The repeated intrusion of cutaways into the main storyline had always begged a question no viewer had likely ever thought to ask until a certain episode in the 10th season: What are the characters in any given episode's main narrative doing, out of sight and "off-camera," while the action cuts away?

In the episode "Back to the Pilot," Stewie and Brian take Stewie's time machine back to the series' pilot episode, where, back on Spooner Street on January 31, 1999, they observe that episode's story as it repeats itself. Peeking in through the Griffin kitchen window, Stewie and Brian watch the interplay among the family members, including their past selves, as it unfolded back then:

Lois (to Peter): "Remember when you got drunk off Communion wine at church?"

Then, suddenly, all the characters freeze for 11 seconds.

Lois pipes up again: "And then there was that time at the ice-cream store."

Then all the characters fall silent again, biding their time for 13 seconds before they resume.

Current-day Brian and Stewie are mystified by this strange red-light, green-light behavior.

"You think they're alright?" Brian asks Stewie. "Should we call an ambulance?"

Suddenly, Stewie realizes what's going on: They're setting up, then pausing for, each cutaway.

"Is *that* what we did back then?" Brian asks him.

Then, as if from a more recent episode, the Griffins are seen the way they kill time while

"off-camera" for a cutaway these days: Lois freshens her makeup; Meg, Chris and Stewie pull out their cell phones; Brian takes a swig from his flask; Peter fires up a cigarette.

"You sure you've got time to smoke?" Lois asks him.

"Ah, yeah," replies Peter. "It's an Al Harrington. It goes on for a while."

With the absurd side trips the cutaways

BABY PETERDACTYL — W/ MOUTH OPEN

embark on, *Family Guy* catalogs the detritus of modern life. It targets how things actually might be if the world were only slightly more askew. It identifies aberrations we may never have acknowledged, much less thought we shared with anybody else. (C'mon, doesn't the Cowardly Lion speak for *all* of us who, when we're watching *The Wizard of Oz*, have always noticed, even without noticing, how carelessly Dorothy dismisses the Lion and Tin Man?)

The cutaways are so endemic to *Family Guy* that it falls to Cleveland to lodge a feeble protest against such a device as he and his chums share a few beers at the Drunken Clam. Referring to the 2001–2008 live-action NBC comedy *Scrubs*, whose tradition of cutaways may well have been inspired by *Family Guy*, Cleveland says, "I hate shows that cut away from the story for some bull crap."

Whereupon we *CUT TO* a scene where Adolf Hitler . . . is on a unicycle . . . juggling fish.

"It was a device *The Simpsons* had used here and there to great effect," says Seth MacFarlane. "But I hadn't seen a show take it and run with it, and make it a stylistic element from the ground up."

MacFarlane began *Family Guy* as a fan of the wacky single-panel comic *The Far Side*, and he loved the cartoons that sparked the pages of *The New Yorker*.

"These great one-frame little tableaux are so memorable," he says. "The cutaways on *Family Guy* are intended to be animated versions of one-frame cartoons in that style. It seemed like a great way to write for the TV medium."

And it serves the show's (very human) writers very well as a clearinghouse for miscellaneous gags.

"Writing traditional sitcoms, you're always thinking of jokes you wished you could somehow bend into that format, but they don't fit," says writer Danny Smith, whose sitcom credits include *3rd Rock from the Sun* and *Yes, Dear*.

But as he found to his delight when he began at *Family Guy*, its cutaways were a default mechanism where, above and beyond the rest of the show, *anything* goes.

Where the cutaways lay the groundwork for the silly and often absurd detours in this animated world, *Family Guy* has expanded enormously upon that foundation over its long lifetime. Like no show has ever done before, the series weaves a pastiche of both visual and comedic styles yet blends them into a format that still feels whole and complete. Through its use—not only of cutaways—but also of TV gags, musical numbers, parody episodes, "Road to . . ." episodes, or even non-traditional media styles (like stop-motion, live-action, 3D, or puppetry), *Family Guy* continues to delight and surprise us 20 years into its run. We can only imagine what exciting and hilarious gags (of all types) lay ahead.

Cutaways

It's difficult to imagine an episode of *Family Guy* without thinking of cutaways. Sometimes they show us a moment in Peter's past (for example, the time he invented the Yanket, a garment designed to allow for discreet self-pleasure). Other times, they might show us a previously unexplored version of historical events (like Thomas Edison brazenly taking credit for other people's work). Whatever any single cutaway depicts, it's always a welcome accentuation to—or unexpected departure from—the main storyline, and something that is an undeniable hallmark of the series.

WILL DO MOOSE STUFF FOR MONEY

OFFICE OF THE MAYOR

COMEDY BALL

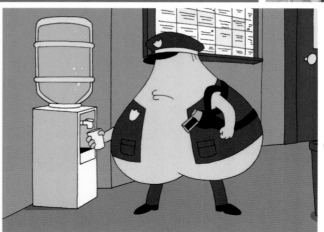

see prop for motorcycle color

BUILT-IN DECOY ARMS *Yanket*

TV Gags

Perhaps no TV family watches more TV themselves than the Griffins. In fact, the very first moments of the very first episode of *Family Guy* ushered in what would become a staple of the series: the TV gag. Rarely affecting the episode's plot, these stand-alone tidbits of pop culture parody or high-concept silliness both give us a glimpse into the Griffins' media diet as well as help to start a scene (or an episode) off on the right comedic footing. Loyal *Family Guy* viewers know that if we see one or more of the Griffins sitting on their lavender couch, there's a very good chance we are about to be treated to a quick view of what show, movie or commercial they are watching.

FINGERNAILS
4CASH.com
You get the cash,
we get to build a fort with
your fingernails!

Musical Numbers

The long *Family Guy* tradition of incorporating extended musical numbers into the show grew directly out of Seth MacFarlane's love of musical theatre and began with "This House Is Freakin' Sweet" in the Season 2 premiere. It has continued through virtually every season since that time, including such songs as "Shipoopi," "Surfin' Bird," "The FCC Song" and "It's a Wonderful Day for Pie." All members of the show's cast and crew work diligently on these sequences, from the meticulous writing of the lyrics and the music to the countless hours spent animating the often enormously complex choreography.

The ultimate touchdown dance.

"Patriot Games": Written by Mike Henry and directed by Cyndi Tang. Dance sequence storyboard panels by Dan Povenmire.

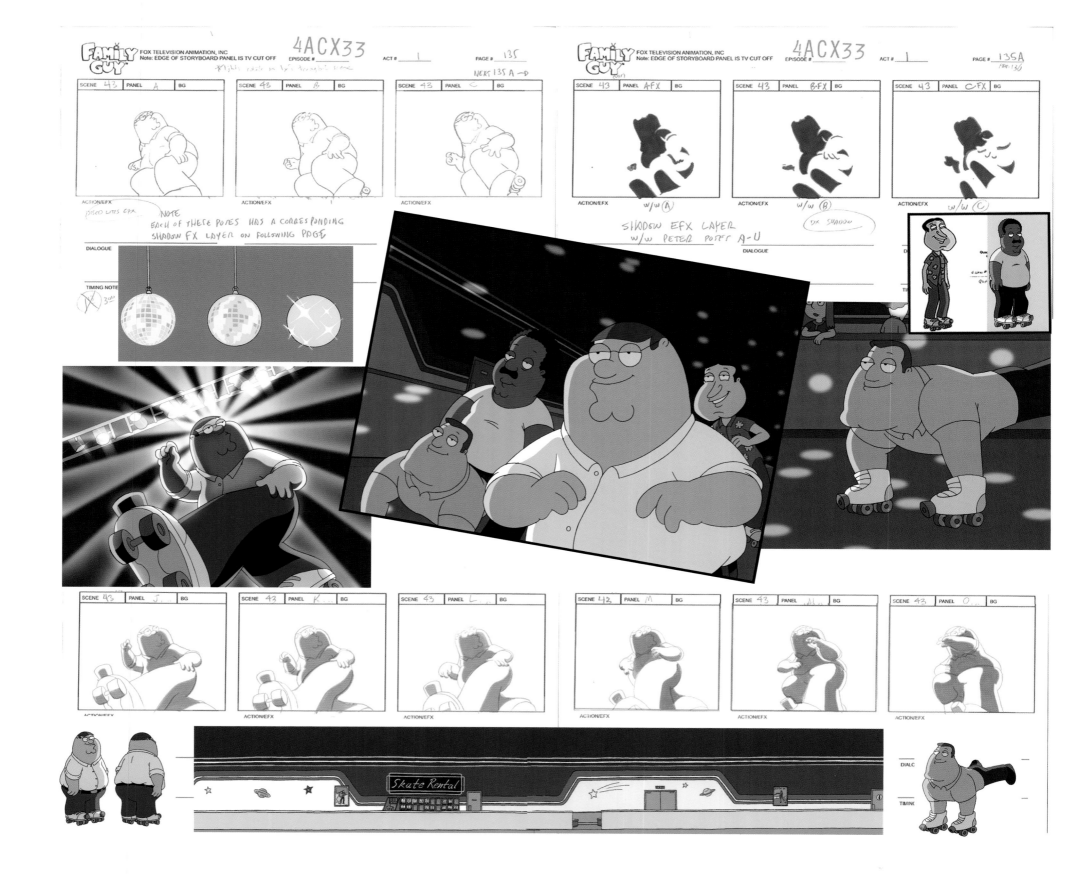

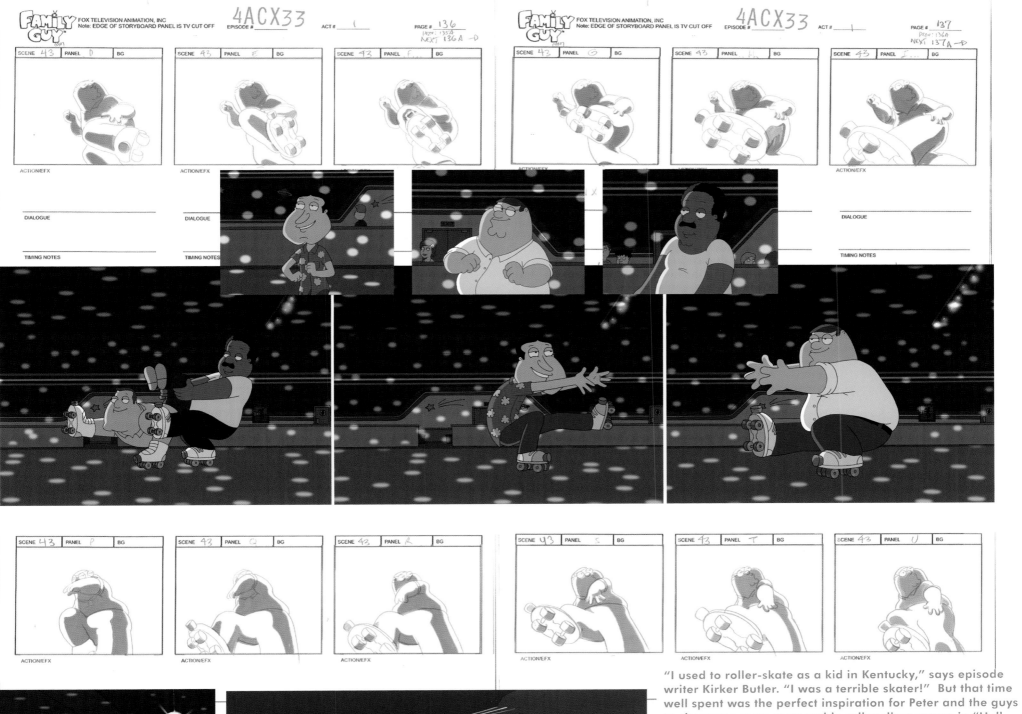

"I used to roller-skate as a kid in Kentucky," says episode writer Kirker Butler. "I was a terrible skater!" But that time well spent was the perfect inspiration for Peter and the guys to showcase some memorable roller-disco moves in "Hell Comes to Quahog." Storyboard panels by director Dan Povenmire would later be animated to composer Walter Murphy's hit song "A Fifth of Beethoven."

"Hell Comes to Quahog": Written by Kirker Butler and directed by Dan Povenmire. Background design by Chad Cooper. Character design by Sharon Ross and Ken Hayashi. Color by Cynthia McIntosh.

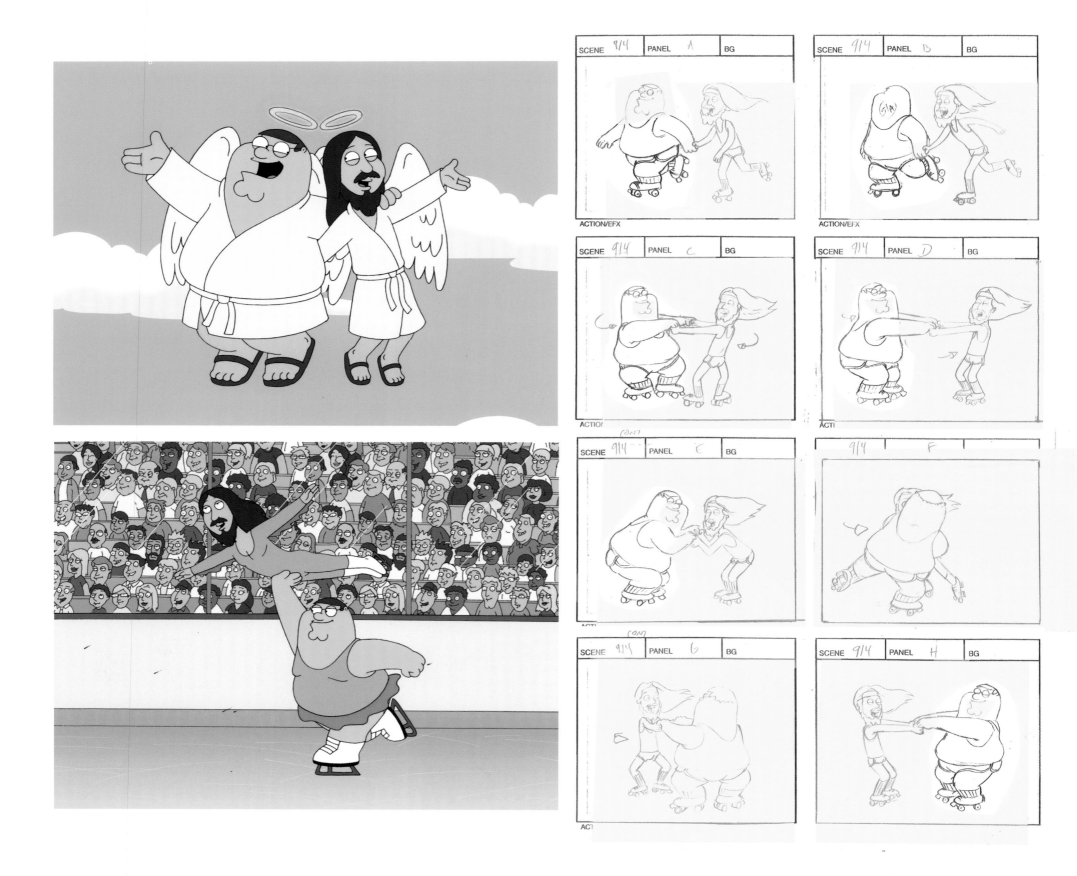

SCENE 915 | PANEL A | BG
ACTION/EFX

SCENE 915 | PANEL B | BG
ACTION/EFX

SCENE 915 | PANEL C | BG
ACTION/EFX

Sc. 915 PNL D

Sc. 915 PNL E

Sc. 915 PNL F

Sc. 915 PNL G

Sc. 915 PNL H

Sc. 915 PNL I

This "Me and Jesus" song-and-dance sequence ended up being cut for time from broadcast but was included on the DVD extended version of the episode.

"I Dream of Jesus": Written by Brian Scully and directed by Mike Kim.

This song and video sequence was inspired by Hyuna's "Bubble Pop" K-pop video. "We just loved it," says Cherry Chevapravatdumrong. "It was definitely the catchiest song and that was the one we probably watched the most times." In order to create a *Family Guy*–style video, the writing and art teams met up to pitch visual ideas over several creative sessions. "Part of the creativity came in the restrictions," says Joseph Lee. "We weren't trying to mimic the video verbatim. We had to come up with new K-pop-inspired choreography and visuals in order to put our own twist on it. We studied the choreography of other popular videos that came out around that time and decided to incorporate a compilation of all the various videos we liked. As a result, the dance became its own K-pop tribute."

"Candy Quahog Marshmallow!": Written by Cherry Chevapravatdumrong and directed by Joseph Lee. Storyboards by Wincat Alcala and Valentino So. Character design by Ed Acosta and Mick Cassidy. Background design by Young Kim and David Beall. Color by Michael Kinkade, Kersti Myberg and Bike Kinzle.

"Candy Quahog Marshmallow!" storyboards by Joseph Lee.

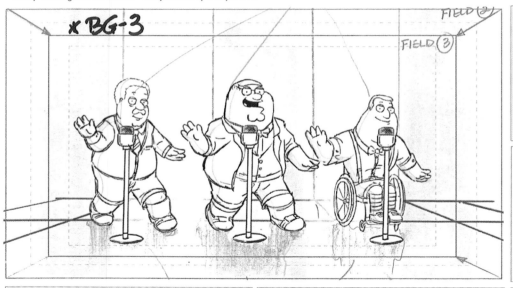

Ralph Fernan and Valentino So, both from *American Dad!*, worked with director Lee and his team of Wincat Alcala, Dominic Bianchi and Peter Shin to nail down this sequence: "Originally, we pitched the video with Peter, Quagmire, Cleveland and Joe dressed like female dancers in bikinis and other outrageous outfits. It was funny at first but it didn't have the variety we were looking for so we decided to go in a different direction."

Background design by Antonio Torres and color by Michael Kinkade.

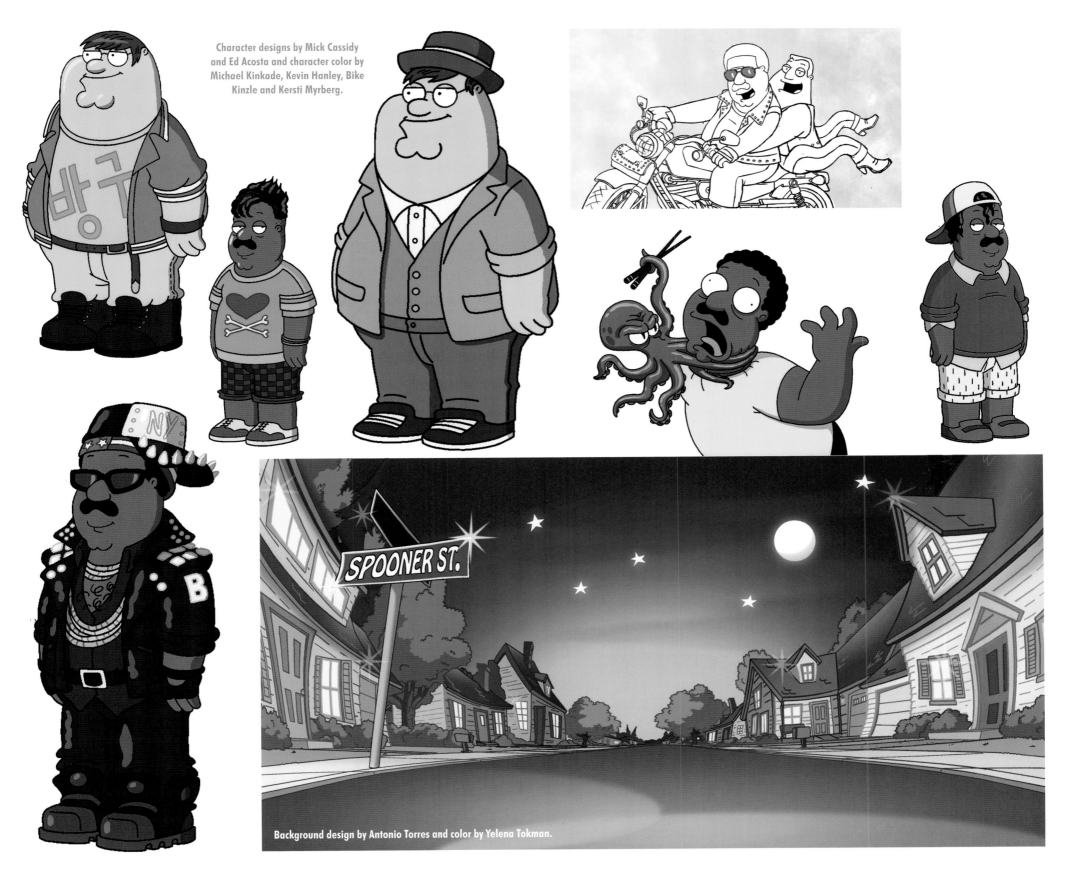

Character designs by Mick Cassidy and Ed Acosta and character color by Michael Kinkade, Kevin Hanley, Bike Kinzle and Kersti Myrberg.

Background design by Antonio Torres and color by Yelena Tokman.

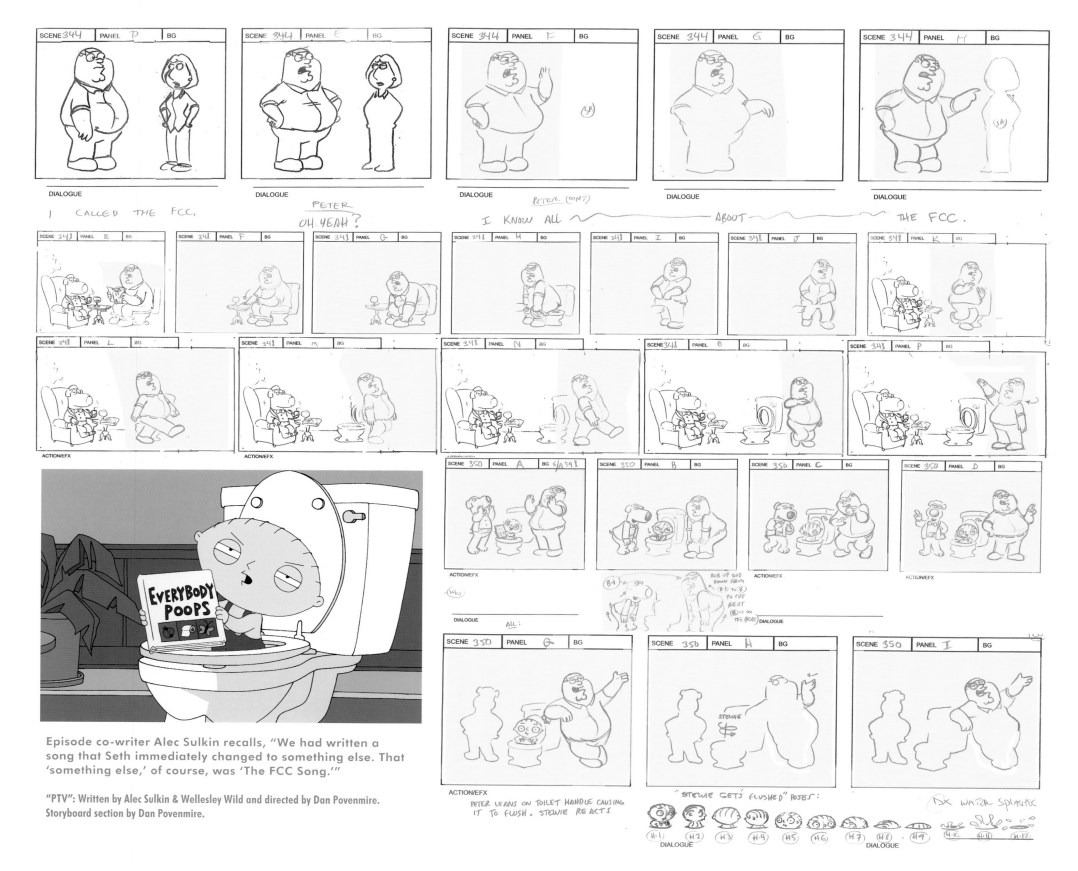

Episode co-writer Alec Sulkin recalls, "We had written a song that Seth immediately changed to something else. That 'something else,' of course, was 'The FCC Song.'"

"PTV": Written by Alec Sulkin & Wellesley Wild and directed by Dan Povenmire. Storyboard section by Dan Povenmire.

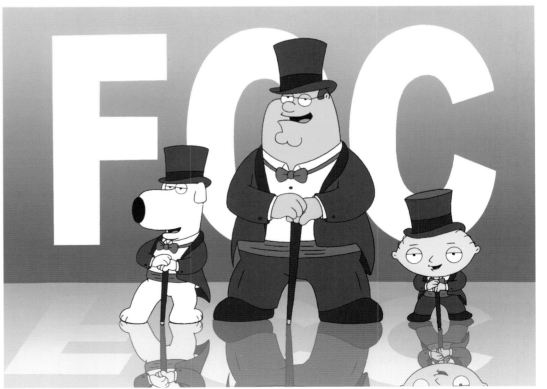

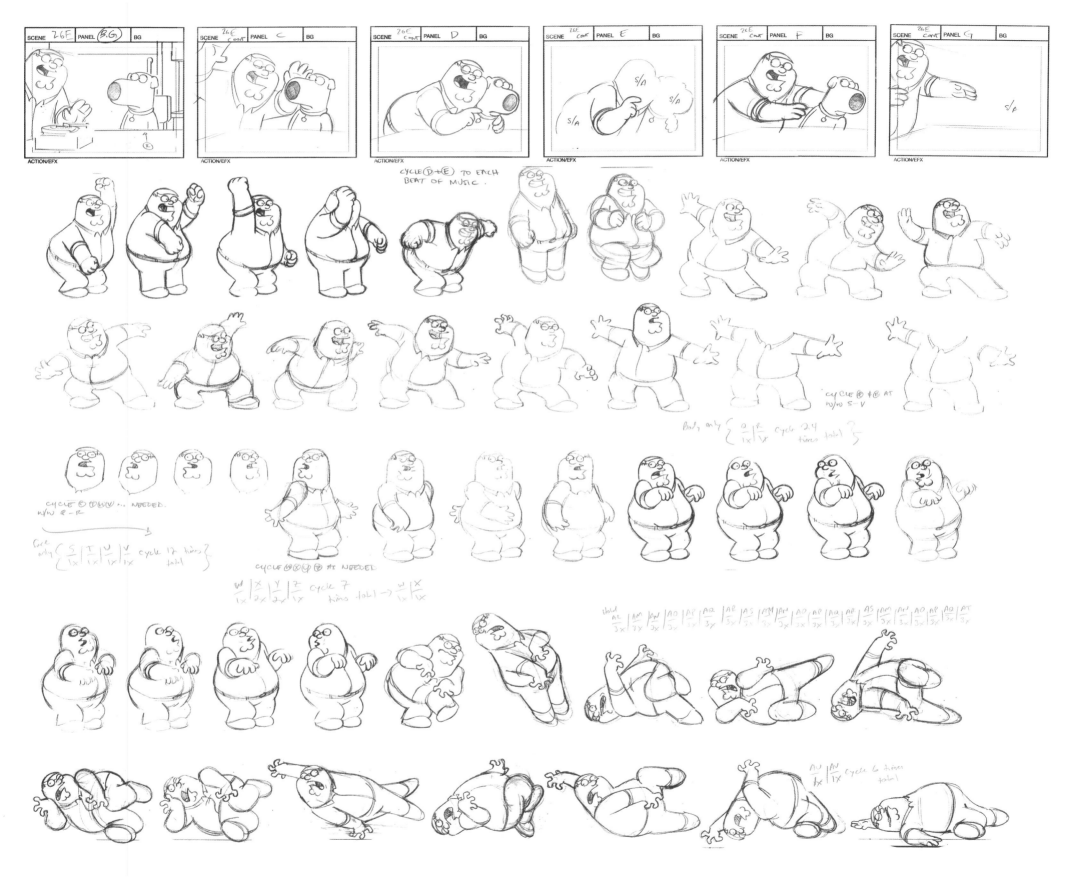

SCENE 26G	PANEL A	BG
SCENE 26G	PANEL B	BG
SCENE 26G	PANEL C	BG
SCENE 26G	PANEL E	BG
SCENE 26G	PANEL F	BG

ACTION/EFX

DIALOGUE

BRIAN

Oh my

53 BRIAN

god, Peter, are you alright?!

54 PETER

(EYES CLOSED) PA-PA-PA

(EYES SNAP OPEN
AND HE STARTS TO DANCE TO HIS FEET)
OOMA-MOW-MOW PA-PA OOMOW-MA-MOW

SCENE 26H	PANEL B	BG
SCENE 26H	PANEL C	BG
SCENE 26H	PANEL D	BG
SCENE 26H	PANEL F	BG
SCENE 26H	PANEL L	BG

ACTION/DIALOGUE

SCENE 26H	PANEL M	BG
SCENE 26H	PANEL N	BG
SCENE 26H	PANEL P	BG
SCENE 26H	PANEL Q	BG
SCENE 26H	PANEL R	BG

ACTION/DIALOGUE CYCLE P Q R AS NEEDED

"We were trying to hit our deadline and I remember doing this sequence around 3 A.M.," says director Mike Kim." Drawing out the key poses on animation paper, Kim cut the images out and registered them within the storyboard panels. But there was not enough material to finish off the scene. With two days left, Peter Shin completed the sequence, adding in the extra poses of Peter twitching on the ground, and timed it all out. "It was pretty impressive," recalls Kim. But board drawings are one thing. Watching it work in real time is another. "I had no idea how it would all turn out until it went to animatic. And when the animatic screening time came, it turned out great! Everyone in the room cheered. It was a pretty cool moment."

"I Dream of Jesus": Written by Brian Scully and directed by Mike Kim.

Created by

SETH MacFARLANE

"Road To . . ." Episodes

Inspired by the Bob Hope/Bing Crosby "Road to . . ." films, *Family Guy* has a long tradition of these "traveling" shows. Beginning with "Road to Rhode Island," this category of episodes has tended to feature an elaborate voyage to an exotic location as well as a lush and whimsical musical number. Some of these fantastical adventures have included "Road to Europe," "Road to the North Pole," "Roads to Vegas" and "Road to India," and they rank among some of the most memorable episodes of the series.

"ROAD TO RHODE ISLAND"

"ROAD TO EUROPE"

"ROAD TO RUPERT"

"ROADS TO VEGAS"

"ROAD TO GERMANY"

"ROAD TO INDIA"

"Road to the Multiverse": Written by Wellesley Wild and directed by Greg Colton.

Background designs by Tony Pulham, Kip Noschese, Audrey Stedman and Jeff Mertz. Color by Tony Pulham, Yelena Tokman, Michael Kinkade and Kevin Hanley.

"Road to the Multiverse": Character design by Seth MacFarlane, Young Baek and Ken Hayashi. Background design by Ken Yi. Color by Michael Kinkade.

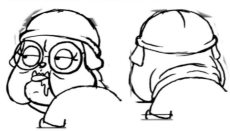

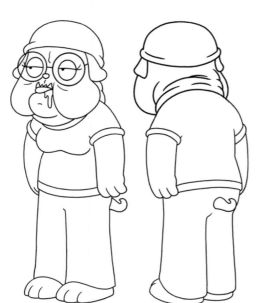

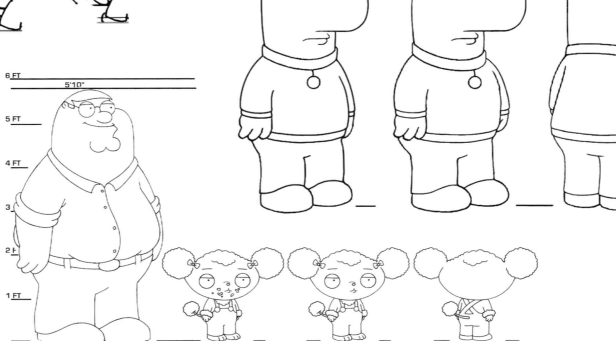

6 FT

5'10"

5 FT

4 FT

3

2 F

1 FT

FOOD ON FACE

The challenge for Future Quahog was to make sure it did not look like other cartoons set in space. When it came to the colors, the team opted for tones that stayed true to Quahog.

LIGHTSPEED
RAILWAY STATION

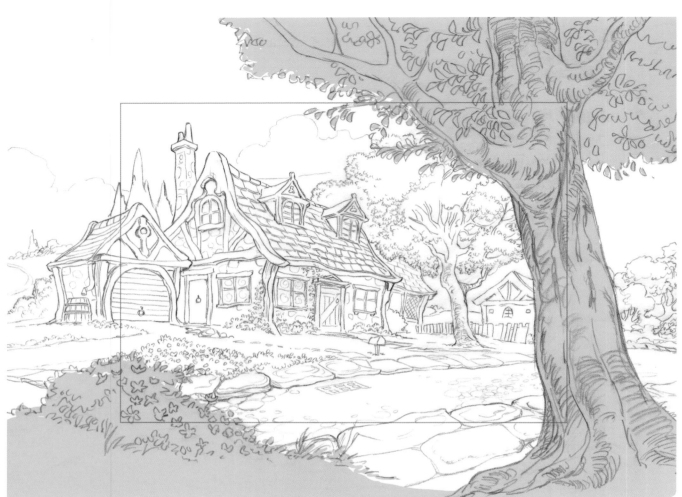

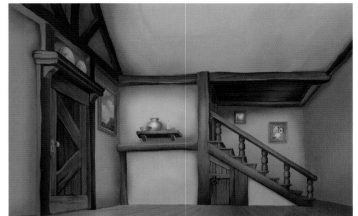

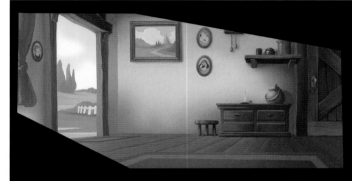

Background design and color by Tony Pulham.

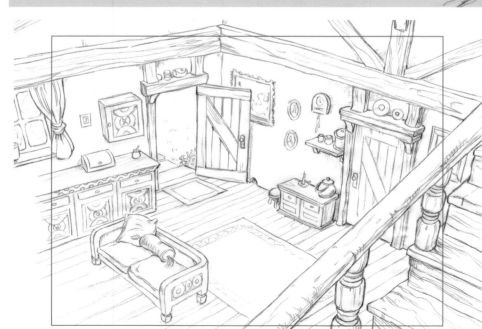

"ROAD TO THE NORTH POLE"

Composer Ron Jones along with lyricists Seth MacFarlane and Danny Smith received a Best Song Emmy for their work on "Christmastime Is Killing Us." Santa speaking and singing role is played by Bruce McGill.

"Road to the North Pole": Written by Chris Sheridan & Danny Smith, and directed by Greg Colton. Background design by Audrey Stedman. Color by Kevin Hanley.

FOX TELEVISION ANIMATION, INC · 8ACX08/09 · ACT# 5

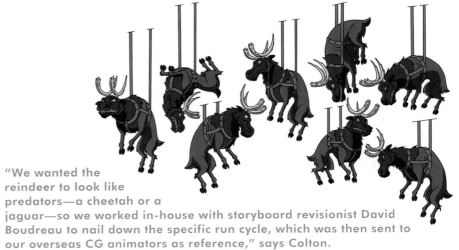

"We wanted the reindeer to look like predators—a cheetah or a jaguar—so we worked in-house with storyboard revisionist David Boudreau to nail down the specific run cycle, which was then sent to our overseas CG animators as reference," says Colton.

Storyboards and pre-design by Joe Vaux. Character design by Ken Hayashi. Color by Kevin Hanley.

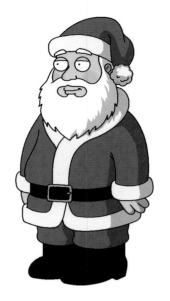

SETH OK-06.11.10

"Road to the North Pole": Character design by Sharon Ross and Ed Acosta. Background design by Ken Yi. Color by Kevin Hanley.

sc 1027 panel A (partial scene – CU)

for when Stewie's first holding it

Stewie Griffin
as
Sherlock Holmes

Brian Griffin
as
Dr. Watson

Title Cards

The "Road Show" episodes started as special Stewie and Brian "buddy" adventures, usually involving some sort of journey as well as an old-fashioned-style musical number. To help set the tone for these unique episodes, Seth suggested creating elaborate opening title sequences intended to evoke the magic of those Hope/Crosby classics. This tradition has continued with each "Road" show since (and even some other special non-"Road Show" episodes). The designs for these title cards require a great deal of extra attention and are typically worked on for many months, resulting in truly original pieces of art.

FAMILY GUY

presents

Family Guy Presents

BRIAN & STEWIE

In

Developed By

SETH MacFARLANE

&

DAVID ZUCKERMAN

Developed by

SETH MacFARLANE

DAVID ZUCKERMAN

Executive Producers

DANNY SMITH

MARK HENTEMANN

STEVE CALLAGHAN

Consulting Producers

DAVID A. GOODMAN

CHRIS SHERIDAN

Producers

JULIUS SHARPE

ANDREW GOLDBERG

ALEX CARTER

Created By
SETH MacFARLANE

Executive Producers
Seth MacFarlane
Alec Sulkin
Richard Appel

Music by
RON JONES

Music by
WALTER MURPHY

Producers
Shannon Smith
Kim Fertman

Supervising Directors
James Purdum
Dominic Bianchi

Consulting Producer
TOM DEVANNEY

Co-Producers
PATRICK MEIGHAN
CHERRY CHEVAPRAVATDUMRONG

Co-Executive Producer
DAVID A. GOODMAN

Supervising Producers
MIKE BARKER
&
MATT WEITZMAN

Producers
ALLISON ADLER
GENE LAUFENBERG

Co-Executive Producers
ALEC SULKIN
WELLESLEY WILD
BRIAN SCULLY
TOM DEVANNEY

Executive Producers
SETH MacFARLANE
STEVE CALLAGHAN
MARK HENTEMANN

Co-Producers
STEVE CALLAGHAN
ALEC SULKIN
&
WELLESLEY WILD
ALEX BORSTEIN
MIKE HENRY
&
PATRICK HENRY

Supervising Producers
Anthony Blasucci
Mike Desilets

Producers
Artie Johann
Chris Regan

Executive Producers
DANNY SMITH WELLESLEY WILD
ALEC SULKIN KARA VALLOW

Produced by
KARA VALLOW

Supervising Producers

MIKE HENRY
ALEC SULKIN
WELLESLEY WILD

Producers

KIRKER BUTLER
SHANNON SMITH

Written by
DANIEL PALLADINO

Co-Executive Producers

DANNY SMITH

MARK HENTEMANN

STEVE CALLAGHAN

Producers

MIKE BARKER
MATT WEITZMAN
BILLIAM CORONEL

Co Producers

RICKY BLITT
CHRIS SHERIDAN

Produced by

KARA VALLOW

Written by

David A. Goodman

Written by

CHRIS SHERIDAN
&
DANNY SMITH

Consulting Producers

CHRIS SHERIDAN

DAVID A. GOODMAN

JOHN VIENER

BRIAN SCULLY

Produced by

KARA VALLOW

Created By

SETH MacFARLANE

Directed by
GREG COLTON

Directed By
PETE MICHELS

Directed By
DAN POVENMIRE

Parody Episodes

Whether it's poking fun at the classics of high school English class; well-known childhood fairy tales; the works of Stephen King; the adventures of Sherlock Holmes; the original Star Wars trilogy or even the tropes of Quentin Tarantino, Wes Anderson and Michael Bay (just to name a few), *Family Guy* has shown a deep capacity for parodying other famous works by placing the entire Quahog gang into these worlds. In storylines that often break the fourth wall, these episodes are a fun chance for the *Family Guy* writers and artists to break out of the mold of a traditional episode and imagine how the Griffins and their crew might behave when inhabiting some of the most famous roles of all time.

FAMILY GUY

"Family Guy Viewer Mail #2"

9ACX19
ACT 1

First Draft:	Date:	08/29/11
Supervising Director:	Comp:	
Seth MacFarlane:	Date:	
	Comp:	
First Animatic:	Date:	
	Comp:	
Post Animatic:	Date:	
Supervising Director:	Comp:	
Seth MacFarlane:	Date:	
	Comp:	
Slug:	Date:	
	Comp:	
Final Ship Draft:	Date:	9-23-11
	Comp:	

ORIGINAL

CREATED BY: Seth MacFarlane
WRITTEN BY: Tom Devanney
STORYBOARD BY: Fanny Brat
SUPERVISING DIRECTOR: Dom Bianchi
DIRECTED BY: Greg Colton

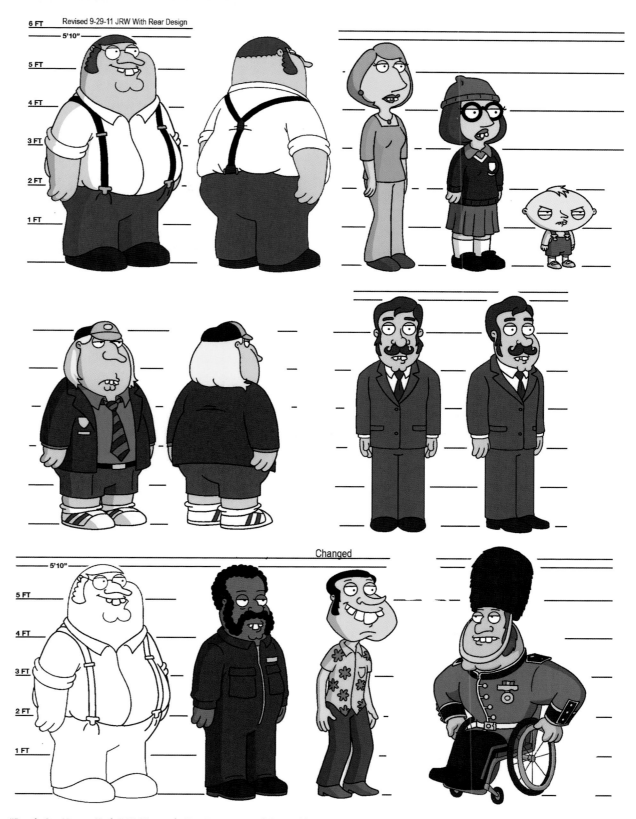

Revised 9-29-11 JRW With Rear Design

Changed

"Family Guy Viewer Mail #2": Written by Tom Devanney and directed by Greg Colton. Character designs by Mick Cassidy. Color by Kevin Hanley.

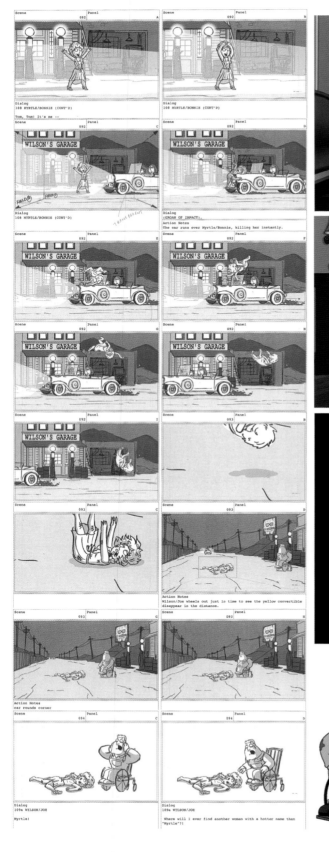

Scene 092 Panel A
Dialog
108 MYRTLE/BONNIE (CONT'D)
Tom, Tom! It's me --

Scene 092 Panel B
Dialog
108 MYRTLE/BONNIE (CONT'D)

Scene 092 Panel C
WILSON'S GARAGE
Dialog
108 MYRTLE/BONNIE (CONT'D)

Scene 092 Panel D
WILSON'S GARAGE
Dialog
(GROAN OF IMPACT).
Action Notes
The car runs over Myrtle/Bonnie, killing her instantly.

Scene 092 Panel E
WILSON'S GARAGE

Scene 092 Panel F
WILSON'S GARAGE

Scene 092 Panel G
WILSON'S GARAGE

Scene 092 Panel H
WILSON'S GARAGE

Scene 092 Panel I
WILSON'S GARAGE

Scene 093 Panel B

Scene 093 Panel C

Scene 093 Panel D
Action Notes
Wilson/Joe wheels out just in time to see the yellow convertible disappear in the distance.

Scene 093 Panel F
Action Notes
car rounds corner

Scene 093 Panel G

Scene 094 Panel C
Dialog
109 WILSON/JOE
Myrtle!

Scene 094 Panel D
Dialog
109a WILSON/JOE
Where will I ever find another woman with a hotter name than "Myrtle"?

FX reference for fountain and pool water.

1404_sc15(cover sc95) Ext gatzby mansion backyard

"High School English": Written by Ted Jessup and directed by Steve Robertson. Storyboards by Dante Leandado. Background design by John Seymore, Tim Hwang and Ken Yi. Character design by Ken Hayashi. Color by Kevin Hanley, Yelena Tokman and Michael Kinkade.

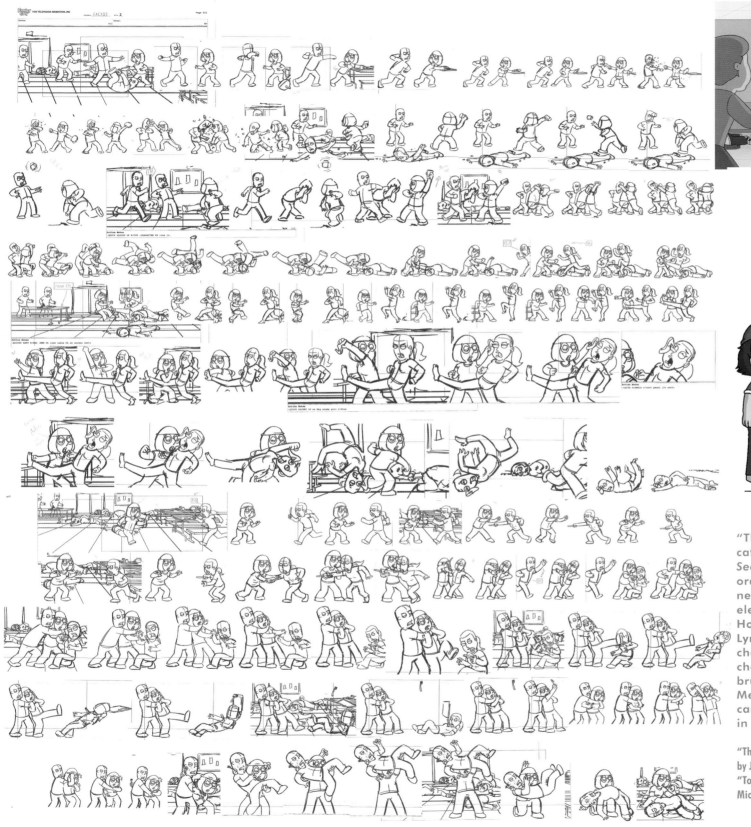

stage 1
sc 403

stage 2
sc 407

"This fight was meant as a parody of the cathedral fight in the film *Kingsman: The Secret Service*," says director Julius Wu. "In order for it to resemble the original, we needed to adhere to the two most identifiable elements that made it so memorable: its Hong Kong–inspired action and the use of Lynyrd Skynyrd's song 'Free Bird.' My main challenge was coming up with nonrepetitive choreography that looked both flashy and brutal, and seamlessly connecting Chris' and Meg's techniques to achieve that handheld-camera 'long take' effect that puts the viewer in the middle of the action."

"The D in Apartment 23": Written by Artie Johann and directed by Julius Wu. Storyboards by Julius Wu, Wincat Alcala and Alfred "Tops" Cruz. Character design by Raymond Arrizon. Color by Michael Kinkade.

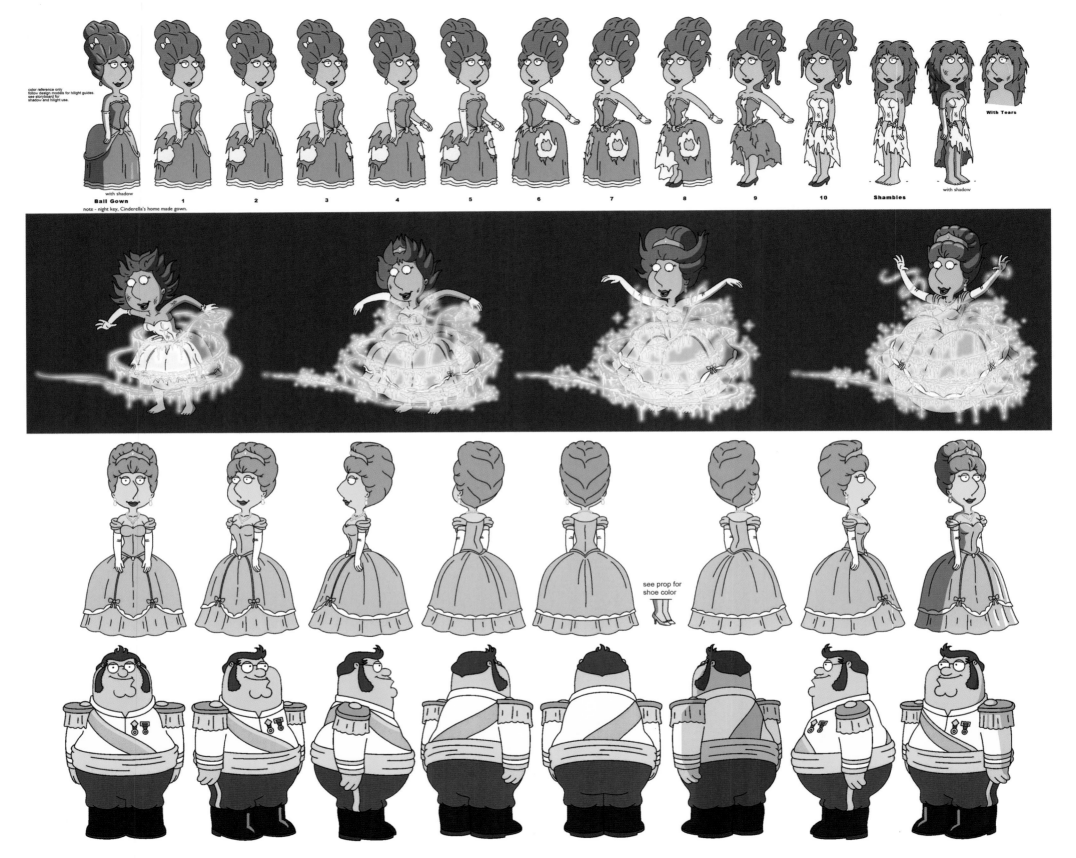

color reference only
follow design models for hilight guides.
see storyboard for
shadow and hilight use.

with shadow

Ball Gown
note - night key, Cinderella's home made gown.

1

2

3

4

5

6

7

8

9

10

Shambles

with shadow

With Tears

see prop for
shoe color

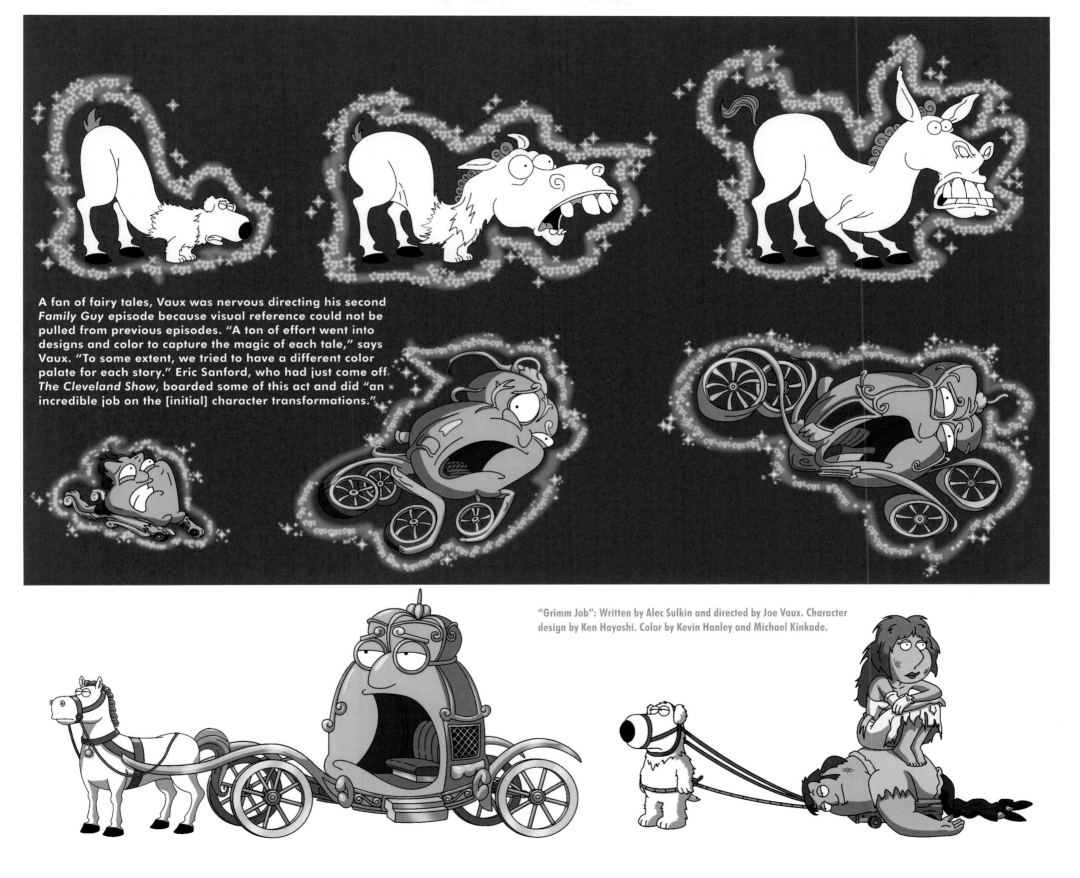

A fan of fairy tales, Vaux was nervous directing his second *Family Guy* episode because visual reference could not be pulled from previous episodes. "A ton of effort went into designs and color to capture the magic of each tale," says Vaux. "To some extent, we tried to have a different color palate for each story." Eric Sanford, who had just come off *The Cleveland Show*, boarded some of this act and did "an incredible job on the [initial] character transformations."

"Grimm Job": Written by Alec Sulkin and directed by Joe Vaux. Character design by Ken Hayashi. Color by Kevin Hanley and Michael Kinkade.

color reference only
follow design models for hilight guides.
see storyboard for
shadow and hilight use.

note glow FX

With Gold Teeth

"Grimm Job": Pre-design by Joe Vaux. Background design by David Beall, Vladi Rubizhevsky and Ken Yi. Character design by Ken Hayashi and Mick Cassidy. Color by Kevin Hanley and Kersti Myberg.

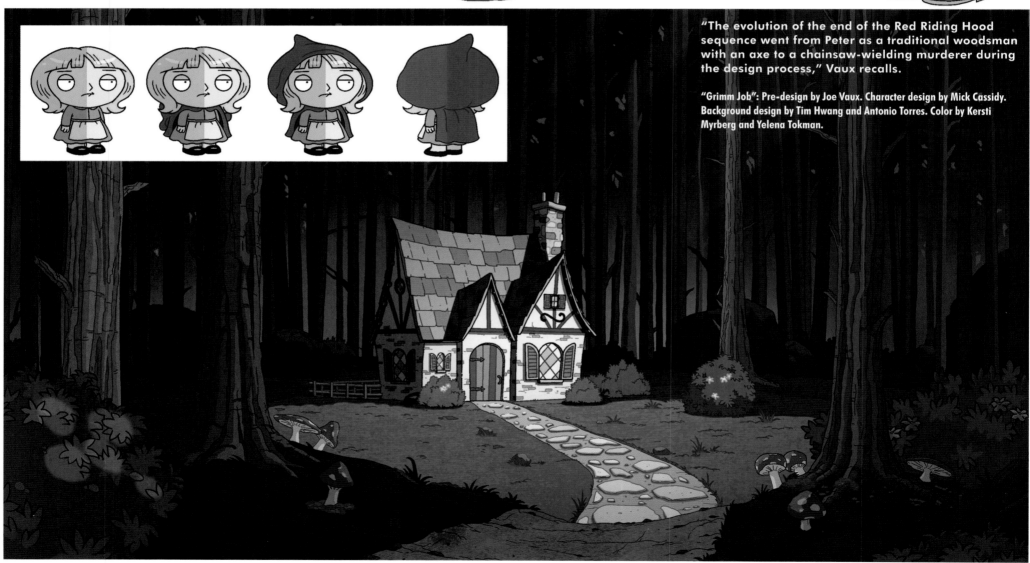

"The evolution of the end of the Red Riding Hood sequence went from Peter as a traditional woodsman with an axe to a chainsaw-wielding murderer during the design process," Vaux recalls.

"Grimm Job": Pre-design by Joe Vaux. Character design by Mick Cassidy. Background design by Tim Hwang and Antonio Torres. Color by Kersti Myrberg and Yelena Tokman.

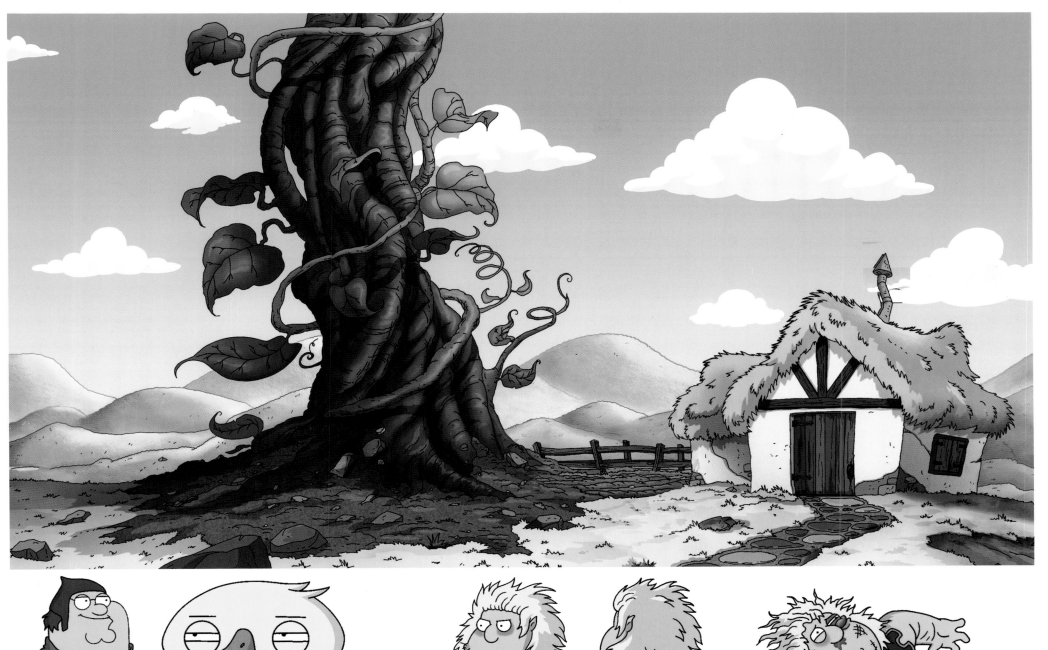

"Road to the Multiverse": Initial character concepts by Greg Colton. Character designs by Sandro Cleuzo. Animation for this sequence was done by Main Street Pictures and supervised by Darlie Brewster.

One of MacFarlane's favorite episodes, "And Then There Were Fewer," was a true departure from the standard *Family Guy* brand—both in storytelling and visual style. It was important that time was taken to create a feeling of suspense, so an hour-long run time was necessary in order to set the mood and tell the story. Right from the top, the opening titles sequence runs almost two minutes long.

Following in the footsteps of the *Family Guy Star Wars* parodies, the episode leans heavily on the cinematic style of film rather than *Family Guy*'s typical sitcom staging. It was the first to air in the 16:9 aspect ratio.

MacFarlane asked director Dominic Polcino and assistant director Lucas Gray to emphasize dramatic staging and pacing. Darker color palettes and gradient shadows were used throughout to create a mysterious atmosphere. The color department worked closely with Peter Shin and Seth to push the color design toward the dramatic look that was finally achieved, and the work accomplished here had a heavy influence on the look of the series going forward. Detailed designs and dramatic staging are now more frequently interspersed with the standard flat *Family Guy* style.

"And Then There Were Fewer": Written by Cherry Chevapravatdumrong and directed by Dominic Polcino. Promotional art by Julius Preite and Kevin Segna.

801_ mansion downshot

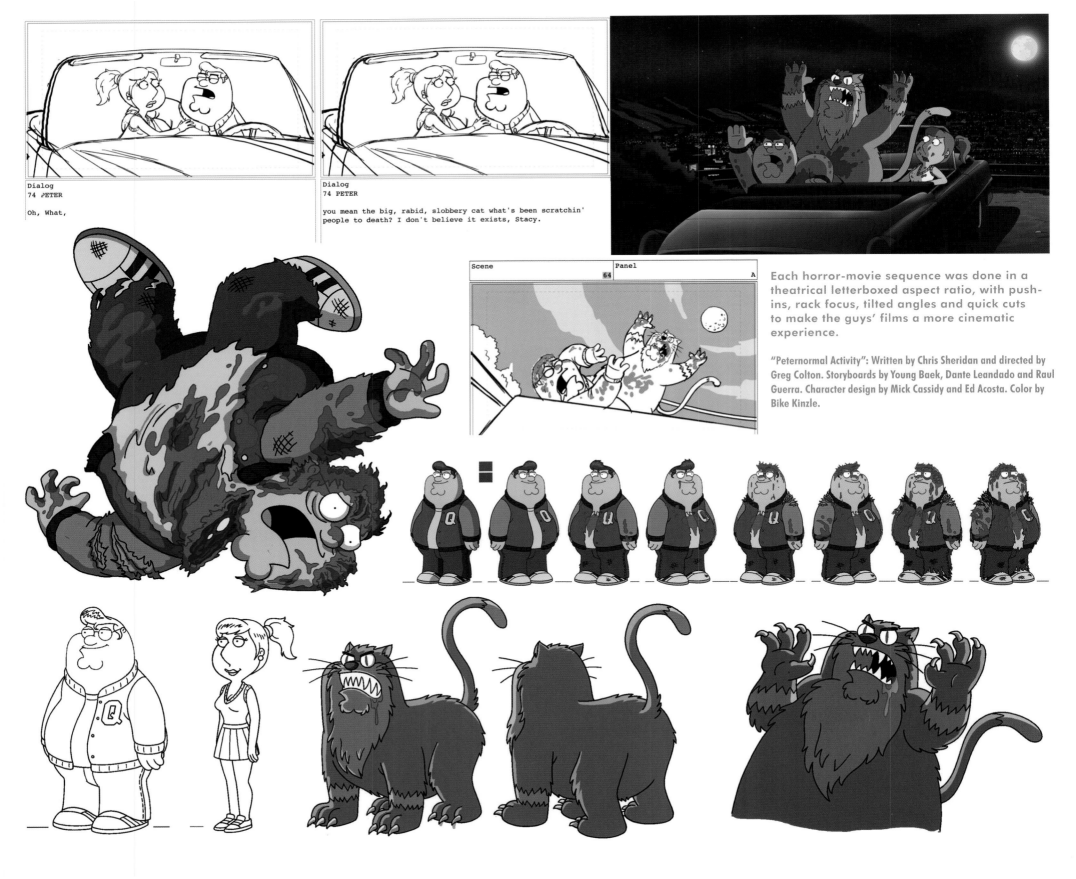

Dialog
74 PETER

Oh, What,

Dialog
74 PETER

you mean the big, rabid, slobbery cat what's been scratchin' people to death? I don't believe it exists, Stacy.

Scene		Panel	
	64		A

Each horror-movie sequence was done in a theatrical letterboxed aspect ratio, with push-ins, rack focus, tilted angles and quick cuts to make the guys' films a more cinematic experience.

"Peternormal Activity": Written by Chris Sheridan and directed by Greg Colton. Storyboards by Young Baek, Dante Leandado and Raul Guerra. Character design by Mick Cassidy and Ed Acosta. Color by Bike Kinzle.

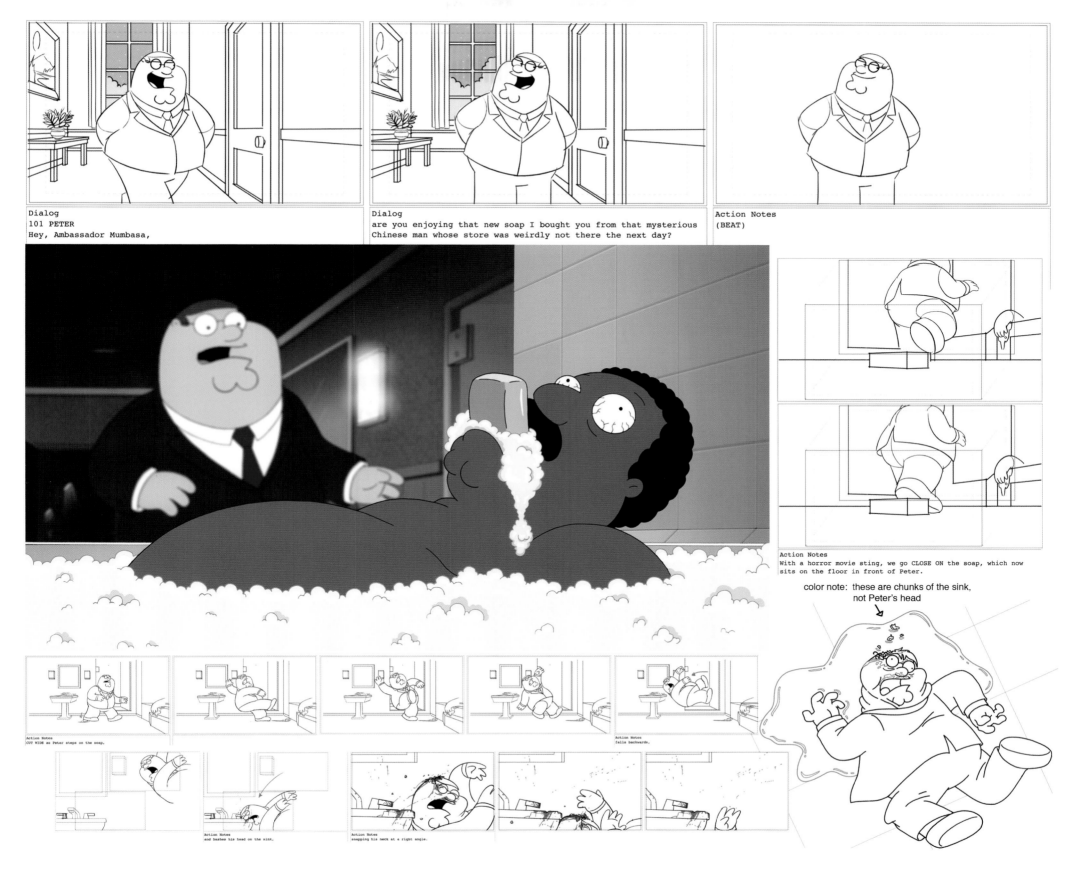

Dialog
101 PETER
Hey, Ambassador Mumbasa,

Dialog
are you enjoying that new soap I bought you from that mysterious
Chinese man whose store was weirdly not there the next day?

Action Notes
(BEAT)

Action Notes
With a horror movie sting, we go CLOSE ON the soap, which now
sits on the floor in front of Peter.

color note: these are chunks of the sink,
not Peter's head

Action Notes
CUT WIDE as Peter steps on the soap,

Action Notes
falls backwards,

Action Notes
and bashes his head on the sink,

Action Notes
snapping his neck at a right angle.

"Peternormal Activity": Background design by John Seymore. Color by Bike Kinzle.

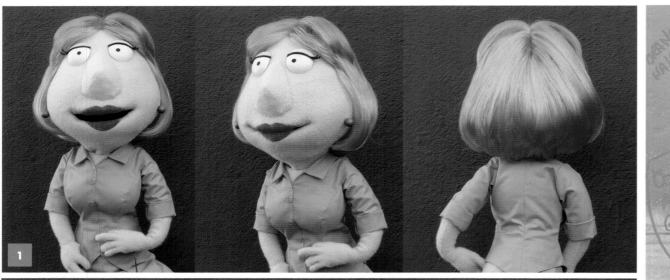

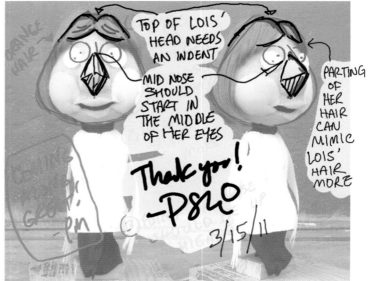

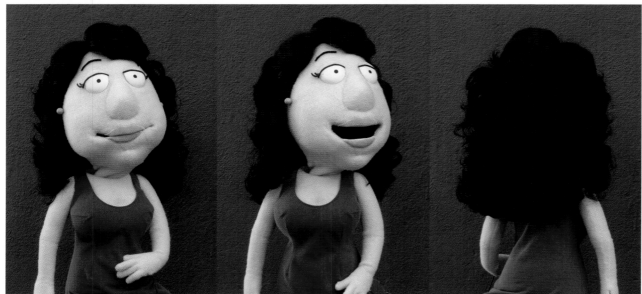

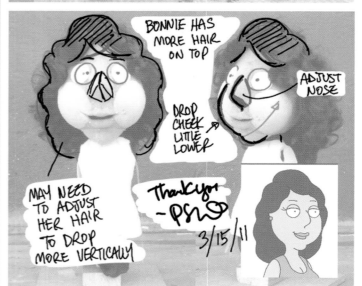

Pushing Beyond Animation

Over its more than 300 episodes, *Family Guy* has pushed beyond the creative boundaries of animation, weaving a wide variety of visual styles into its narratives: live-action sequences (as with Ashton Kutcher's fake Korean commercial), stop-motion animation (e.g., when the Griffins appeared as a "Robot Chicken" version of themselves), 3D models (like the time the show envisioned an apocalyptic end to Quahog) and even puppetry (as when Stewie appeared in a cutaway as King Friday from *Mister Rogers' Neighborhood*). Many more examples of these alternate visual styles can be seen here and give us hints of what future surprises lie ahead in upcoming seasons of *Family Guy*.

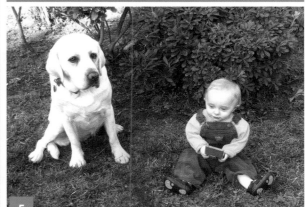

1. Lois and Bonnie puppets by Screen Novelties in "Foreign Affairs."

2. 2-D Brian guest stars in *Die Hard* in "Brian's Got a Brand New Bag."

3. Stewie appears with a live-action mouth courtesy of Kat Purgal in "Seahorse Seashell Party."

4. Stop-motion Griffins animated by Screen Novelties in "Road to the Multiverse."

5. Live-action Brian and Stewie, played by Henry Wellesley Wild III and Grace Hentemann, in "Road to the Multiverse."

6. Live-action bumper featuring Ron MacFarlane in "Road to the North Pole."

7. Stewie in CG spaceship animated by Atmosphere Visual Effects and models by Super 78 in "Brian Griffin's House of Payne."

8. Live-action Peter Griffin in "Let's Go to the Hop."

LOOKING A LOT BETTER!!

"We had a lot of fun going back and forth with Atmosphere figuring out the designs," says director Dominic Bianchi. "Building the sets and characters was like shopping—they would send us sample textures, and we would pick and choose what worked best with our characters to still feel like it was in the *Family Guy* world." Turning a 2D character into 3D is no simple task either: "Our characters don't translate well into CG. We had to do frame-by-frame cheats of the faces to keep them looking on-model since they were morphing during head turns."

Post-apocalyptic Quahog 2D color was determined by the color department, and Atmosphere made things even more dynamic with 3D elements, smoke and explosions. Even 3D Frogmire looks slimy and wet with the textures they used on the character.

"Back to the Pilot": Written by Mark Hentemann and directed by Dominic Bianchi. Computer animation by Atmosphere Visual Effects. Character designs by Ed Acosta and Ken Hayashi. Color by Kevin Hanley and Bike Kinzle.

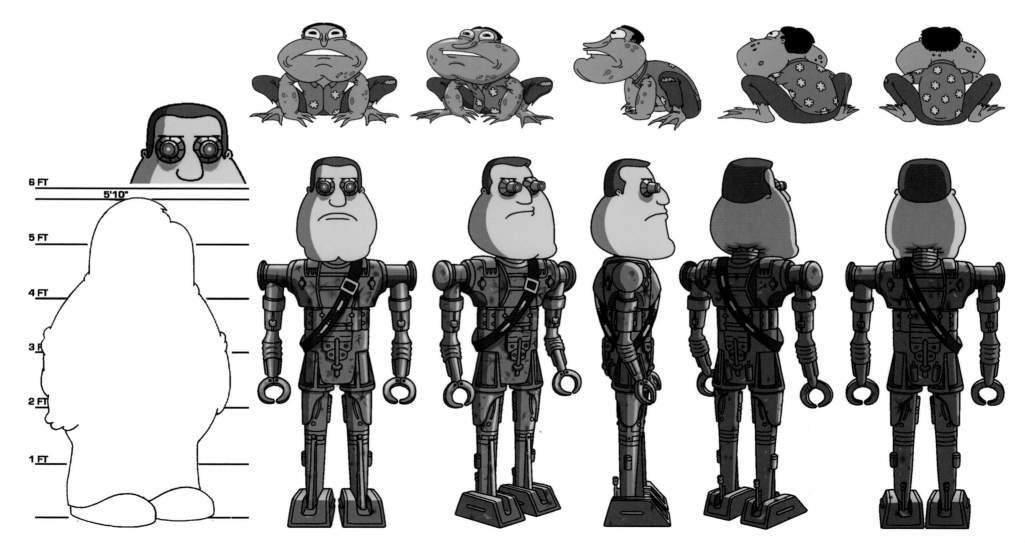

MAKING MISCHIEF

You might think that a TV show where the hero sings about "needing a Jew" to put his finances in order . . . and who plots to end his wife's pregnancy with break-dancers cavorting on her midsection . . . and whose surname gets a real-life family of Griffins riled up because they think the show is insulting *them*—well, you might think a show like that has a gift for making mischief.

You'd be right.

Pushback against *Family Guy* started even before it went on the air in 1999. A week before its premiere, the headmaster of the Kent School in Kent, Connecticut, contacted Seth MacFarlane, a 1991 alumnus, and, on behalf of an associate at the school, demanded that the last name of his cartoon family be changed. The reason: "Griffin" was the last name of the headmaster's secretary and he thought MacFarlane was trying to demean her and her family.

Needless to say, "Griffin" it was and "Griffin" it remained. But the headmaster, decrying the show's racy content, mounted a one-man letter-writing campaign under the weighty-sounding name Proud Sponsors USA, lobbying advertisers to pull ads from the show without disclosing his own personal connection to the show's creator, or to MacFarlane's mother, who had recently resigned from the school after more than a decade as its admissions officer.

"Seth chose the name 'Griffin' not because of the Griffins of Kent, Connecticut, but because it was a common Irish name," says his dad, Ron MacFarlane.

Until then, the MacFarlanes and the real-life Griffins had been friends, Ron explains, the sort of friends who would get together for dinners and go together on vacations. "The Griffins on the show weren't *them*. But they just didn't appreciate the fact that the same name was being used on *Family Guy*, so there was a falling-out between the two families."

Meanwhile, thanks to Proud Sponsors USA, a few advertisers dropped out of the show, at least temporarily, even as the Griffins stayed the Griffins and *Family Guy* stayed on the air. In an interview at the time, the headmaster-

turned-activist declared, "It's a moral matter to me."

A more robust organization would feel similarly. The Parents Television Council, founded by conservative activist L. Brent Bozell "to promote and restore responsibility and decency to the entertainment industry," has repeatedly criticized the show for its content, rallied at least one letter-writing campaign aimed at removing *Family Guy* from Fox's schedule and filed complaints with the FCC alleging that some episodes contain indecent content.

In one case, Bozell blasted the show for its depiction of Peter's father as "a sour, absurdly rigid Catholic" in the episode when he moves in with the family upon his retirement from a lumber mill, and proceeds to rag on and scorn each member of the family.

In that second-season episode, provocatively titled "Holy Crap," Bozell labeled "especially

tasteless" the grandfather's confusion about what Chris is up to when he spends time in the bathroom.

"It's a sin," growls the grandfather, angrily mistaking Chris' relieving himself for pleasuring himself. "If you ever do it again, you'll burn in hell!"

"But I do it every *day*," Chris wails. "Sometimes *twice.*"

"You may think you're alone in there," his grandfather warns fiercely, "but God's watching."

"God's watching me do Number Two," moans Chris, who will feel compelled for much of the episode to resist Nature's call. "Oh, man, now I'm a sinner and God's a pervert!"

Bozell argued that to suggest that the grandfather is indicative of "anything Christian is an insult, a deliberate, bigoted anti-Christian insult."

Along with other "offenders" like *Will & Grace* and *Buffy the Vampire Slayer*, *Family Guy* was

named among the PTC's "10 Worst Family Shows" for 1999–2000: "In its first full year, the show's creators managed to include nearly every conceivable obscenity," the PTC declared, "and references to every imaginable sexual perversion from incest to necrophilia."

From the very beginning, the show was savaged for what critics perceived as random and often shocking absurdity. In particular, it drew the ire of *Entertainment Weekly*'s TV critic Ken Tucker, who when it came time for *EW*'s worst shows list singled out *Family Guy* as "vile swill."

Family Guy would also draw the ire of Sarah Palin, former Alaska governor and onetime GOP vice presidential hopeful.

An episode in 2010 found girl-shy Chris to be smitten with Ellen, a bubbly new classmate who happens to have Down syndrome. While on a date, Chris asks about her family. Ellen replies, "My dad's an accountant, and my mom is the former governor of Alaska."

If that throwaway response was meant to yank Palin's chain, it worked. The day after the episode aired, Alaska's self-proclaimed Mama Grizzly took to Facebook to characterize the line as targeting her son Trig, who has Down syndrome. In her widely reported post, Palin said the episode "felt like another kick in the gut."

Palin's daughter Bristol also weighed in on Facebook. She reamed *Family Guy* for "mocking my brother and my family" and branded the writers "heartless jerks."

But then the actress who voiced Ellen in the episode spoke up, springing to the defense of the show and of her character.

"I guess former Governor Palin does not have a sense of humor," stated Andrea Fay Friedman, who herself has Down syndrome and found the character she played to be spunky and engaging. "I was making fun of Sarah Palin, not her son."

KILLING BRIAN

Three years after outraging the Palins, *Family Guy* outraged its own fans when it took a very-special-episode tack and killed off Brian in fall 2013.

The Griffins' dog was struck down brutally by a speeding motorist in front of his house. A wrenching deathbed scene at the veterinarian's office followed. Then came a tear-jerking graveside service. The way the hit-and-run and its aftermath unfolded, there was every reason for the viewer to believe that Brian was gone from *Family Guy* forever.

No wonder. Before "Life of Brian" was over, the brokenhearted Griffins had adopted a new family dog, who not only would replace Brian in their home but also in the show's song-and-dance main-title sequence the next week.

Many viewers reacted with a "how could you" display of indignation and fury. A Change.org petition called for Brian's resurrection. Writer and then-showrunner Steve Callaghan even received a death threat from a furious fan, directed both at Callaghan as well as MacFarlane.

"We expected the fans to have a reaction. We just failed to anticipate the magnitude of the reaction," recalls Callaghan. "But in some respects, the fan response to that episode also

showed us that our audience had, over the years, developed genuine emotional feelings toward these characters. That was actually gratifying to learn."

Given the long lead time required for a *Family Guy* episode, Brian's death was a stunt that had been cooked up a full year earlier. So was his return (which was as cleverly portrayed as it was inevitable) two weeks later.

Callaghan explains, "After seeing how upset the fans were over Brian's departure, we worried they might also be upset when we brought him back two episodes later in that year's Christmas episode. But most viewers realized, in retrospect, that we had laid the groundwork and logistics for Brian's return in the first of the three episodes in that arc. I think they appreciated the way the trio of episodes was constructed and, frankly, were just happy to see Brian back on the show."

Brian's replacement for that brief period was a street-wise, rough-around-the-edges talking mutt named Vinny (voiced by Tony Sirico, also known for his portrayal of Paulie Walnuts on *The Sopranos*). Vinny proved such a popular character that, even after his departure, the writers created opportunities in future episodes for him to reappear (albeit in ways that would still keep the timeline and lore of the series intact).

"Tony was a hilarious addition to the show and an enormous pleasure to work with," says Callaghan. "I still vividly

Early concept designs for Vinny by Peter Shin, Wincat Alcala and Seth MacFarlane.

STAGE 2

STAGE 3

COLOR NOTE: The jagged areas are ripped off fur, not cuts or bloody slashes

END POSE WITH SPIT AND BLOOD

PLEASE SEE STORY BOARD FOR SHADOW GUIDES

VINNY

Rough 9-27-12 P.828

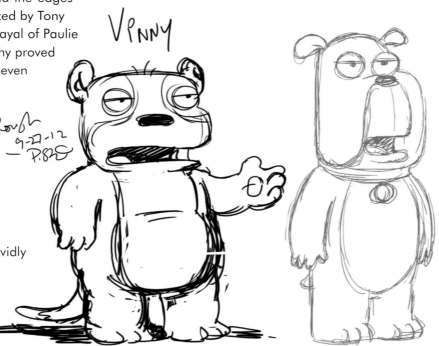
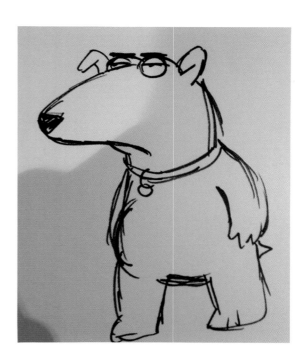

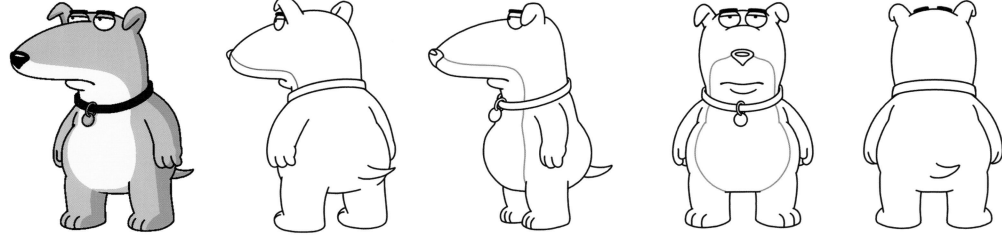

remember calling Tony right after 'Life of Brian' aired and there was so much attention on Brian's death. I asked him not to speak to the press before Brian's return so as to keep the storyline secret. He said to me—in his famous accent—'Don't worry, Steve. I'm from New York. I don't tell *nobody nothing.*'"

*F*amily Guy has weathered lawsuits. In December 2007, the show was accused of copyright infringement when actor-comedian Art Metrano filed a lawsuit addressing a scene in *Stewie Griffin: The Untold Story*, a direct-to-DVD animated feature that also aired as three episodes in May 2006.

Metrano's absurdist magic act drew its humor from the lack of anything that could be mistaken for magic: Metrano's "tricks" amounted to random hand gestures performed with the flourish of an overwrought magician while he hummed a bouncy showtune. In the episode at issue, it was Jesus who was performing "magic" acts clearly devoid of any Jesus-worthy miracles—for an unimpressed flock. The case was settled out of court.

Also in 2007, comedy grande dame Carol Burnett filed a $2 million lawsuit in response to a brief gag in an episode, "Peterotica," that had aired a year before.

In the scene, Peter and his friends enter a porn shop. Quagmire notes that the shop is surprisingly tidy because Carol Burnett works there as a janitor. Burnett is then seen in her "Charwoman" getup (a signature persona for the comedy legend that was even adapted

in cartoon form for the main title of her CBS variety show) as she mops the floor while a knockoff of her show's theme song is heard.

Joe says, "You know, when she tugged her ear at the end of that show, she was really saying good night to her mom."

Quagmire cracks, "I wonder what she tugged to say good night to her dad."

Apparently, the fact that Burnett tugged her earlobe as a loving good-night signal not to her mother, but her grandmother, who raised her, didn't bother Burnett in this dispute. Rather, she charged copyright infringement and misappropriation of her name. The courts ruled in favor of the network.

Also in 2007, *Family Guy* was sued for copyright infringement by the music publisher of "When You Wish Upon a Star." Written for Walt Disney's 1940 animated film *Pinocchio* and sung by the puppet hero's pal, Jiminy Cricket, it won the Academy Award for best original

song and is ranked seventh by the American Film Institute among its 100 Greatest Songs in Film History.

A song of that musical style titled "I Need a Jew" appeared in the episode "When You Wish Upon a Weinstein," prompting the publisher to claim the new lyrics were anti-Semitic.

The episode actually flatters—if arguably in a backhanded way—the Chosen People: Peter learns that Cleveland and Quagmire have done well with their portfolios thanks to their financial advisers, both of whom are, well, Jewish. Peter, equating "Jewish" with "smart," realizes he needs such a consultant of his own.

"Let's not deny our heritages," Peter tells the accountant he is trying to enlist. "You're Jewish—you're good with money. I'm Irish—I drink and ban homosexuals from marching in my parades."

By then, Peter has performed a tender musical number that includes his blasting into space on a giant flying dreidel.

The episode, originally set to air in 2002 as the third-season finale, was yanked from the schedule by a jittery network. It was released on DVD in September 2003 and aired on cable's Adult Swim a few weeks later. Only in December 2004 did it first air on Fox. (And a full five years after that, the lawsuit was settled when a judge ruled in favor of Fox and the show.)

Perhaps befitting the contentiousness of the subject it tackled, the most notorious episode in the *Family Guy* canon struck in Season 8 as Peter and Lois hurled themselves into the abortion debate.

The episode, "Partial Terms of Endearment," begins with Lois agreeing to become a surrogate mother for a college friend who can't conceive. But after the friend and her husband are killed in a car crash, the Griffins are left with the quandary of whether or not to proceed with Lois' pregnancy.

Determined to help Lois make this difficult decision, Peter at one point watches an anti-abortion video, whose speaker makes a rousing case: "Science has proven that within hours of conception, a human fetus has started a college fund and has already made your first Mother's Day card out of macaroni and glitter."

The video then argues that, if not for abortion, several people would have lived to benefit humankind, including a fourth Stooge, a guy who would have killed Adolf Hitler early on, and Osama bin Laden's America-loving brother, who could have prevented 9/11.

Confronted with these overwhelming arguments, Peter instantly decides against Lois getting an abortion.

But earlier, he was insistent that her pregnancy be terminated. In one attempt to induce a miscarriage, Peter pleasantly tells Lois, "I've hired some 1980s black break-dancers to do their routine on your stomach."

Then Peter takes matters into his own hands for what becomes an homage to the classic Warner Bros. Road Runner cartoons.

Having ordered an Acme Miscarriage Kit, Peter becomes the Wile E. Coyote counterpart to Lois' Road Runner as he lures her from their home not with bird seed but with *Grey's Anatomy* DVDs. He deposits the DVDs, one after another, to coax her all the way to the obligatory desert. As Lois steps into the circle he has marked as his target on the desert floor, Peter, perched on a butte high above her, aims his crossbow, which is armed not with an arrow but a bathroom plunger meant to induce a miscarriage.

But as he pulls the trigger, Lois bends over,

unwittingly ducking the line of fire, to retrieve one remaining *Grey's Anatomy* disk. Missing her, the plunger strikes the ground, then ricochets wildly. At last it thuds against the boulder precariously balanced over Peter's head. After a, well, pregnant pause, the boulder still hasn't crashed on top of him. Instead, the cliff he's standing on collapses under his feet. Suspended

for a moment in midair, Peter sheepishly waves bye-bye to the viewers. Then he plummets into the impossibly deep valley, crashing at the bottom with a distant puff of dust and a faint "Owww": in short, the same mortifying fate Wile E. Coyote has met with so often, with so many Acme products failing him, in his vain pursuit of the Road Runner.

ABORTION MADNESS!

No matter. By the end of the episode, Peter and Lois have agreed on what to do.

"I think we made the right decision," Lois says brightly as they sit at their kitchen table, summing things up in the episode's last moments. "One more person to share the world with, another little voice in the backseat of the car."

But there was more to the story . . .

The episode had been set to air during the 2009–10 season. But didn't. It never aired. It finally went public, with great interest and healthy sales, as a much-anticipated DVD in fall 2010.

While "Partial Terms of Endearment" addresses the furious debate with the show's characteristic sass—Lois is said to have been impregnated by Peruvian natives wielding blow-dart guns—it succeeds in capturing a bit of the complexity the issue ignites. The problem was, it also became embroiled in that conflict.

The irony was that TV comedy *can* deal, and in the distant past *has* dealt with a subject just this serious in the context of comedy. A two-episode arc of the Norman Lear–produced sitcom *Maude* found the title character, played by Bea Arthur, facing an unwanted pregnancy in midlife, and forced to make her wrenching choice to end it. That aired on CBS in 1972.

AN AIRING ABORTED

Forty years later, "Partial Terms of Endearment" hit a wall with its network.

"I felt that script was the best thing I've done, and all the other writers' input was so

strong," says Danny Smith, the *Family Guy* veteran who wrote it.

"Seth wanted the episode to be measured," Smith says. "The episode is *not* pro-abortion. No one is happy about getting an abortion and having to face such a terrible decision. This is a really difficult subject, and one that I felt proud to have been entrusted to explore."

In the final scene, "Lois has this beautiful speech about what it's going to be like to have another life, a new baby, in the house," Smith says. "But then Peter looks into the camera and says, 'We had the abortion.'"

Then: Cut to black. The episode is over.

"That ending is so funny, it's so dark and it's so true," says Smith. "And it's that one line that kept the episode from being on the air. The network said, 'We'll put it on the air but you can't have them say to America, "We had the abortion"'—even though it's clear that's what they did."

MacFarlane stood his ground.

"From day one, that had been Seth's punchline," says Smith. "From the outset, he had seen what the ending would be. That's what we built the whole story to."

Says MacFarlane, "There's a tendency in television to present both sides of an issue and then leave it to the audience to decide. But sometimes television should be able to tell a different kind of story where there's a point of view. And it made for a fun little bonus joke at the end where, until the very last second, you think we're gonna take the traditional middle-of-the-road approach."

MacFarlane had assigned Smith to write the script with the directive that it should not only embrace the typical outrageousness of

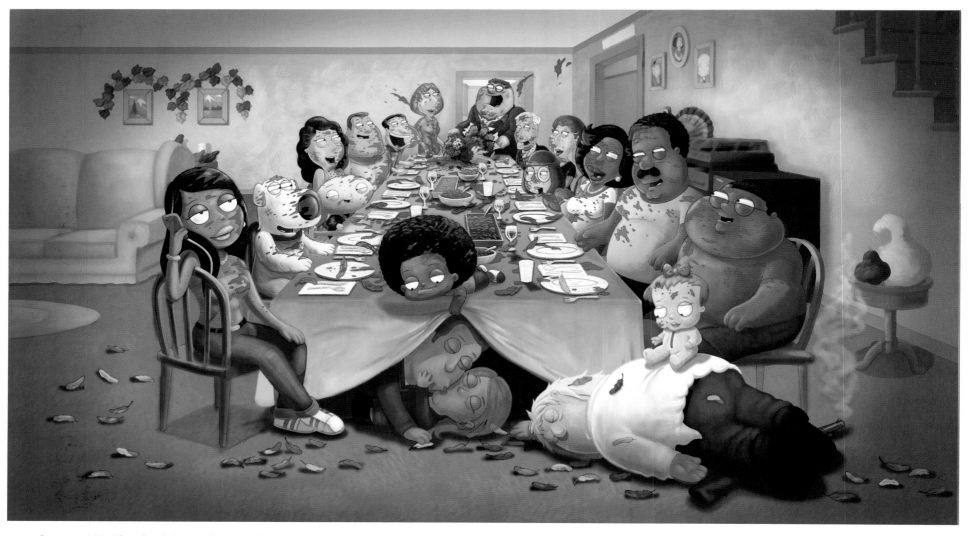

Season 13's Thanksgiving episode, "Turkey Guys," written by Cherry Chevapravatdumrong and directed by Julius Wu, concluded with this happy family image. Art by Dave Boudreau and Kevin Hanley.

Family Guy but also channel *All in the Family*, a series they both cherished that routinely mined both comedy and penetrating truths from urgent social issues. Airing from 1971 to 1979, it focused on a working-class family living in Queens, New York, whose patriarch,

Archie Bunker, was narrow-minded, ignorant, enraged—and a loudmouth. Harsh language and racial epithets were his lingua franca as he routinely exposed the utter wrongness of his views and those of everybody in the real world who shared them.

"We grew up watching Archie Bunker," says Smith. "Now we cannot say on our show more than half of the things Archie said in 1972 or '73. We have to be so worried about offending a certain percentage of people. It's frustrating."

The network's Department of Standards and Practices has frequently challenged the writers' creative vices. What results is a process of negotiation, shrewd evasion, razer-thin distinctions and . . .

GAMING THE SYSTEM

"We know basically what they're gonna allow and not allow," says co-showrunner Alec Sulkin. "We can do a joke about the Holocaust, but someone can't be holding a cigarette. You can't say 'Jesus Christ,' unless we're referring to Jesus Christ and he's *there*, animated, which happens on the show. With my voice, by the way."

"You can't show somebody on a toilet taking a crap," says writer David A. Goodman. "You could have someone *sitting* on a toilet"—which *Family Guy* certainly has—"but it has to be *clear* that they're not actually crapping at that moment. And while you can't describe a graphic sexual act, you can use a metaphor: Stewie says, 'What's it like? Throwing a hot dog down a hallway?' We can get away with that, because it could have two meanings."

Says fellow showrunner Rich Appel, "In one scene, Quagmire was singing a song with the word 'pussy' in it." Problem!

"Then we added a cat to the visual." Problem solved. "There are little tricks of the trade."

"We do a lot of violence," says producer Shannon Smith. "But any kind of nudity is very closely scrutinized."

Even exposing too much side-boob can be problematic, she says. Likewise, showing too much *under*-boob or too long a butt crack.

One prevailing policy: *no* Y-boobs. That is, the line that defines a woman character's cleavage should be a short, simple vertical, not a full-fledged "Y" that would suggest a more voluptuous bosom.

"They let us get away with a lot," says voice actor (Cleveland) and former writer Mike Henry. "And if something's *funny*, that goes a long way with them" in approving a joke.

But funny isn't always good enough, as he knows well enough.

"We did an episode set in the future where Meg had had a sex change," Henry recalls. "They would not let us say she'd had an 'addadicktomy.' That was my joke. I really wanted to use it!"

"*My* perspective," says co-executive producer and animation czar Peter Shin, "is to push it over the top to about 200 percent, then have them tell me to tone it down."

He points to an episode from Season 16 where Brian, for once, is trying to woo not a woman, but another dog.

But Ellie isn't just a smart and beautiful canine. She's a dog show champion. And although she is as taken with Brian as he is with her, she is already spoken for: "I have to breed with whichever male dog wins the competition," she tells him.

In an effort to win Ellie for himself, Brian resolves

The solution: viewing Brian from Ellie's perspective as they engage in a poignant conversation. The only visual reminder that a sex act is in progress between Ellie and the unseen Max: This shot of Brian, as seen from Ellie's POV, is rocking rhythmically.

Says Shin, "There are always creative ways to communicate the idea of the joke without sacrificing too much."

If *Family Guy* had ever locked horns with its Standards overseers before, things got especially tough—not just for *Family Guy*, but for everyone in broadcasting—after February 1, 2004. This was the day of Super Bowl XXXVIII, when Janet Jackson's right nipple was unwittingly exposed at the hands of Justin Timberlake in a split-second "wardrobe malfunction" aired live by CBS during the halftime show.

After that Super Bowl mishap, which the media dubbed Nipplegate, the threat of an

to enter the dog show and win it. And he does. He beats out the competition favorite, a boxer named Max.

That means Brian can finally get next to Ellie. But rather than romancing her with wine and soft music, Brian finds himself next to her on an examination table under bright lights and the gaze of dog-show officials there to supervise their coupling.

Understandably, Brian can't make whoopee that way.

It falls to Max, the runner-up, to be the substitute suitor.

Fine. But how would their mating be *depicted* in the episode?

"The network said, 'No! We can't show the boxer mounting Ellie,'" Shin recalls. "We made many attempts at drawing the boxer a little bit further away from Ellie, and then a little bit further than *that*. The network kept saying, 'No, no, no!'"

FCC crackdown on programmers and networks had everyone in the industry on edge. "They were not letting us get away with anything," says writer Mark Hentemann. "Words and phrases we had said in previous episodes suddenly were not acceptable. It was driving everyone crazy. The production process was hurting."

This reign of terror against TV "indecency" inspired *Family Guy* to air a jeering response in November 2005. The episode, "PTV," included a full production number featuring Peter, Brian and Stewie.

The writers also decided to push back in a subtler way. Recalls Hentemann, "We were so exasperated by the words they wouldn't let us say that we decided we would make up a fake swearword and put it in an episode and see if they flagged it."

The test word the writers came up with (as they spelled it in the script) was "kleeman." Before he broke for a commercial, Quahog 5 anchorman Tom Tucker would say, "Coming up: America's hottest new curse word, 'kleeman.' We'll tell you what it means after this."

"Sure enough," says Hentemann, "the script came back from Standards and the word was flagged. And we said, 'Gotcha! You find out anywhere that this word exists and tell us what it means!' They did their research and came up with nothing and they said, 'OK, we'll allow it.'"

The word was duly uttered by Tom Tucker in the episode "Patriot Games," which aired in January 2006.

But the writers weren't satisfied, as Hentemann explains.

"KLEEMAN" RULED TABOO

"Maybe five episodes later we were writing another script, and we said, 'Hey, let's throw 'kleeman' in again, as a fun callback for the fans.' So we put it in the script. Once again, the script comes back and 'kleeman' is censored.

"We said, 'We've already gone through this! The word doesn't exist!' But by then there were several online dictionaries that included the word 'kleeman' [albeit spelled in a variety of ways] with lots of offensive definitions. So we couldn't say 'kleeman' again, even though we invented it and for us, it had zero meaning."

Here was proof, if proof was needed, that what's "acceptable" remains an elusive and ever-moving target. As it always has, *Family Guy* continues to observe that old maxim, "If you're afraid to go too far, you won't go far enough."

"If you're dealing with comedy that skirts the edge and you're trying to navigate where that edge is on a daily basis, you're gonna cross it now and then," says MacFarlane. "When I wrote on the show, there were a few jokes that I look back at and think we probably shouldn't have done. And even now, not writing it but watching it on TV, there are things I see on *Family Guy* and think, 'Yeah, that was probably over the line.'

"But they're not that frequent, and they are a natural by-product of the exploration of comedy. That's part of the discovery process. Comedy survives on the unexpected."

"The sequences on these two pages are good examples of the extreme attention to detail paid to exceptionally gross or awkward moments that *Family Guy* is so well known for," says director Joseph Lee. "We often drag out uncomfortable moments to the extreme and much of the comedy comes from nuances in posing and expression."

"I Am Peter, Hear Me Roar": Written by Chris Sheridan and directed by Monte Young. Storyboard panels by Monte Young.

Dialogue
158 LOIS

Fine, do what you want, I don't care.

"The original storyboard pass did not have the realism we were looking for," says director Joseph Lee, "so Ricky and I decided to close the door and act it out—filming it for reference. Twenty minutes later we knew what we needed to do."

"Mr. and Mrs. Stewie": Written by Gary Janetti, storyboard sequence director Joseph Lee and storyboard panels by Ricky Manginsay.

Dialogue
But I

Dialogue
think

Dialogue
it's very

Dialogue
strange.

Dialogue
159 PETER
(DEFENSIVE) Okay, that's the one thing it's not.

Dialogue
162 QUAGMIRE
(TO PETER, SOFTLY) It's

Dialogue
not strange.

Dialogue
163 PETER
(COMFORTING WHISPER) I know.

Dialogue
164 QUAGMIRE
Alright,

Dialogue
let's

"Stew-Roids": Written by Alec Sulkin and directed by Jerry Langford. Storyboards by Jerry Langford, Shawn Palmer and Annemarie Brown. Character design by Ed Acosta. Color by Kevin Hanley.

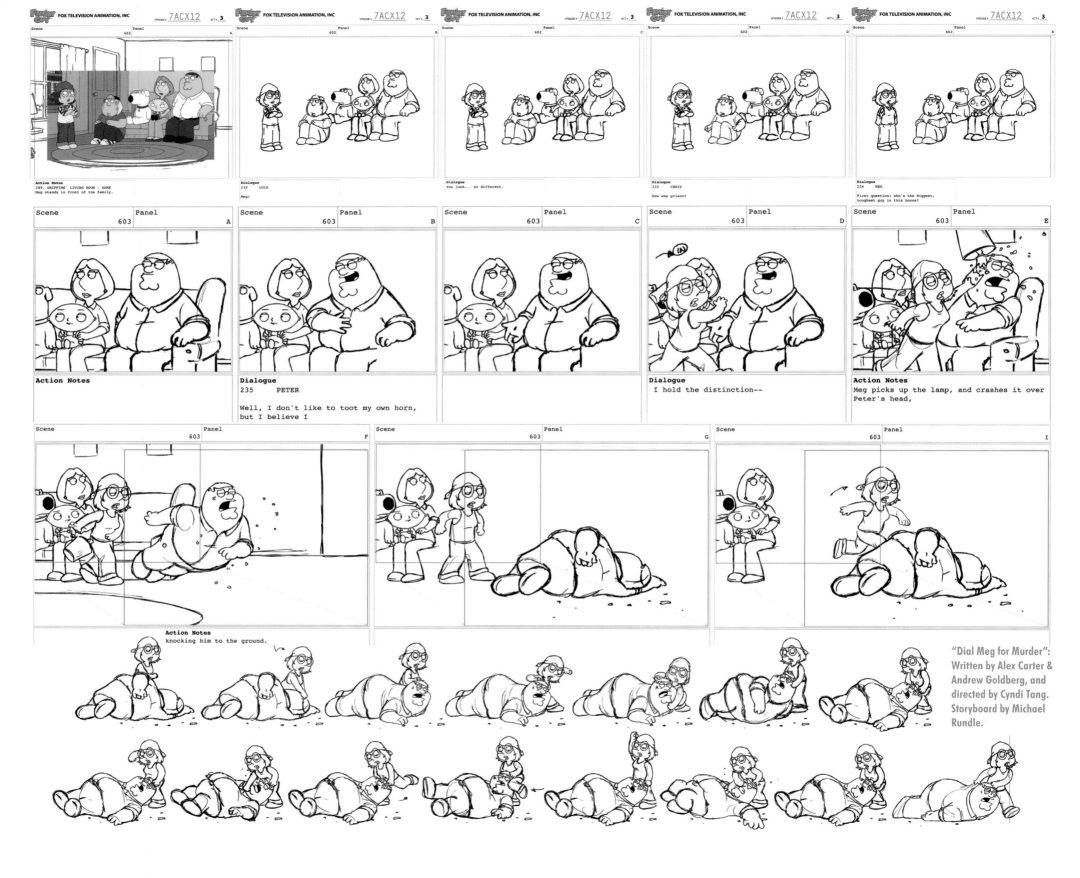

Scene 602 Panel
Scene 602 Panel A
Scene 602 Panel B
Scene 602 Panel C
Scene 602 Panel D
Scene 602 Panel E

Action Notes
INT. GRIFFINS' LIVING ROOM - SAME
Meg stands in front of the family.

Dialogue
232 LOIS

Meg!

Dialogue
You look... so different.

Dialogue
233 CHRIS

How was prison?

Dialogue
234 MEG

First question: who's the biggest,
toughest guy in this house?

Scene 603 Panel A
Scene 603 Panel B
Scene 603 Panel C
Scene 603 Panel D
Scene 603 Panel E

Action Notes

Dialogue
235 PETER

Well, I don't like to toot my own horn,
but I believe I

Dialogue
I hold the distinction--

Action Notes
Meg picks up the lamp, and crashes it over
Peter's head,

Scene 603 Panel F
Scene 603 Panel G
Scene 603 Panel I

Action Notes
knocking him to the ground.

"Dial Meg for Murder":
Written by Alex Carter &
Andrew Goldberg, and
directed by Cyndi Tang.
Storyboard by Michael
Rundle.

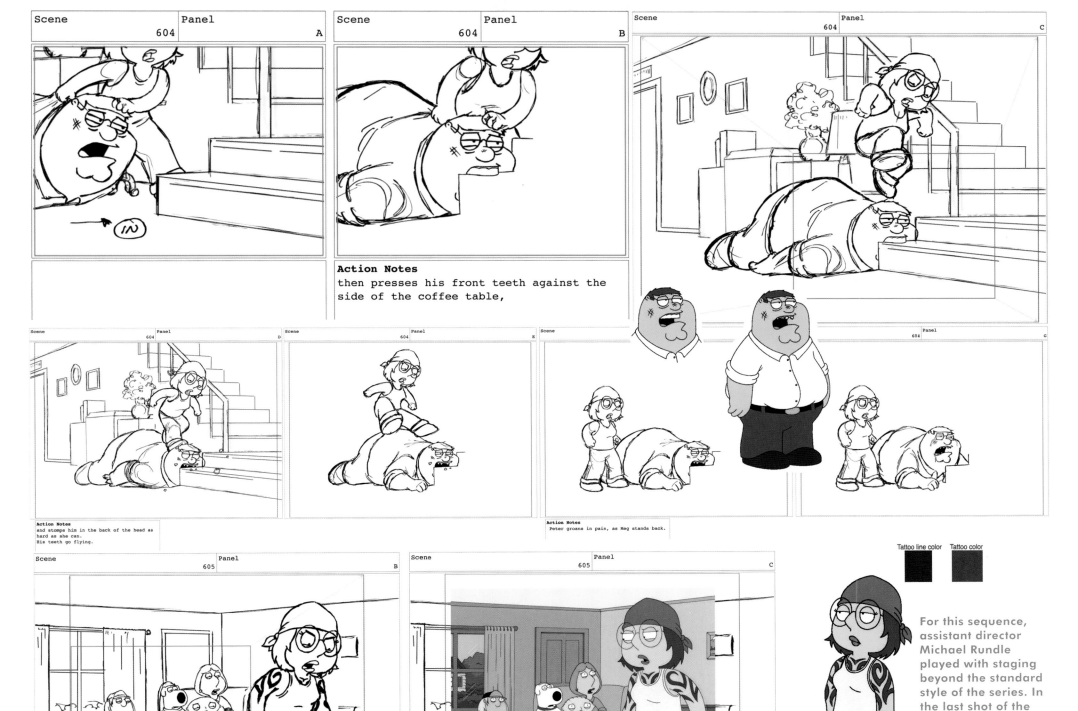

Scene	Panel
604	A

Scene	Panel
604	B

Action Notes
then presses his front teeth against the side of the coffee table,

Scene	Panel
604	C

Scene	Panel
604	D

Scene	Panel
604	E

Scene	Panel
604	G

Action Notes
and stomps him in the back of the head as hard as she can.
His teeth go flying.

Action Notes
Peter groans in pain, as Meg stands back.

Scene	Panel
605	B

Dialogue
236 MEG

My house now, bitch.

Scene	Panel
605	C

Dialogue
Now who's the funniest?

Tattoo line color Tattoo color

For this sequence, assistant director Michael Rundle played with staging beyond the standard style of the series. In the last shot of the sequence, he placed Meg in the extreme foreground and forced the perspective of the living room to emphasize the drama of the moment.

Dialogue
66 PETER

(INTO PHONE) I don't know who you are, I don't know what you want. But I have a very particular lack of skills. I will never be able to find you. But what I do have is two dollars and a Casio wristwatch.

Action Notes
Camera drifts-In slowly as Peter talks and listens on the phone-

Dialogue
66 PETER
You can have one of them.

Assistant director Rick Del Carmen researched present-day and '90s videos (they were cheesier) to get Stewie's dance movements down. Says Del Carmen, "I wanted to make the dancing sway—move his head one way, hands the other—and had a chance to get really into the animation, posing it out in detail on the boards. I even did my own animatic and shared it with John Holmquist and supervising director James Purdum to make sure I got it right."

"Leggo My Meg-O": Written by Brian Scully and directed by John Holmquist. Storyboard panels by assistant director Rick Del Carmen.

Scene 413A	Panel A	Scene 413A	Panel B	Scene 413A	Panel C	Scene 413A	Panel D	Scene 413A	Panel F

Dialogue
233a STEWIE

(TO SOMEONE O.S.) Alright, fellas,

Dialogue
233a STEWIE
bring the lights up a bit, play the CD I gave you,

Dialogue
233a STEWIE
and let's

Dialogue
233a STEWIE
do this!

Action Notes
After a beat, "California Gurls" by Katy Perry starts to play as Stewie launches into a bit of choreographed dancing. We see red lights illuminate in different rooms, indicating bids.

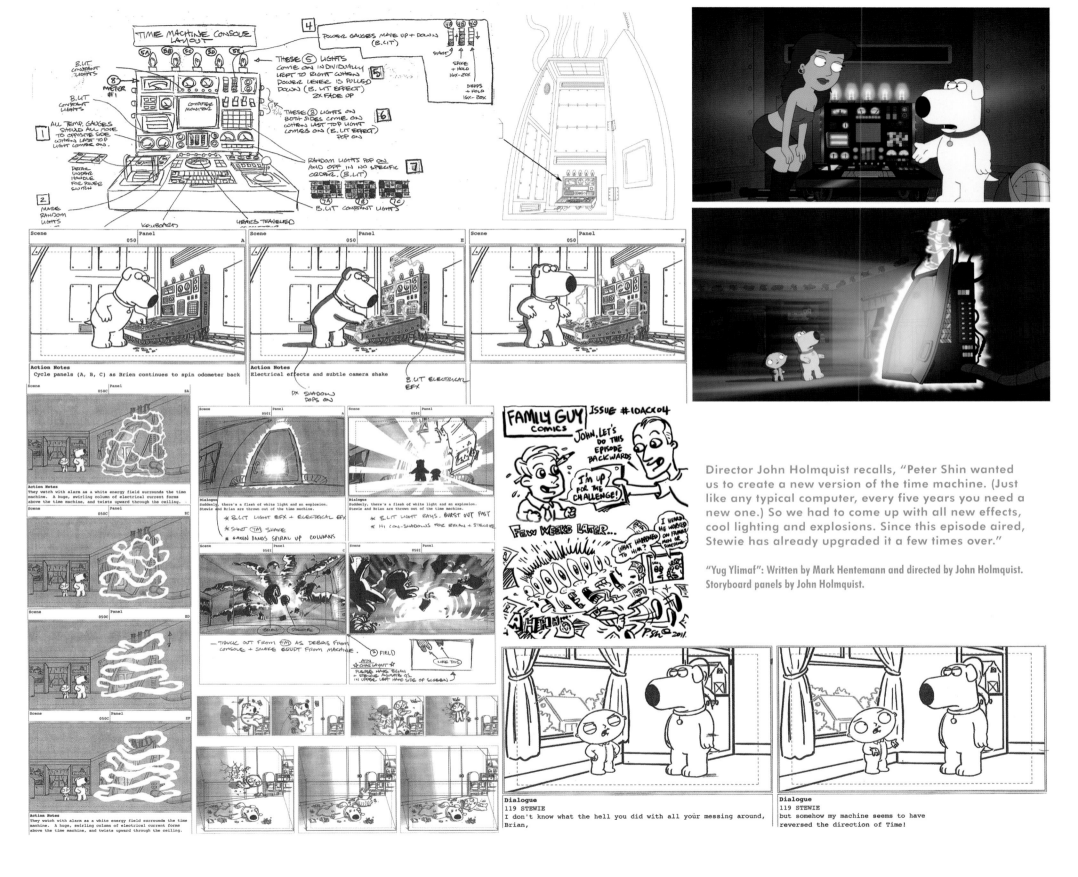

Director John Holmquist recalls, "Peter Shin wanted us to create a new version of the time machine. (Just like any typical computer, every five years you need a new one.) So we had to come up with all new effects, cool lighting and explosions. Since this episode aired, Stewie has already upgraded it a few times over."

"Yug Ylimaf": Written by Mark Hentemann and directed by John Holmquist. Storyboard panels by John Holmquist.

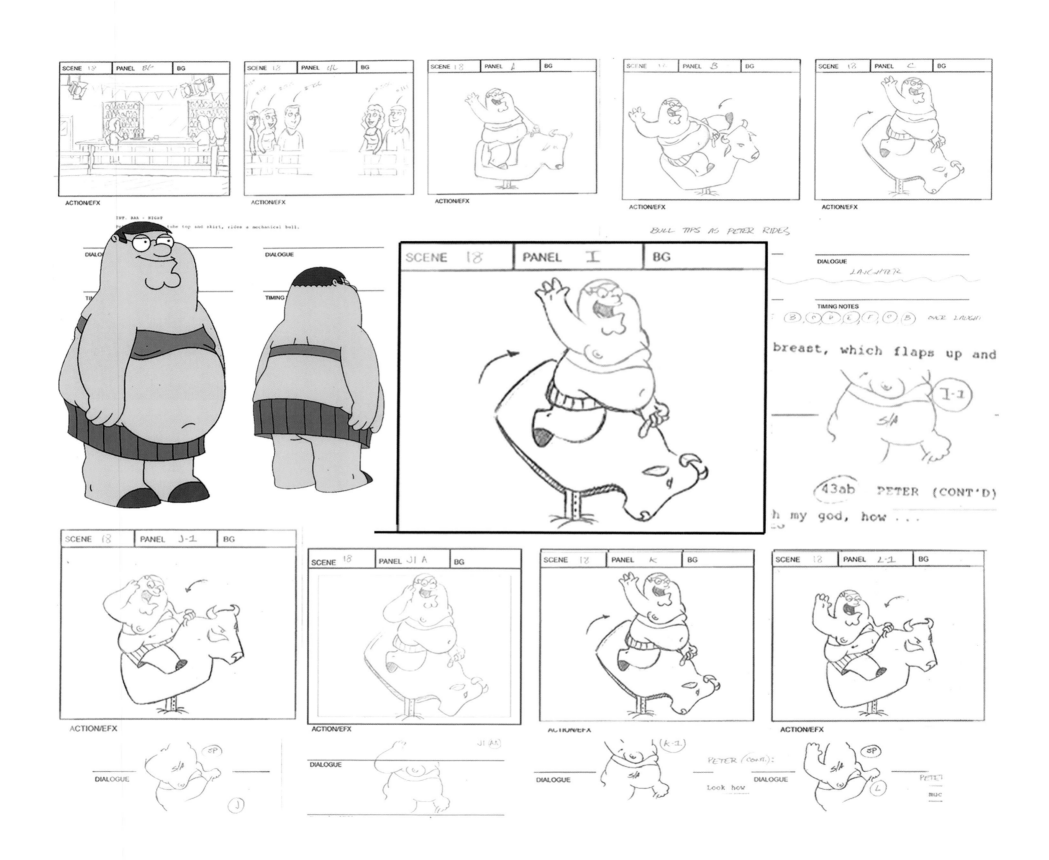

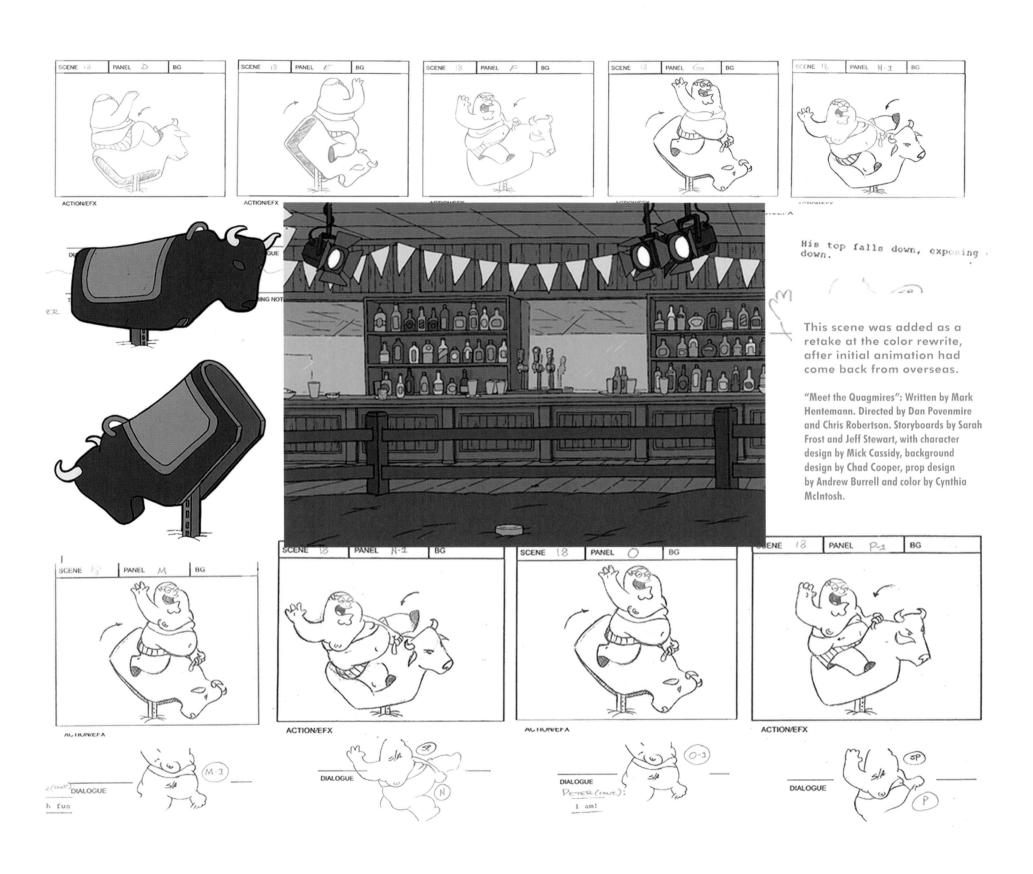

This scene was added as a retake at the color rewrite, after initial animation had come back from overseas.

"Meet the Quagmires": Written by Mark Hentemann. Directed by Dan Povenmire and Chris Robertson. Storyboards by Sarah Frost and Jeff Stewart, with character design by Mick Cassidy, background design by Chad Cooper, prop design by Andrew Burrell and color by Cynthia McIntosh.

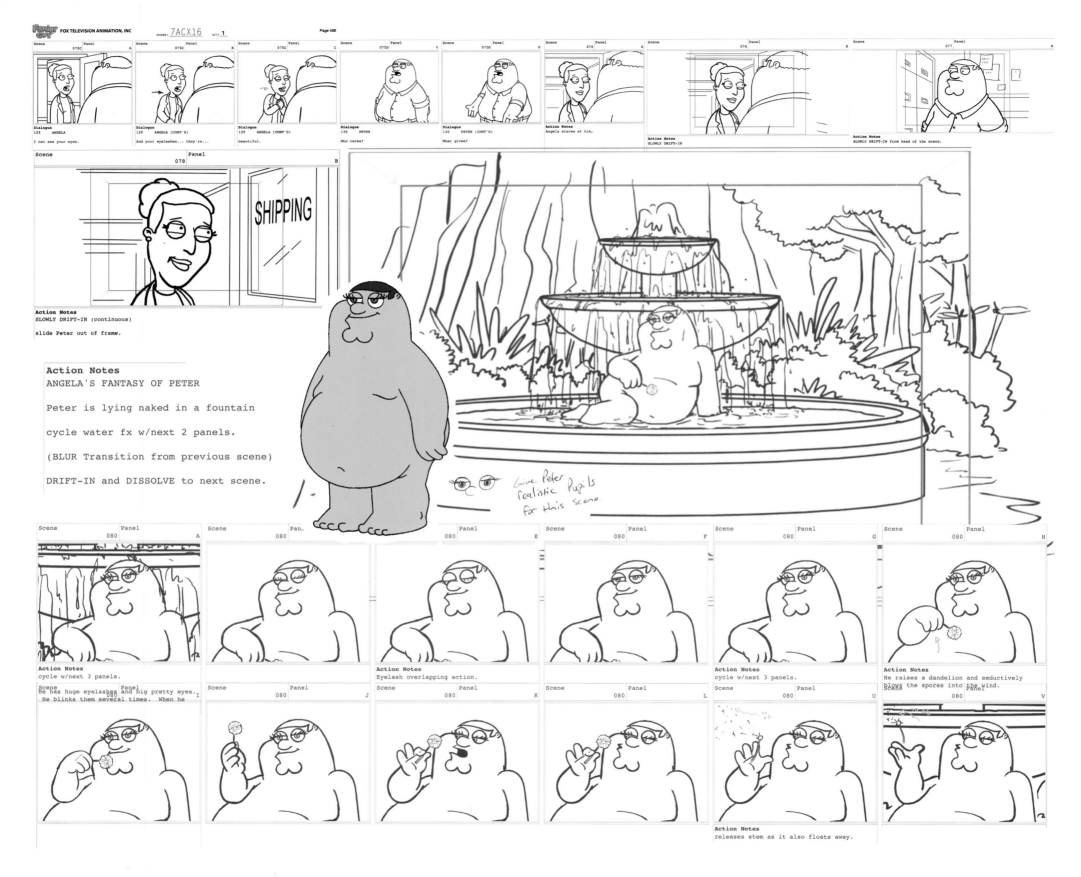

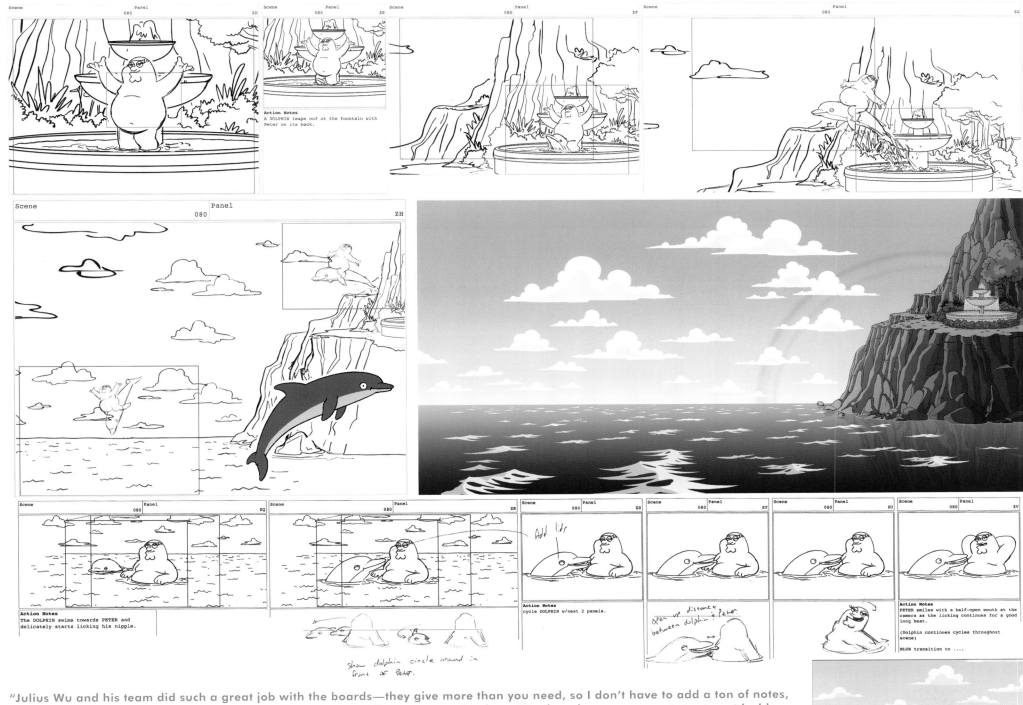

"Julius Wu and his team did such a great job with the boards—they give more than you need, so I don't have to add a ton of notes, but I do try to push some of the drawings," says supervising director James Purdum. "My thought process was to try to get inside Angela's head and show how she envisioned Peter. Thought it would be funny, coming from a male perspective, the idea that she sees Peter with feminine features which make him all the more attractive." By pushing Peter's eyes, Purdum was able to give Peter a more realistic appearance for this daydream fantasy. And if what happens next makes you squirm, you're not alone. "This moment where Peter receives an affectionate lick from the dolphin—it's weird—he's sort of tickling him and Peter throws his head back in a state of euphoria. It's completely over the top and ridiculous. Even a little creepy."

"Peterassment": Written by Chris Sheridan and directed by Julius Wu. Storyboard panels by Julius Wu and John Banh. Background design by Audrey Stedman. Color by Yelena Tokman.

"We hear a flash go off. We FREEZE ON several different PHOTOS of Brian and Stewie flying into frame. Each more disturbing than the last," writes Gary Janetti in his initial writer's draft of the script.

After researching awkward pregnancy photos, the team tried to re-create those "disturbing" moments with characters Brian and Stewie. "We wanted to make them as corny as we could," says storyboard artist Annemarie Brown. "Director Steve Robertson gave me these sequences to work on since I was actually pregnant at the time and thought I might have some insight." But drawing Stewie and Brian close together might not be as easy as one might think. "Their arms are so short—Stewie's head shape and Brian's long nose make it difficult to put them together in poses two adult humans would naturally be in."

"Stewie Is Enciente": Written by Gary Janetti and directed by Steve Robertson. Art by Annemarie Brown, Raul Guerra, Mick Cassidy and Peter Shin. Color by Michael Kinkade.

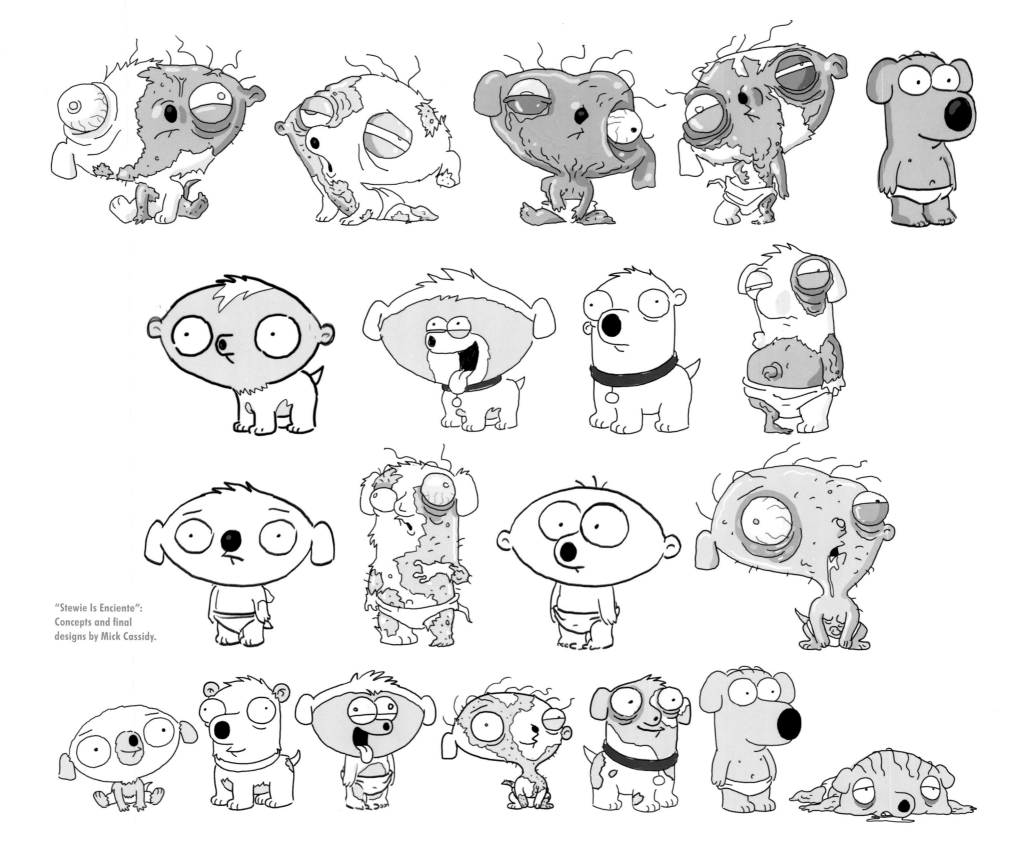

"Stewie Is Enciente":
Concepts and final
designs by Mick Cassidy.

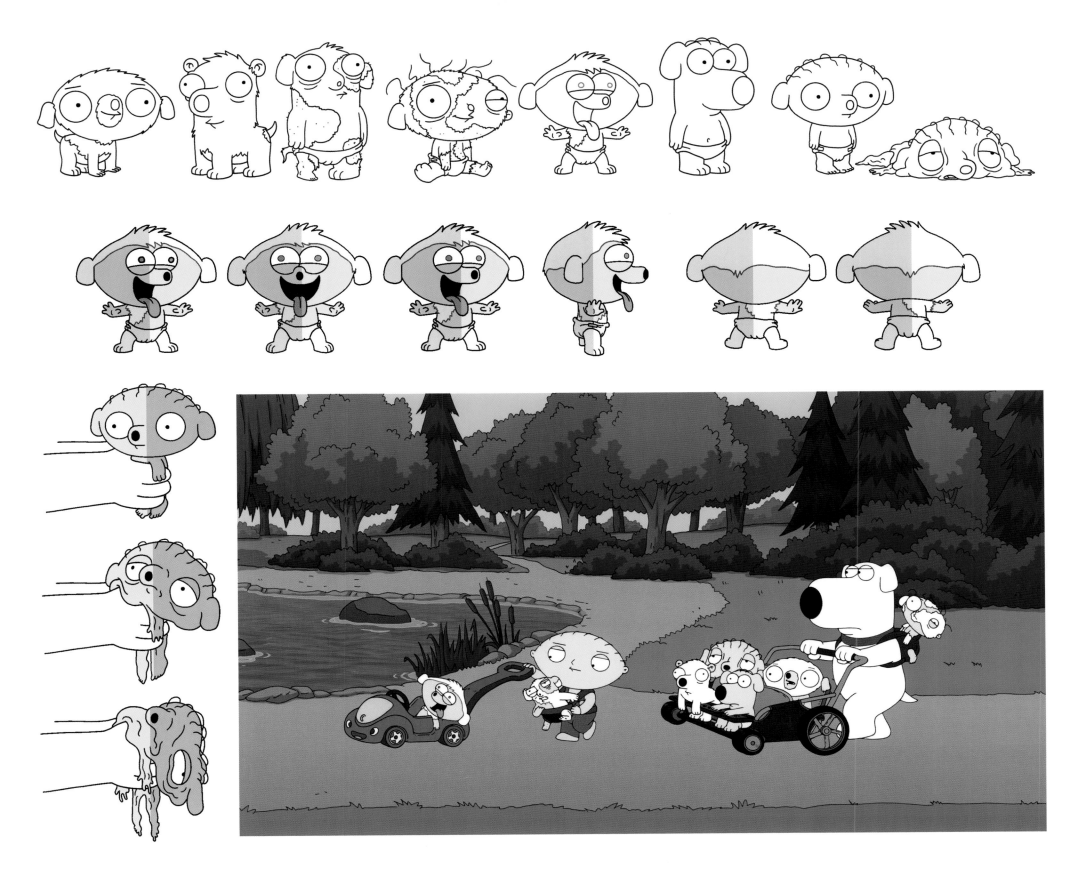

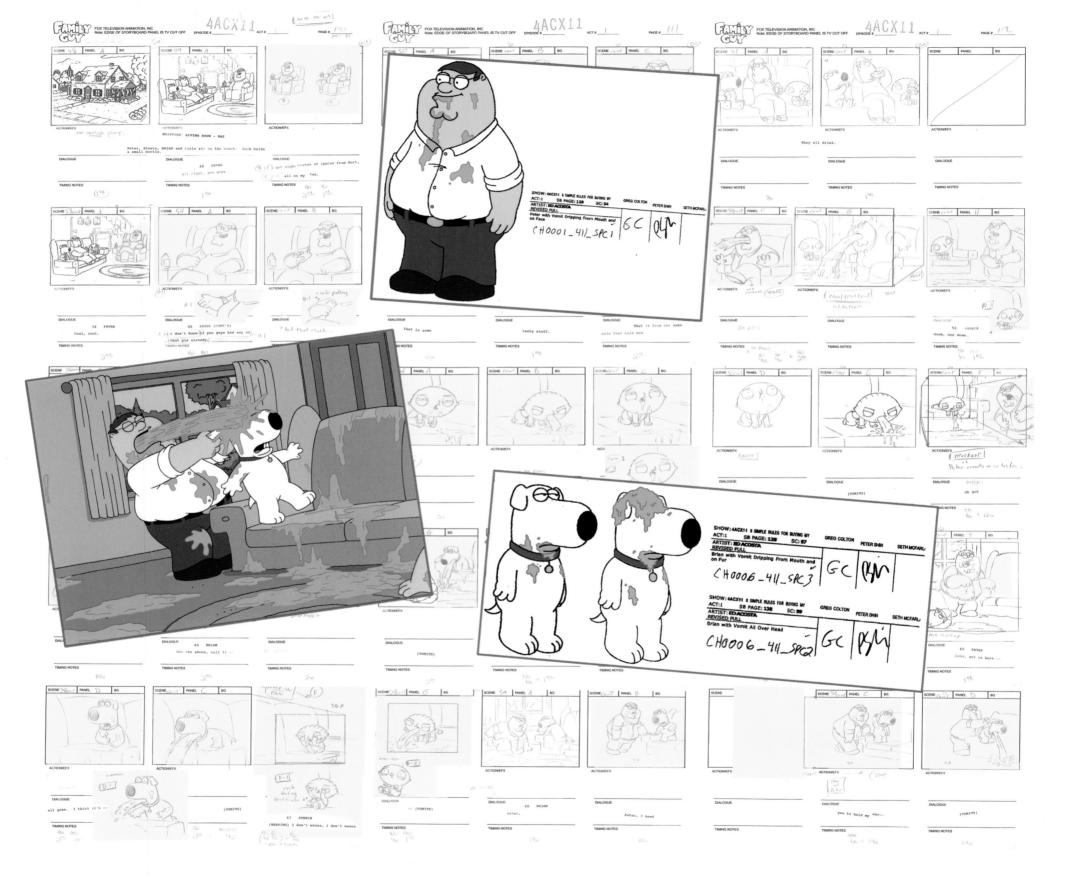

This was the first episode Colton directed, and he approached this sequence as if it were a puzzle. Colton says, "I had certain imagery in my head—the end scene—so I knew what I needed to get to. Sometimes you have better results if you don't work in order. Know where your joke needs to go and work backwards from there.

"For example, Peter started in the chair but needed to work his way over to Brian on the couch, therefore Peter barfs himself back against the wall, which puts him in a position where he can hold on to Brian's ears."

Don't try this at home, folks.

"8 Simple Rules for Buying My Teenage Daughter":
Written by Patrick Meighan and directed by Greg Colton.
Storyboard panels by Greg Colton.

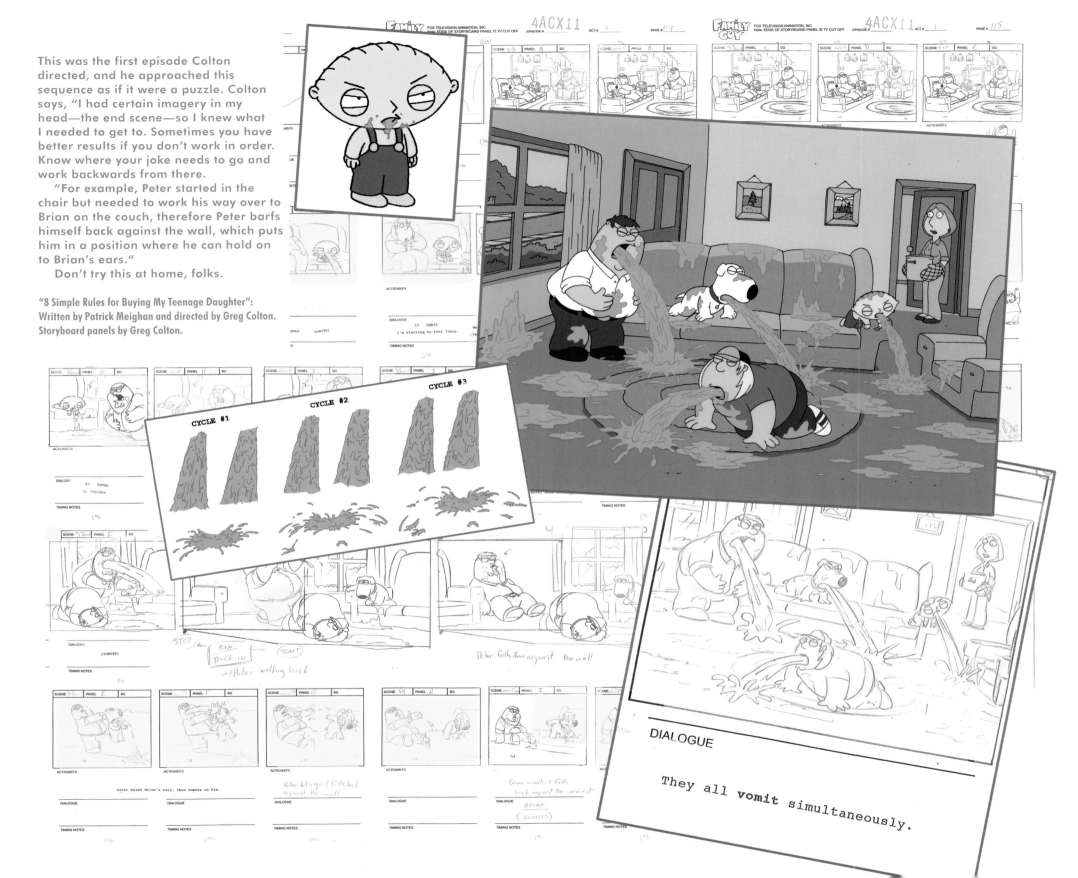

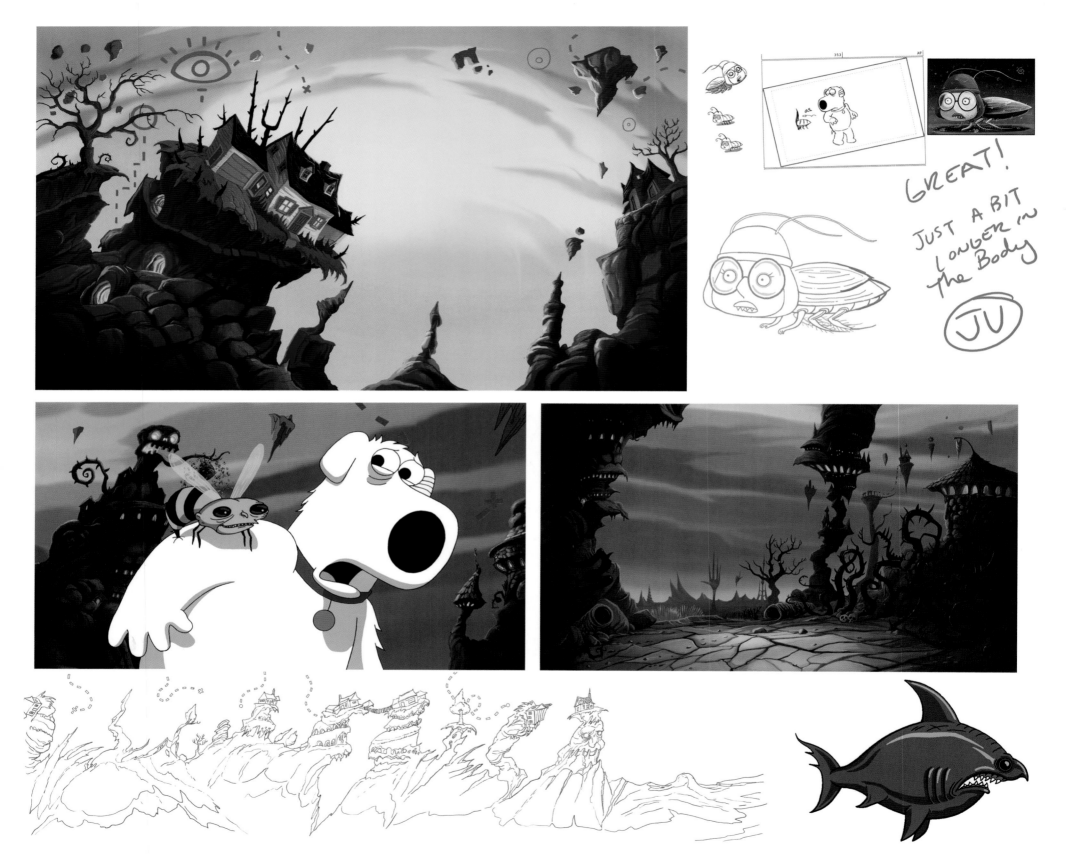

GREAT!
JUST A BIT
LONGER IN
THE BODY
JU

Joe Vaux was unaware a sequence that focused on his personal art style would be an element in the show until the table read. Writer Wellesley Wild scripted Brian Griffin on a mushroom trip and told Joe everything in the script for that moment was filler. Having seen Joe's art at an annual studio exhibit, "he just wanted me to do my thing," says Vaux. "I was given a six minute window [the scene would later be cut down to approximately three] and was left alone to build on the sequence and get to a point where Brian would snap out of his trip."

"Seahorse Seashell Party": Written by Wellesley Wild and directed by Brian Iles.

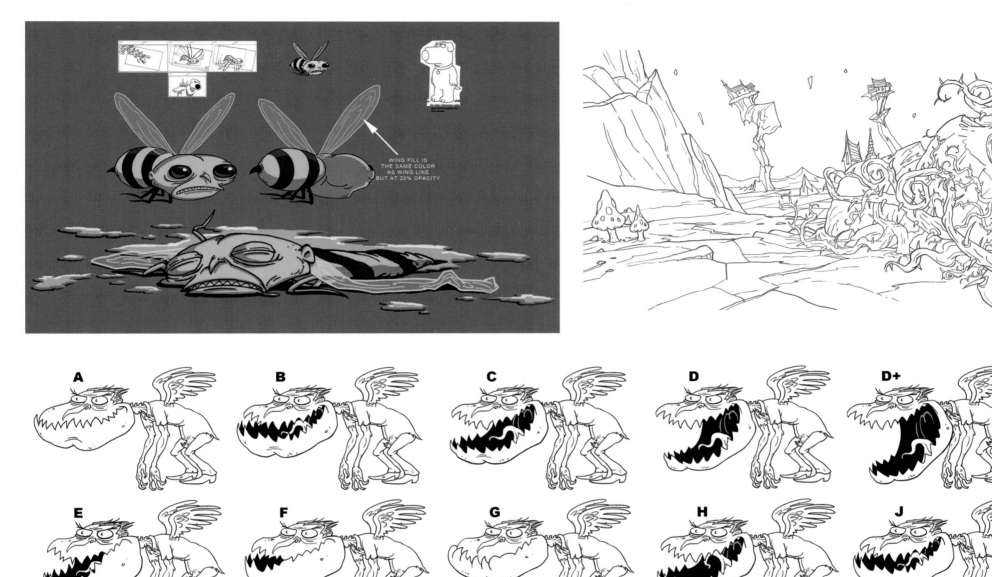

WING FILL IS
THE SAME COLOR
AS WING LINE
BUT AT 20% OPACITY

A B C D D+

E F G H J

MacFarlane and Shin wanted this to look like a serious fight and therefore had certain panels revised so that it felt like a choreographed sequence. Everything had to be realistic.

"Patriot Games": Written by Mike Henry and directed by Cyndi Tang. Storyboard scene by Cyndi Tang, Pete Michels and Peter Shin.

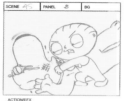
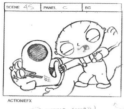
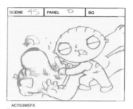
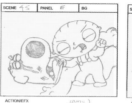
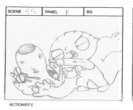
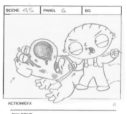
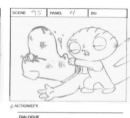
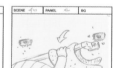

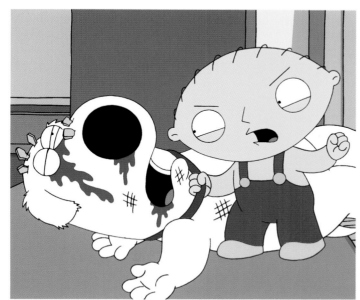

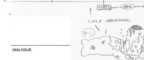

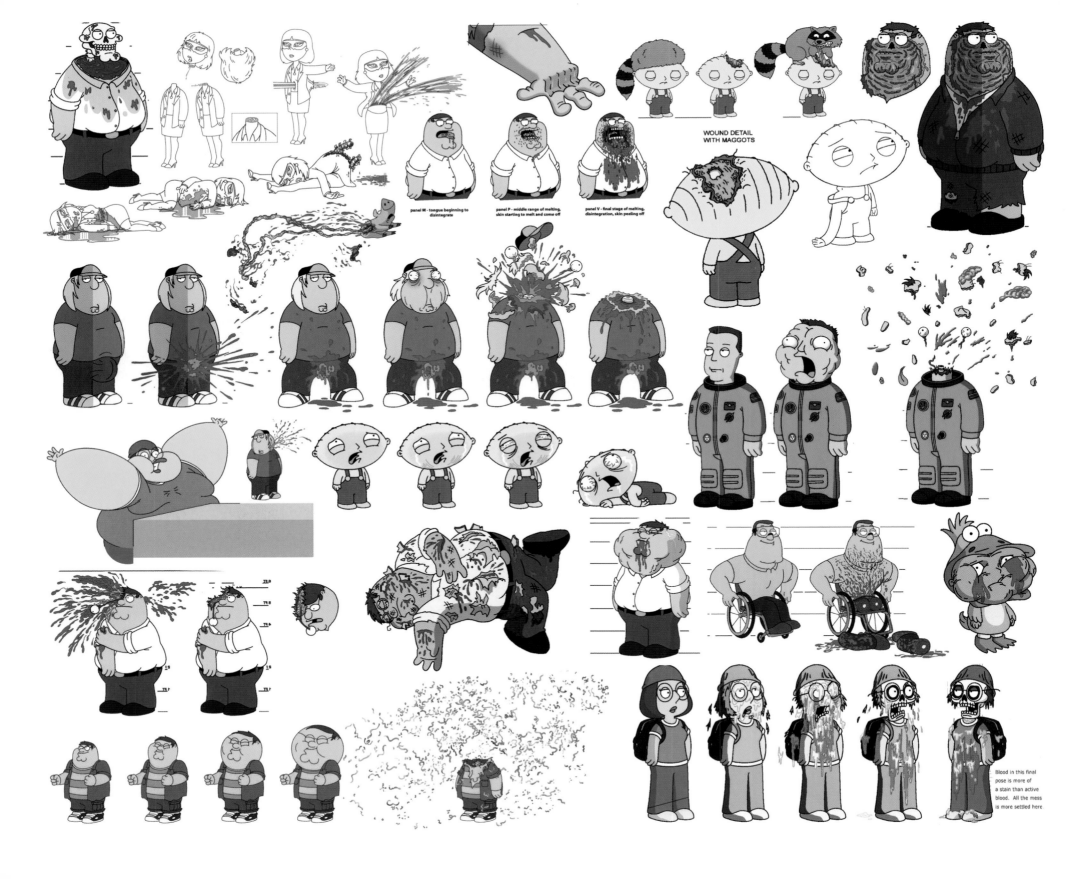

WOUND DETAIL
WITH MAGGOTS

panel M - tongue beginning to
disintegrate

panel P - middle range of melting,
skin starting to melt and come off

panel V - final stage of melting,
disintegration, skin peeling off

Blood in this final
pose is more of
a stain than active
blood. All the mess
is more settled here

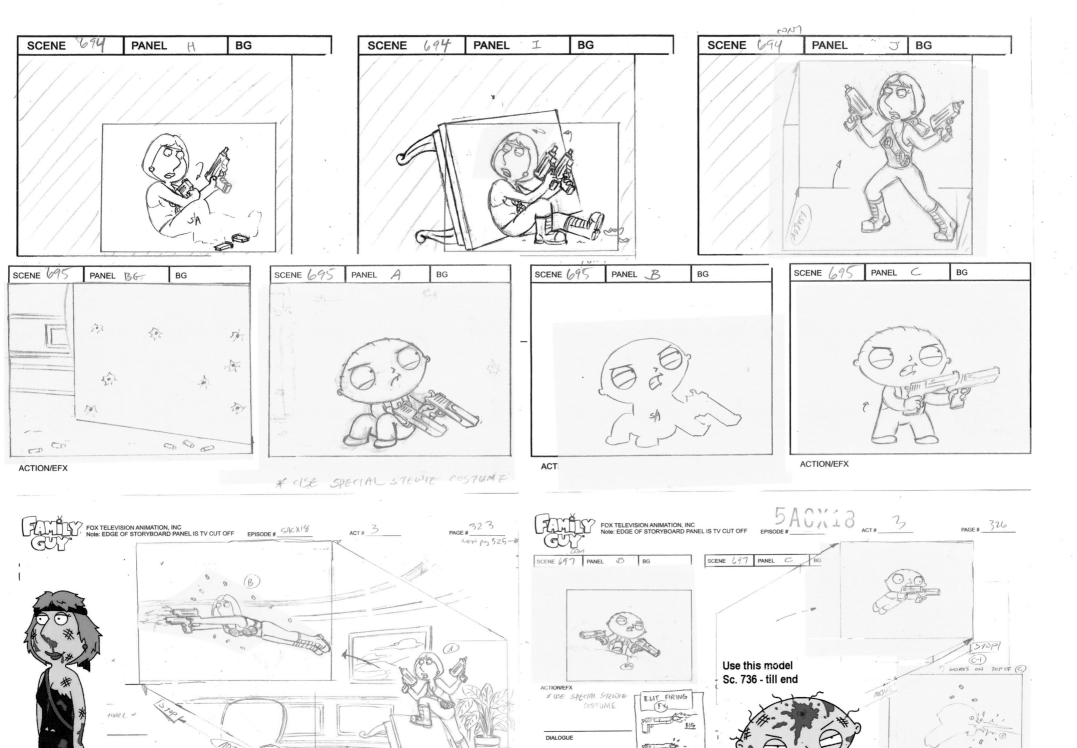

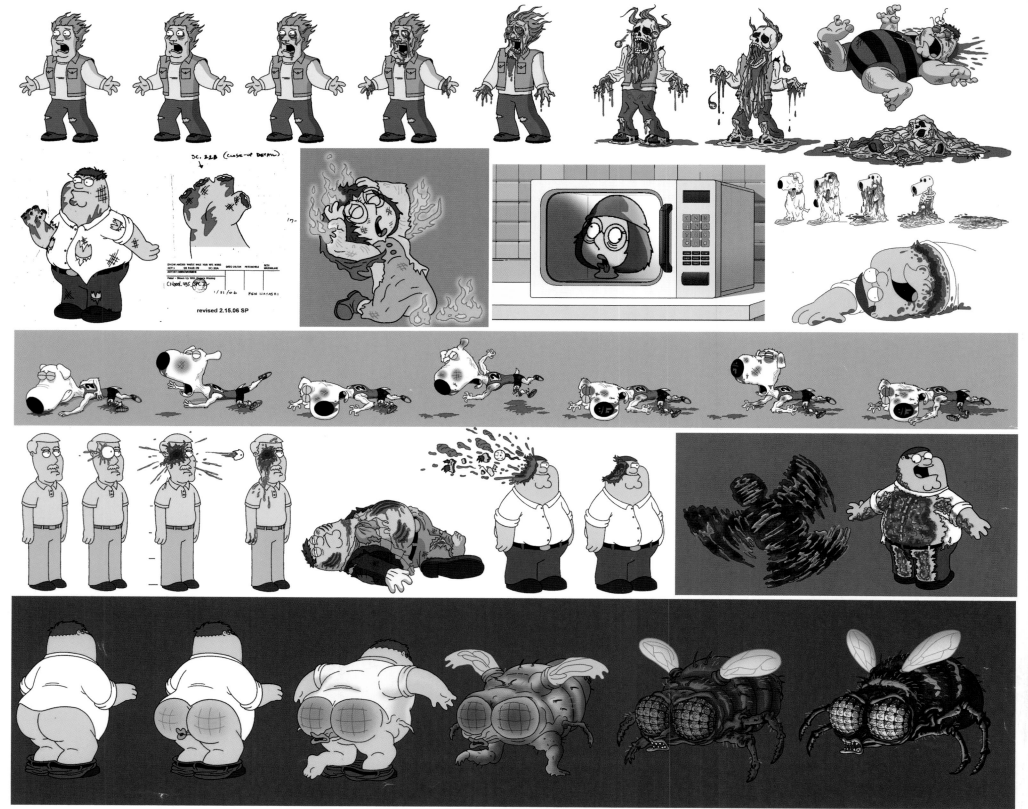

Terrible things happen to *Family Guy* characters. A lot. Whenever a story calls for something horrific, an artist has to draw exactly how it should look—down to the gory details.

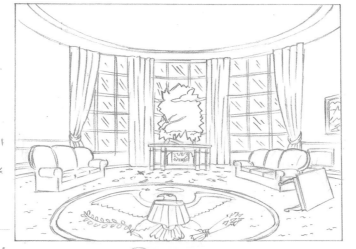

* USE SPECIAL COSTUME

GUY™ FOX TELEVISION ANIMATION, INC. Note: EDGE OF STORYBOARD PANEL IS TV CUT OFF EPISODE # _____ ACT # _____ PAGE # _____

5ACX18 3 332

GUY™ FOX TELEVISION ANIMATION, INC. Note: EDGE OF STORYBOARD PANEL IS TV CUT OFF EPISODE # _____ ACT # 3 PAGE # 332

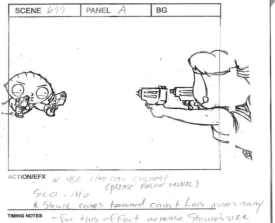
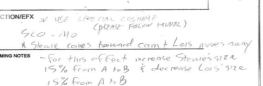

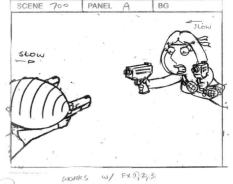

SCENE 699	PANEL BG	BG
SCENE 699	PANEL A	BG
SCENE 700	PANEL BG	BG
SCENE 700	PANEL A	BG

ACTION/EFX BG ONLY

ACTION/EFX * USE SPECIAL COSTUME (PLEASE FOLLOW MODEL)
SLO-MO
* Stewie comes toward cam & Lois moves away
TIMING NOTES
- For this effect increase Stewie's size 15% from A to B & decrease Lois' size 15% from A to B

ACTION/EFX BG ONLY
TIMING NOTES 204 slow 95%

ACTION/EFX WORKS W/ FX (1)(2)(3)
SLO-MO * USE SPECIAL COSTUME (PLEASE FOLLOW MODEL)
TIMING NOTES
* Stewie moves away from camera + Lois moves towards
- For this effect decrease Stewie's size 15% from A to B, & increase Lois' size 15% from A to B

As written in the script, this particular scene was just three short sentences: "Lois charges Stewie, who fights back easily. The two of them engage in a heated battle combining hand-to-hand combat and weapon use. Lois gets the upper hand and draws her gun on him." Two hundred and fifty pages of storyboard later, you have an incredible fight sequence between mother and child.

"I watch action movies so I didn't have to do any research," says Young Baek, assistant director on this episode. "For initial boarding, I was responsible for a whole act, and everything wrapped up with this scene. I stayed here late a *lot*."

And Baek was able to plan just how this fight would play out. "I wanted to start the battle with a big gun, then get more personal with hands. The fist fight escalated from there—eventually it's a knife, then flamethrower, and the whole thing ends with a grenade."

Larger panels were used to accommodate more dynamic camera moves. "Back when we worked with pencil on paper it took a little longer," Baek adds. "For a simple expression fix [changing the eyes or mouth], you had to redraw the character and position/register it correctly. Now you can cut and paste in the computer."

"Lois Kills Stewie": Written by Steve Callaghan and directed by Greg Colton. Storyboard sequence by Young Baek.

LOOKING FORWARD

In an episode of *Family Guy* that first aired in 2010, Stewie and Brian take a trip back to the past. Stewie had offered to help when hearing Brian speak fondly of a lost tennis ball he wanted to retrieve from where it had been buried in the yard long ago. Brian had forgotten exactly where he buried it, though he remembered the date: January 31, 1999 (by chance, the airdate for the *Family Guy* premiere).

Escorting Brian to his bedroom, Stewie enters the date in the time machine he kept there. In a flash, the two of them are whisked back in time.

"That's the spot," says Brian, pointing to the freshly filled-in hole in the yard, once he and Stewie land in 1999.

Stewie cautions him, "You can't dig it up *here*. Just make a mental note of where you buried it. And as soon as we're back in the present, you can dig it up then."

"Why?"

"There's *one* rule of time travel," Stewie says—"Do not alter the past in any way, or the consequences could be dire."

"Yeah? Where'd you hear that?" asks Brian, to which Stewie replies, "*Quantum Leap.*"

But the episode, aptly titled "Back to the Pilot," soon finds the two of them breaking that rule, and with very dire consequences: Numerous versions of Stewie and Brian begin popping up not just from the future but from the *further-further* future, too, after Brian, submitting to temptation, makes an ill-fated effort to rewrite history by preventing 9/11.

The episode is a zany goof on a shopworn sci-fi narrative. But more than that, it gave *Family Guy* a chance to take stock. To look back on the distance the series had travelled in its first decade. And since this, after all, was *Family Guy*, to poke fun even at itself and its beginnings.

For instance, peeking in through the Griffins' kitchen

When present-day Stewie and Brian time travel back to the pilot episode, footage was animated in the original 4:3 aspect ratio instead of the current 16:9. Black bars were applied to the sides for these scenes.

window on a scene unfolding from the pilot episode, the time-travelling Stewie and Brian take verbal swipes at the less polished look and feel of the pilot.

"My God, what's with Meg's voice?" Stewie says to Brian as they overhear Meg begging Lois to pay for collagen injections for her lips. "She sounds like someone who's about to give up a huge opportunity," Stewie says in a veiled reference to actress Lacey Chabert, who, after having voiced Meg for that first season, left

the series, relinquishing the role to Mila Kunis, who still plays her.

"That's nothing! Look at *you*," Brian says to Stewie, noting that Stewie as he looked in 1999 resembles "a prize at some Mexican church carnival."

"Back to the Pilot" was written by Mark Hentemann, who says the episode set out to lay bare "all those awkward pilot moments that, by Season 10, we were happy to leave behind. But it was fun to go back and shine a

light on all those things that were awkward, things that, hopefully, the fans had forgotten about."

In particular, current-day Brian and Stewie take great glee in pointing out a certain animation glitch in the pilot episode that only the most vigilant fan (along with Hentemann and Company) would ever have noticed.

"Ewww, I remember *this*," says Stewie as he observes Peter talking to Lois. "Peter's eye does that weird, creepy thing where it goes

By 2011 the look of the show was markedly improved. The outlines lining the characters were more precise and crisper (the move from pen-and-paper to drawing on a computer screen, which happened around 2008, will do that). If you compare the early episodes to those a few years later, you will note that the slightly ragged clapboard exterior of the Griffin homestead back then (which in "Back to the Pilot" prompted present-day Brian to say, "That's odd: That's our house, but somehow it looks a little different") had gained a sharper, cleaner look.

GRIFFINS GOING WIDE

The most notable change came in 2010, when the show upgraded to digital high-def and a widescreen format (the widescreen 16:9 format most shows were switching to from analog video's traditional, boxy 4:3 ratio).

Family Guy made sport of its digital transformation in an episode that fall.

"What's wrong with the TV?" Chris exclaims to the rest of the family in the living room.

"*All* the shows are in widescreen now," Brian explains, "so you can see all the stuff on the sides you *couldn't* before."

He illustrates this breakthrough with the show they happen to be watching, *The Brady Bunch*: When parents Mike and Carol wish each other good night, all you could see on old-fashioned TVs was the two of them in bed. But now, suddenly in sight thanks to widescreen TV, are

over his nose." And for a couple of seconds, his eye does just that. "Ewww," cringes Stewie. "Gross! *Look* at that!"

Then they spy on Peter as he heads off to a stag party.

Stewie sneers at the scene in a neighbor's living room where the guys chug beer and watch TV. "The TV isn't even plugged in," Stewie scoffs.

He's right. An electric cord from the TV plugged into a wall outlet is a detail the animators somehow forgot to include. Mocking its own former self, "Back to the Pilot" ends

with the 1999 version of Peter and his chums taking over the present-day Griffin living room as Former Peter proposes, "Let's *unplug* the TV and watch a movie."

"There were so many things in the pilot, like the TV not being plugged in, that we couldn't afford to fix," recalls David Zuckerman. "And they were still sticking in Seth's craw.

"But believe it or not, we did fix a *lot* of things back then. I think Seth and I actually paid for some of the retakes ourselves, because Fox wouldn't pony up for some of the things they didn't feel were essential."

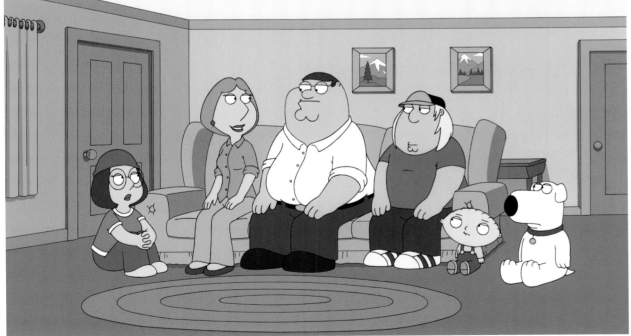

Above: From 2009 when the show was still 4:3. *Below:* Pulled from a 16:9-format episode.

a half-dozen brawny black men in their skivvies flanking Mike and Carol in the sack.

While *Family Guy* producers didn't have to relearn lighting and makeup techniques for the hi-def age, as did their counterparts making live-action TV with live-action humans, the animation process, especially the way *Family Guy* does it, presented its own challenges.

"One of our favorite gags is a quick pullout to reveal something," says producer Shannon Smith. But with the new widescreen format, "it's much harder to do that: to have a single shot of Peter, for instance, then pull out to reveal something standing beside him. You don't want to have to put what you're revealing too far away, but it has to be out of the single shot.

"When we were 4:3, Seth really liked having everything really centered in a shot," she says. "We were used to composing people where they stood really close together to fit into that little square, and now they had more horizontal space. But when you're in a 16:9 aspect ratio, there's a lot more dead space. So we started offsetting our characters into complementary angles, which we hadn't done before.

"But it made the living-room couch shot a lot easier," she adds brightly, "since it was wider."

(Also, it was all the more convenient to display the sprawling on-screen credit for writer Cherry Chevapravatdumrong, which was employed as a visual gag in an 11th-season episode when Peter, breaking the show's fourth wall, rearranged the on-screen letters of her formidable surname to read "CHEMOTHERAPY VANGUARD VCR" with one "R" left over, which he hurled at Lois when she pointed that out.)

All of that was a big adjustment, sure. But it

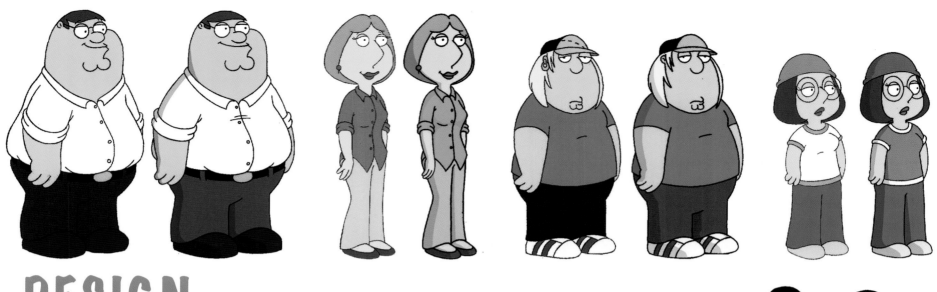

DESIGN EVOLUTION

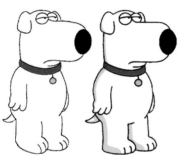

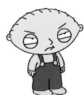

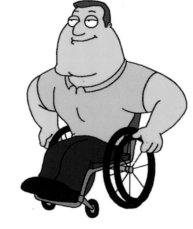

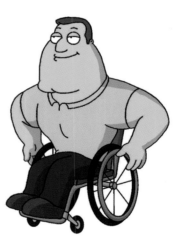

Like all good cartoons, the Griffins don't age, but they have evolved over twenty years of being on TV. The show's designs and style have been subtly updated over time—some of the changes address animation issues, while others have to do with the transition to HD, where a greater attention to detail is required.

SHOW#1ACX-02

FINAL

SHOW#1ACX-02

PAWTUCKET PATRIOT ALE

Co-Executive Producer
Chemotherapy vangu......er

veteran writer and current co-showrunner Alec Sulkin. "We've kept so much of the same production team and writers and animators in place.

"To his credit, Seth knew that he had a really talented staff and they understood the voice of the characters and the tone of the show, but he could still always weigh in and say, 'Change this.' We were very happy that he had confidence in us.

"And the snacks all stayed the same," Sulkin adds.

WONDERING WWSD?

"We had been mentally preparing for it for a while," says Shannon Smith. "But it was nerve-racking. "When he left, I had these jelly bracelets made up for everybody: 'WWSD?' What Would Seth Do?

"We would send the animatic or the color screenings for his approval, and while we were waiting, we would think, 'We know he's going to see something [to adjust]—but *what*?'

"But everyone had a pretty good idea of his sensibilities. Seth had always been really particular about the shot language and the timing of the episodes. There are hundreds of artists working on every episode, and their fingerprints are all over it. But they are all coming at it using storytelling techniques that are from our vocabulary"—a vocabulary MacFarlane had forged years before.

was nothing like the leadership upheaval facing *Family Guy* around the same time: the end of MacFarlane's day-to-day hands-on involvement in the show. For a decade he had been solely, even obsessively, focused on the *Family Guy* world. But by Season 9, he was looking to redeploy his energies into other projects, notably his first film, *Ted*.

"That began to occur when I was one of the showrunners," says Steve Callaghan, who was partnered with Hentemann to helm the show around that time. "Seth began to express interest in going beyond *Family Guy*."

"Part of the reason that Seth needed to break away is, too much of the show was funneling through him," says Hentemann. "It put a ton of pressure on him. We had to develop a system by which Seth could be involved in the show

in a creative way, but could free up his time somewhat so he could be involved in other things."

This led to a revamped system where, for each script, different touchpoints were designated along the way where MacFarlane could weigh in with creative notes or direction: the outline stage, a first draft, "or when he'd get into the recording booth and say, 'Maybe we need a different joke here.' He was still very involved through the life span of every script," says Callaghan, "and since the process takes so long, there were many opportunities to weigh in as each script made its way through the pipeline."

It was quite a change from his former omnipresence.

"But a lot of things didn't change," says

Along the way, MacFarlane recorded three vocal albums, delivering the pop standards he adores while invoking the heyday of Sinatra with his rich baritone. The third of those releases came christened with perhaps the most bittersweet, evocative title of all time: *No One Ever Tells You*.

And in 2013, he made perhaps his biggest play for on-screen, mainstream, everyone-will-know-his-name-and-face-from-now-on prominence: He hosted the 85th Annual Academy Awards. But as if that weren't enough, he was also on hand as a nominee in the Best Original Song category for co-writing (with *Family Guy* music director Walter Murphy) the theme song "Everybody Needs a Best Friend" from *Ted*.

It didn't win. But the song best *remembered* from the Oscars telecast was performed by MacFarlane in his opening routine. "We Saw Your Boobs" was a musical number prompting him to call out actresses present in the hall and the movies in which they had exposed their bare breasts.

The song, and MacFarlane's Oscars performance overall, burnished the bad-boy image still being reinforced week after week on *Family Guy* even now, years past his official departure, thanks simply to his name still flashing on the screen in the show's credits. He drew fire from a number of critics, including *The New Yorker*'s Amy Davidson Sorkin, who slammed the "crudely sexist antics led by a scrubby, self-satisfied" host.

Scrubby? Self-satisfied?

Although MacFarlane's withdrawal from his *Family Guy* involvement is remembered by some as an incremental process, he puts it in starker terms.

"I hadn't written on the show since 2010," he has said. "Doing *Ted* was cutting the umbilical cord. When I left to do *Ted,* I left cold turkey. Up to that time I was running *Family Guy* 150 percent, and that went to zero when I left. I only like to work on one thing at a time. I want to put all my passion into one project."

As his new chosen project for his Fuzzy Door Productions, *Ted* would be MacFarlane's debut directing a live-action film, for which he also served as writer, producer and performed in the title role of a spunky, smart-mouthed teddy bear that comes to life. Released in 2012, this stuffed-bear romp also starred Mark Wahlberg and *Family Guy* veteran Kunis. It proved to be a big hit and spawned a MacFarlane-helmed sequel, *Ted 2,* released in 2015.

In between the *Ted*s, he was director and co-writer (with *Family Guy* comrades Sulkin and Wellesley Wild) of the live-action cowboy spoof *A Million Ways to Die in the West*. This also was his film debut as an on-screen leading man, a big step for him coming several years after he was quoted as saying, "I periodically get offers for acting, but I dance round it with a kind of trepidation. I'll probably take a stab at it at some time."

He also co-produced *Cosmos: A Spacetime Odyssey*, a 13-part update of the 1980 PBS series hosted by Carl Sagan. The new series aired on both Fox and the National Geographic Channel.

"Stewie Kills Lois"

Production Number 5ACX17

Crew and studio art used to celebrate *Family Guy*'s milestone episodes.

"Yug Ylimaf"

Production Number AACX04

Rough sketches evolve into final line work for these Comic-Con promotional posters.

Art by Julius Preite, Mick Cassidy, Kevin Segna and Kersti Myrberg.

WHAT IS THE SECRET TO FAMILY GUY?

What is the secret to *Family Guy*?

In addressing that issue, Sulkin mentions a long-running, much-awarded TV comedy he prefers not to identify in print, for obvious reasons: "I've always described that show as 'smart comedy for stupid people,'" he says. "In contrast, I believe that *Family Guy* is stupid comedy for smart people.

"Yes, we do fart jokes and extended scenes of people throwing up, and crude jokes about sexuality—but I also believe that some of the smartest bits I have ever heard come out of our writers room.

"It happens a lot, where I will be thinking, 'OK, there are two or three jokes in the show this week that no one else would ever tell.' Everybody is going to laugh at someone farting for 15 seconds, but *Family Guy* is also a place where smart people can say, '*I* get that, and I wonder how many *other* people do.' I think we balance it all out pretty well."

"I grew up watching Monty Python," adds Danny Smith. "If *they* wanted to do something, they would just *do* it."

The result for audiences of *Monty Python's Flying Circus*—its TV shows, its films, its comedy recordings—was a population split into two categories: those who loved (and will always love) this British comedy troupe still spoken of in awe and reverence by its disciples . . . and those who dismissed those six blokes as some unholy blend of incomprehensible, tedious, infantile, tasteless and just plain unfunny.

Family Guy is quite a different animal, and decades removed from Python at its height.

But Python's incorrigible brand of insanity can be felt in *Family Guy,* along with other comedy influences including Bugs Bunny cartoons, *Rocky and Bullwinkle, All in the Family* and, yes, *The Simpsons*.

And it seems to trigger either of two hard-and-fast responses:

Adoration.

Or contempt, particularly from *Family Guy* detractors who accuse it of promoting the idiocy that defines it.

"We do the opposite," MacFarlane insists. "At no point have we ever put up Peter Griffin as a model of what a person should be. *Family Guy* has taken a lot of guff for making fun of a lot of different groups, but I think what some people forget is who we're making fun of more than anyone, and on a weekly basis: the typical white American patriarch. We're not exactly painting this guy as a paragon of virtue."

No paragon of virtue, Peter Griffin, like all of *Family Guy*, provides a comical glimpse into a world that seems more random and inexplicable than ever. He, like the rest of the town he resides in, seems remarkably stable while the real world seems to be spinning out

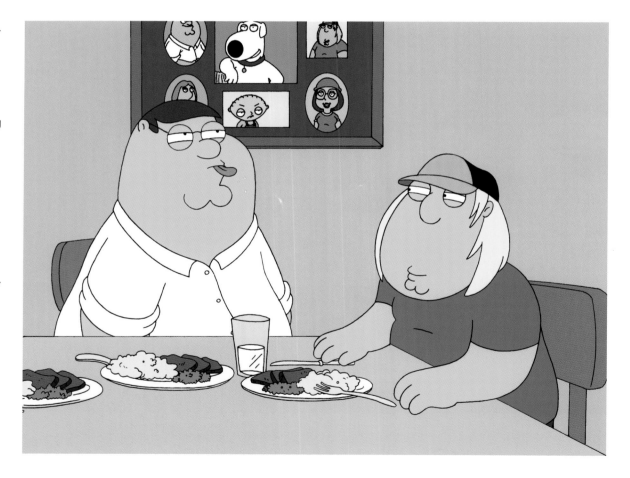

of control. And in the best tradition of cartoons, he and the rest of his family and the populace of Quahog are reassuringly impervious to time: Stewie is still a baby; Brian has far exceeded the expected life span of a dog yet remains in his prime.

"When *Family Guy* started, I was a 15-year-old playing a 15-year-old," says Kunis. "Now, 20 years later, I'm playing a character who's perpetually a teenager."

For all that, *Family Guy* is something to take comfort from.

Sure, Peter betrays rare moments of existential doubt. For a fleeting instant in a Season 14 episode he complains that he's a loser: "Dead-end job. Crappy house. Aging

wife who's getting skinny where fat's supposed to be and fat where skinny's supposed to be."

For the record, there's no visual evidence that Lois is aging, any more than any sign suggests that Peter is wising up.

The overarching lesson from *Family Guy*: The present may be ill-conceived, the past is a lost cause and the future isn't headed anywhere that won't mean trouble. So relax and just watch. Again and again.

That's what *Family Guy* fans do.

"It's so packed with jokes and its characters are so compelling, you can watch an episode and watch it again in a week and not remember half of it," says David A. Goodman.

With its arrival, *Family Guy* unwittingly

anticipated the internet and streaming-video viewing.

"That's what led to our show's success," says Alex Borstein (Lois). "It was the ability to stop, rewind, play, stop, freeze, go back, play, pause and then play again that led people to drink in every little flashback and cutaway and gag that was so densely packed into each episode. It wasn't just the absurdist, postmodern content of the show, it was also the magic of the timing of its release."

Family Guy prepared itself and its audience for an era beyond the pre-measured, take-it-or-leave-it packaging of TV that had prevailed since TV's birth. Here were modular, available-anywhere portions of video humor.

"You can watch the story. You can pull it apart. You can pull the gags out. The gags will still be funny," Borstein says.

"I love watching old episodes," says Mike Henry (Cleveland), "because I don't remember which gags are in each episode. They have nothing to do with the story, so, to me, it's like watching a new show every time."

It has been a game changer with its curated clutter of cultural references, its "found art" of funny as it draws attention to things we may have never acknowledged, or refused to acknowledge, or acknowledged and then dismissed from our minds (or so we thought).

And it will always make us wiser, if in ever-dumber ways.

Just consider this never-fail math stunt from Peter: "Take your age. Subtract two. Add two. That is your age."

Or his religious observation: "If wine is the blood of Christ, he must have been wasted 24 hours a day."

Never forget: Even after all these years, the word (of course) is "bird." Pay heed: When you poop in your dreams, you poop for real. And as for something freakin' good, rest assured no treat comes close to butter spread across a Pop-Tart.

Also: Keep in mind that when the message in your bowl of Alpha-Bits just says "Oooooo," what you've really got is a bowl of Cheerios.

And for the sake of the entire universe, every fan of *Family Guy* should remember this: Do *not* alter the past in any way if you happen to go back in time. The consequences could be dire.

ACKNOWLEDGMENTS

This book is the result of the hard work from a number of people.
Special thanks to Mick Cassidy, Amy Wagner, Steve Callaghan, Tania Francisco, Anne Michaud, Denesha Williams, Deborah Winslow, Anjel Shehigian, Shannon Smith, Kara Vallow, Sheri Conn, Carol Roeder and Nicole Spiegel.

And of course a huge thank you to all the talented people who have helped Seth make *Family Guy* the show that it's been for over twenty years. The preceding pages only show a small sampling of their talent.

Adam Alexi-Malle, Adam Carolla, Adam Levine, Adam Rickabus, Adam Steel, Adam West, Addis Zaryan, Adela Robinson, Adela Schwab, Adria Firestone, Affion Crockett, Agatha Sarim Kim, Aglaia Mortcheva, Aimee Garcia, A.J. Benza, Alan Bennett, Alan King, Alan Shearman, Alan Tudyk, Alastair Shearman, Albert Acosta, Albert Feliciano, Aldin Baroza, Aldrin Cornejo, Alec McClymont, Alec Sulkin, Alessandra Rizzotti, Alex Barnow, Alex Borstein, Alex Breckenridge, Alex Carter, Alex Fernandez, Alex Park, Alex Rocco, Alex Thomas, Alex Trebek, Alex Zabolotsky, Alexa Nikolas, Alexa Ray Joel, Alexander Campos, Alexander Dilts, Alexander Siddig, Alexandra Enck, Alexandra Kube, Alexis Knapp, Alfred "Tops" Cruz, Ali Raizin, Alice Chang, Alison Brown, Alissa Kueker, Allie Crane, Allison Adler, Allison Janney, Allison Smith, Allyson Philobos, Alyssa Milano, Amanda Bell, Amanda Bynes, Amanda Seyfried, Amanda Young, Amber Lee Hardin, Amir Talai, Amy Schumer, Amy Wagner, Ana Christina Perez, Ana Gasteyer, Ana Ortiz, Anatole Klebanow, Anders Holm, Andi Klein, Andre Robinson, André Sogliuzzo, Andrea Beutner, Andrea Fay Friedman, Andrew Burrell, Andrew Egiziano, Andrew Ellerd, Andrew Friedman, Andrew Goldberg, Andrew Gormley, Andrew Hibbard, Andrew Hollandsworth, Andrew Karr, Andrew Kishino, Andrew Overtoom, Andrew Schmidt, Andrzej Kozlowski, Andy Dick, Andy Jolliff, Andy Tauke, Angela Mueller, Angelo Fazio, Anil Kapoor, Anjel Shehigian, Ann Wilson, Anna Kendrick, Anna-Jane Casey, Anne Hathaway, Anne Michaud, Anne Murray, Annemarie Brown, Anne-Michelle Seiler, Anthony Agrusa, Anthony Blasucci, Anthony Morris, Anthony Skillman, Anthony Tavera, Antonio Torres, Ari Graynor, Ariana Grande, Arianna Huffington, Aries Spears, Arif S. Kinchen, Armin Steiner, Arnold McCuller, Art Mawhinney, Arthur Morales, Artie Johann, Asa Akira, Aseem Batra, Asha Flowers, Ashley Benson, Ashley Long, Ashley Tisdale, Ashton Kutcher, Audrey Stedman, Audrey Wasilewski, Audrina Patridge, Augie Castagnola, Augusto Bastos, Ava Acres, B. J. Ford, Bao Nguyen, Barbara DeSantis, Barclay DeVeau, Barry Manilow, Barry Moran, Becca Ramos, Becky Lau, Belita Moreno, Belle Norman, Ben Lane, Ben Stein, Bert Ring, Beth Littleford, Betty White, Bev Chapman, Beverly D'Angelo, Bike Kinzle, Bill Barry, Bill Devine, Bill Edwards, Bill English, Bill Engvall, Bill Escudier, Bill Ho, Bill Maher, Bill Ratner, Bill Riling, Bill Thyen, Billiam Coronel, Billy Domineau, Billy Eichner, Billy Gardell, Billy Unger, Billy West, Biz Urban, Bob Barker, Bob Bowen, Bob Costas, Bob Foster, Bob Gunton, Bob Jaques, Bob Joyce, Bob Kurtz, Bob Newlan, Bobby Costanzo, Bobby Lee, Bobby Slayton, Bonnie Jhocson, Bonnie Joseph, Boohwan Lim, Brad DePrima, Brad Goreski, Brad Winters, Brandee Stilwell, Brandi Young, Brandon Hines, Brandon Kruse, Brandon Strathmann, Breckin Meyer, Breilyn Brantley, Brenda Campbell, Brendan Konrath, Brendyn Bell, Brent Crowe, Brent Michael, Brent Spiner, Brent Woods, Brett Varon, Brian Blessed, Brian Capati, Brian Doyle-Murray, Brian Dunkelman, Brian Hogan, Brian Iles, Brian Scully, Brian Tochi, Brian Williams, Bridget Kyle, Brigitte Nielsen, Brinson Thieme, Brittany Snow, Brody Hutzler, Bronwen Barry, Brooke Roberts, Bruce Jenner, Bruce Lanoil, Bruce McGill, Bruce Willis, Bryan Cranston, Bryan Garver, Bryan Konietzko, Bryce Collins, Brynne Orloski, Butch Hartman, Byunghwee Kim, C.J. Spiller, C.S. Lee, Caitlin Alexander, Caitlin Bockmier, Camilla Stull, Camille Guaty, Camryn Manheim, Candace Marie Celmer, Candice Bergen, Cara Zozula, Carl Linton, Carl Lumbly,

244

Carl Reiner, Carla Delaney, Carlos Alazraqui, Carlos Luzzi, Carlos McCullers II, Carlos Ortega, Carlton Chestnut, Carly Simon, Carol Binion, Carol Channing, Carol Kane, Carolyn Datuin, Carrie Fisher, Carrot Top, Cary Elwes, Cary Gillenwater, Cassandra Brewer, Cate Blanchett, Catherine Reitman, Cathy Cahlin Ryan, Cedric Yarbrough, Celeste Pustilnick, Chace Crawford, Chad Cooper, Chad Katona, Chad L. Coleman, Chad Morgan, Chang-Woo Shin, Charlene Smith, Charles Durning, Charles Kimbrough, Charles Payne, Charles Ragins, Charles Reid, Charles Song, Charlie Cooper, Charlie King, Charlie Sheen, Cherry Chevapravatdumrong, Cheryl Tiegs, Chevy Chase, Chip Chinery, Chong Lee, Chris Alexander, Chris Bartholet, Chris Bennett, Chris Cox, Chris Diamantopoulos, Chris Doll, Chris Edgerly, Chris Finnegan, Chris Galya, Chris Gentile, Chris Gronkowski, Chris Hardwick, Chris Long, Chris Loudon, Chris Matthews, Chris McKay, Chris O'Dowd, Chris Parson, Chris Pompeo, Chris Regan, Chris Robertson, Chris Sheridan, Christina Milian, Christina Pickles, Christine Baranski, Christine Lakin, Christine Smith, Christine Terry, Christopher Glenn, Christopher Hacker, Christopher Holt, Christopher Keith, Christopher Ross Martin, Christy Romano, Chuck Klein, Chul Gang, Chul-Hee Han, Ciro Nieli, Cleo King, Cloris Leachman, Colin Ford, Colin Heck, Conan O'Brien, Connie Britton, Connor Trinneer, Corey Barnes, Corey Manuel, Craig Anderson, Craig Burgee, Craig Elliott, Craig Ferguson, Craig Hoffman, Craig Reid, Crawford Wilson, Cristin Milioti, Crystal Perea, Cy Amundson, Cyndi Tang, Cynthia Carrington, Cynthia McIntosh, Cynthia Watros, D.D. Howard, D.F. McKenzie, D.J. Qualls, Dakota Dennis, Dakota Fanning, Damien Fahey, Dan Aykroyd, Dan Castellaneta, Dan Conroy, Dan Cubert, Dan Gronkowski, Dan Lund, Dan Mills, Dan Nainan, Dan Peck, Dan Povenmire, Dan Smith, Dana Gould, Dana Walden, Daniel Hogan, Daniel Osaki, Daniel Palladino, Daniel Ridgers, Daniel Stern, Daniele Gaither, Danielle Panabaker, Danny Smith, Danny Trejo, Dante Fabiero, Dante Leandado, Dao Le, Darlie Brewster, Darrel Heath, Dave Boat, Dave Brain, Dave Collard, Dave Corwin Policino, Dave Moses, Dave Sherburne, Dave Walsh, Dave Weathers, Dave Willis, Dave Wittenberg, Dave Woody, Davey Faragher, David A. Bemis, David A. Goodman, David Beall, David Berry, David Boreanaz, David Boudreau, David Cross, David Hemingson, David Herman, David Ihlenfeld, David Jung, David Lee, David Lodge, David Lyman, David Lynch, David Mazouz, David Pressman, David Pritchard, David Tennant, David Thewlis, David Wright, David Zuckerman, Davis Jones, Dayla Corcoran, Dayna Kelly, DC Douglas, Dean Barlow, Dean Bauer, Dean Richman, Debbie Reynolds, Debbie Shin, Debbie Stoyanof, Debby Hindman, Deborah Winslow, Debra Skelton, Debra Wilson, Dee Bradley Baker, Deepak Sethi, Delara Saberi, Denesha Williams, Denis Martell, Denise Crosby, Denise Mitchell, Denise Tam, Dennis Farina, Dennis McElroy, Derwin Jordan, Devala "de de luxe" Marshall, Diane Robin, Dick Van Patten, Dick Wolf, Dikembe Mutombo, Dima Malanitchev, Dimitri Diatchenko, Dolph Lundgren, Dominic Bianchi, Dominic Polcino, Don Digirolamo, Don Gordon, Don Judge, Don LaFontaine, Don Most, Don Sciore, Don Swayze, Don Tai, Don Woodard, Dong Ryul Baek, Dongkwan Kim, Dong-Young Lee, Dong-Yul Baek, Doug Anderson, Doug Cooper, Doug Lackey, Doug Williams, Dr. Anders Carlson, Dr. Drew, Dr. Neil deGrasse Tyson, Dr. Wesley A. King, Drew Barrymore, Drew Carey, Drew Gentile, Drew Graziano, Dwight Schultz, Eamon Pirruccello, Ed Acosta, Ed Asner, Ed Helms, Ed McMahon, Ed O'Neill, Ed Westwick, Eddie "Piolin" Sotello, Eddie Jaeil Byun, Eddie Kaye Thomas, Edgar Duncan, Edmund Fong, Eduardo Olivares Jr., Edward Mariscal, Eileen Kohlhepp, Elaine Ko, Elijah Wood, Elisha Cuthbert, Elizabeth Banks, Elizabeth Boston, Elizabeth Nelson, Ellen Albertini Dow, Ellen Page, Elmo Ponsdomenech, Emily Osment, Emily Towers, Emma Roberts, Enn Reitel, Enzo Baldi, Eric Anderson, Eric Brown, Eric Dane, Eric Fredrickson, Eric Lloyd Brown, Eric Sanford, Eric Schermerhorn, Eric Vesbit, Erik Moxcey, Erik von Detten, Erin Hayes, Erinn Hayes, Ernie Sheesley, Esther H. Lee, Esther Ku, Estrella Capin, Estrelle Harris, Eunhee Shim, Eunjoo Lee, Eunok Park, Eva Bella, Fairuza Balk, Faith Ford, Fiona Gubelmann, Fitzgerald Gonzalez, Flea, Florence Stanley, Floyd Van Buskirk, Fran Doyle, Frances Callier, Francis Dinglasan, Francis Lucas, Frank Molieri, Frank Peak, Frank Sinatra Jr., Frank Welker, Fred Savage, Fred Tatasciore, Fred Willard, Freddy Rodriguez, Fredrick Kim, Gabriel DeFrancisco, Gabriel Iglesias, Gabrielle Union, Gaby Moreno, Garrett Donovan, Garrett Morris, Gary Beach, Gary Cole, Gary Hall, Gary Janetti, Gary Newman, Gates McFadden, Gavin Dell, Gavin Dunne, Gedde Watanabe, Gene Laufenberg, Gene Simmons, George Christy, George Igoe, George Rogan, George Wendt, Gi-Hong Jeong, Gilbert Gottfried, Gina Gershon, Gina Lugo, Ginger Gonzaga, Ginny Sherwood, Giovanni Cavalieri, Giovanni Ribisi, Glenn Close, Glenn Dion, Glenn Gronkowski, Glenn Hill, Glenn Howerton, Glenn M. Higa, Gordan Kent, Gordon Gronkowski, Gordon Suffield, Gore Vidal, Greg Colton, Greg Jbara, Greg Lovell, Greg Manwaring, Greg Nelson, Gregg Allman, Gregory Jbara, Gregory Thomas Garcia, H. Michael Croner, Hal Grant, Haley Joel Osment, Han Songyul, Hank Azaria, Hanki Hong, Hannah Han, Hannah Pitts, Hans Ranum, Hart Bochner, Harvey Fierstein, Harvey Levin, Hayes Davenport, Hayley Adams, Heather Shannon, Hee Ja Cho, Helen Kim, Helen Reddy, Helen Roh, Helen Tse, Helena Lamb, Helene Yorke, Henriette Mantel, Henry C. Montgomery, Hilary Hager, Hillary Tuck, Hlynur Magnusson, Hopper Penn, Hugh Downs, Hugh Hefner, Hugh Laurie, Hugh MacDonald, Huni Fodor, Hunter Gomez, Hwajong Kim, Hyesun Kim, Hyungsam Park, Hyunkook Gang, Ian Chen, Ian Graham, Sir Ian McKellen, Ignacio Serricchio, Ike Barinholtz, Ikhwan Yim, Ilya Chegodar, Indigo, Ioan Gruffudd, Irina Fuzaylova, Isaac Hempstead Wright, Isabel Vargas, Isabella Acres, Issac Ryan Brown, Ivan Tankushev, Ivaylo Angelov, Ivis Freeman, Iwan Rheon, J Lee, J. Alex Butler, J.J. Abrams, Jack Carter, Jack Dyer, Jack Perkins, Jack Samson, Jack Sheldon, Jackie Sollitto, Jackson Douglas, Jackson Rathbone, Jackson Schwartz, Jacob Hair, Jacob Pressman, Jacob Tremblay, Jacqueline Sheng, Jae Woo Kim, Jaechul Yoon, Jaehee Kim, Jaehee Lee, Jaeho Moon, Jae-Sik Whang, Jago Soria, Jaheem Toombs, Jairo Lizarazu, James "Cannonball" Greene, James Burkholder, James Caan, James Hartley, James Kyson, James Lipton, James Martin, James Purdum, James R. Bagdonas, James Woods, Jamie Denbo, Jamie Farr, Jamie Ledner, Jamison Yang, Jamy Huang, Jan DeWitt, Jane Carr, Jane Lynch, Jansen Yee, Jason McGuinness, Jason Milov, Jason Mraz, Jason Park, Jason Pittman, Jason Priestley, Jason Segel, Jason Weitzner, Jason Wood, Jay Chandrasekhar, Jay Leno, Jay Mohr, Jay Pharoah, Jay Wood, Jaydi Samuels, Jea-Ok Jeong, Jed Rees, Jee Hyun Yoo, Jeff Bergman, Jeff Cross, Jeff Daniels, Jeff Garlin, Jeff Howard, Jeff Mertz, Jeff Myers, Jeff Probst, Jeff Ross, Jeff Stewart, Jeff Witzke, Jeff Wong, Jefferson R. Weekly, Jeffrey Benavides, Jeffrey Gatrall, Jeffrey Plamenig, Jenna Jameson, Jenna Lamia, Jenna Von Oy, Jennie Garth, Jennifer Beltrami, Jennifer Birmingham, Jennifer Coyle, Jennifer Graves, Jennifer Jean Snyder, Jennifer Kessler, Jennifer Love Hewitt, Jennifer Patton, Jennifer Tilly, Jeremy Hoey, Jeremy Kehler, Jeremy Olsen, Jerilyn Sedgewick Blair,

Jermaine Fowler, Jerry Lambert, Jerry Langford, Jerry Sroka, Jessica Barth, Jessica Biel, Jessica Stroup, Jevon Bue, Jihoon Lee, Jihyun Lee, Jill Talley, Jim Bernstein, Jim Breuer, Jim E. Lara, Jim Fitzpatrick, Jim Fleckenstein, Jim Garifi, Jim Goldenberg, Jim Keeshen, Jim Meskimen, Jim Parsons, Jim Rash, Jimmy Fallon, Jimmy Iovine, Jimmy Kimmel, Jinho Heo, Jinjoon Hwang, Jisung Bahng, Jo Jo Aguilar, Joanna Fuller, Joanna Garcia, Joe Buck, Joe Cecchini, Joe Daniello, Joe Denton, Joe Flaherty, Joe Lomonaco, Joe Schmidt, Joe Vaux, Joel David Moore, Joel Hurwitz, Joey Slotnick, Johann Urb, John Aoshima, John Banh, John Bunnell, John Bush, John de Lancie, John Dubiel, John Erwin, John Finnemore, John Holmquist, John Jacobs, John Joyce, John Mathot, John Mellencamp, John Morey, John Moschitta Jr., John O'Day, John O'Hurley, John Pattison, John Rice, John Riggi, John Ross Bowie, John Seymore, John Tumlin, John Viener, John Walts, Johnny Brennan, Johnny Depp, Johnny Galecki, Johnny Knoxville, Johnny Weir, Jon Benjamin, Jon Cryer, Jon Daly, Jon Favreau, Jon Hamm, Jonah Platt, Jonathan Frakes, Jonathan Gebhart, Jonathan Harris, Jonathan Kite, Jonathan Morgan Heit, Jonathan Osser, Joonwon Song, Jordan DiNapoli, Jordan Ramp, Joseph Aguilar, Joseph Lee, Joseph Seal, Josh Lehrman, Josh Radnor, Josh Robert Thompson, Joshua Rush, Joshua Taback, Joy Fehily, JP Manoux, Juanita Jennings, Judd Hirsch, Judith Light, Judy Greer, Jules Green, Juli Hashiguchi, Julia Sweeney, Julie Bowen, Julie Hagerty, Julie Kavner, Julius Sharpe, Julius Wu, Juluis Preite, June Foray, Jung Yon Kwon, Jung-A Yoo, Jungja Wolf, Jungjae Lee, Justin Bram, Justin Kawamoto, Justin Koznar, Justin Wakefield, Justin Warren, Justin Zuckerman, Kabir "Kabeezy" Singh, Kadeem Hardison, Kaitlin Olson, Kara Vallow, Karen Marjoribanks, Karen Vice, Karhad Abdi, Karin Perrotta, Karley Scott Collins, Kat Foster, Kat Purgal, Kate Jackson, Kate McKinnon, Kate Rigg, Kate Riley, Kate Todd, Katharine McPhee, Katharine Ross, Kathleen Turner, Kathleen Wilhoite, Kathy Seymour, Katie Heckey, Katie Krentz, Katie Sah, Kay Arutyunyan, Kaya Dzankich, Kaye Hong, Kaylee DeFer, Kei Ogawa, Keir Gilchrist, Keith Ferguson, Keith Olbermann, Keke Palmer, Kel MacFarlane, Kelen Coleman, Kellie Lewis, Kelly Mazurowski, Kelly Ripa, Ken Dennis, Ken Goin, Ken Hayashi, Ken Laramay, Ken Marino, Ken Meyer, Ken Yi, Kenji Ono, Kenny Loggins, Keri Lynn Pratt, Kerrigan Mahan, Kersti Myrberg, Kevin Biggins, Kevin Durand, Kevin Hanley, Kevin Michael Richardson, Kevin Newman, Kevin Segna, Kevin Thresher, Kevin Spicer, Kiefer Sutherland, Kiernan Shipka, Kiff VandenHeuvel, Kihee Kim, Ki-Hong Jung, Kim Fertman, Kim Keung Yeon, Kim Le, Kimberly D. Brooks, Kimberly Ferguson, Kip Noschese, Kirker Butler, Kisso Shim, Kotaro Watanabe, Kristen Bell, Kristen Keeves, Kristin Long, Kristina Bustamante, Kristy Grant, Kuni Tomita, Kurt Dumas, Kyle Fukuto, Kyle Jolly, Kyle Lau, Kyle Leverett, Kyle Morgan, Kyoung Hee Lim, Kyrie Irving, Kyunghyun Kim, Kyungnam Go, Kyungran Joo, Kyung-Yeon Kim, Kyungyul Kim, Lacey Chabert, Lane Schnaitter, Larisa Perelman, Larry Smith, Larry Solomon, Larry Stensvold, Laura Atkinson, Laura Hilker, Laura Maurizi, Laura Silverman, Laura Smalec, Laura Vandervoort, Lauren Bacall, Lauren Caltagirone, Lauren Conrad, Lauren Graham, Lauren Hooser, Laurie Wetzler, Lea Thompson, Leasa Eisele, Lee Majors, Lee Sungwoo, Leif Garrett, Leilah Behrmann, Len Maxwell, Lena Haesoo Song, Lenny Clarke, Leslie E. A. Rider, Leslie Uggams, LeVar Burton, Lew Morton, Liam Neeson, Liam Payne, Liddane Sanders, Lieve Miessen, Lilit Atshemyan, Lily Talmy, Linda Lamontagne, Linda Porter, Lindsay Flinn, Lindsey Pollard, Lisa Cardenas, Lisa D. Fetterman, Lisa Hallbauer, Lisa Souza, Lisa Wilhoit, Lizzy Caplan, Lolee Aries, Lori Alan, Louis C.K., Louis Gallegos, Louis Gossett Jr., Louis J. Cuck, Louis Leung, Louis Tomlinson, Louise Duart, Lucas Grabeel, Lucas Gray, Lucas Van Wormer, Luciana Farias, Luke Adams, Luke Donaldson, Luke Perry, Lupe Ontiveros, Lyndon Smith, Mae Whitman, Maggie Mull, Majel Barrett Roddenberry, Marc Alaimo, Marc Mealie, Marci Proietto, Marcus Myrick, Margaret Cho, Margaret Easley, Mario Williams, Marion Ross, Marissa Loren Teitelman, Mark Borchardt, Mark Burnett, Mark Caballero, Mark Covell, Mark DeCarlo, Mark Eklund, Mark Ervin, Mark Firek, Mark Garcia, Mark Hamill, Mark Hentemann, Mark Koetsier, Mark Miraglia, Mark Paredes, Mark Zoeller, Mark-Paul Gosselaar, Marlee Matlin, Martha MacIsaac, Martin Mull, Martin Savage, Martin Spanjers, Mary Anne Deal, Mary Kay Bergman, Mary Kay Place, Mary Scheer, Masam Holden, Mason Cook, Matt $ Smith, Matt Barrios, Matt De Cesare, Matt Fleckenstein, Matt Harrigan, Matt McElaney, Matt Pabian, Matt Sullivan, Matt Weitzman, Matt Whitlock, Matthew Clinton, Matthew Krakour, Matthew Lawrence, Maureen Mlynarczyk, Maureen Weston, Maurice LaMarche, Maurice Lamont, Max Burkholder, Max Charles, Max Dibble, Max Hodges, Max Martinez, Maya Rudolph, Megan Grano, Megan Hilty, Megan Hoffman, Megan Kelly, Megan Scully, Melissa Aives, Melissa Lugar, Melissa Owen, Melissa Villasenor, Melora Hardin, Meredith Baxter, Meredith Scott Lynn, Meta Valentic, Mia Hyemin Kim, Mia Kai Simonne Moody, Mia Maestro, Micaela McCauley, Michael A. Osborne, Michael Bell, Michael Bennett, Michael Chiklis, Michael Clarke Duncan, Michael Dante DiMartino, Michael Dorn, Michael Gainey, Michael Gross, Michael Guerena, Michael Gurau, Michael Kinkade, Michael Loya, Michael McKean, Michael Narren, Michael Pataki, Michael Rowe, Michael Shipley, Michael T. Kennedy, Michael Trotter, Michael Upperco, Michael York, Michaela Watkins, Michel Lyman, Michele Lee, Michelle Bryan, Michelle Dockery, Michelle Dorn, Michelle Kwan, Michelle Sabrina Wong, Mick Cassidy, Mick Hucknall, Micky Rose, Miguel "Gorilla" Lopez, Mija Hwang, Mike Barker, Mike Barone, Mike Desilets, Mike Elias, Mike Henry, Mike Judge, Mike Kadlec, Mike Kalec, Mike Kim, Mike Lazzo, Mike Polcino, Mike Rundle, Mike Schank, Mike Wolf, Mike Yang, Miken Wong, Mikyung Kim, Mila Kunis, Mindy Cohn, Miriam Flynn, Miriam Margolyes, Misook Park, Misoon Kim, Missi Pyle, Mo Collins, Monica Lee, Monte Young, Murray Adler, Namsuk Cho, Nana Visitor, Nancy Cartwright, Nancy Wilson, Nat Faxon, Natasha Melnick, Nathan Gunn, Nathan Jones, Nathan Schafer, Neal Warner, Neil Affleck, Neil Brown Jr., Neil Goldman, Neil Patrick Harris, Neil Wade, Nic Camecho, Nicholas Cofrancesco, Nicholas Gonzalez, Nicholisa Contis, Nick Cannon, Nick Cron-Devico, Nick Dubois, Nick Kroll, Nick Rufca, Nick Toth, Nicki Hill, Nickie Bryar, Nicole Bernard, Nicole Byer, Nicole Joette Speed, Nicole Kohut, Nicole Sullivan, Niecy Nash, Niki Hyun Yang, Nina Dobrev, Noah Gray-Cabey, Noah Matthews, Noel Blanc, Noh Yonkun, Nolan North, Nora Johnson, Norm MacDonald, Olesya Rulin, Oliver Li, Oliver Pearce, Oliver Vaquer, Olivia Hack, Omid Abtahi, Oreste Canestrelli, Orlando Gumatay, Oscar Sosa, Owen Daniels, Pablo Solis, Padma Lakshmi, Pam Cooke, Pam Hyatt, Pamala Tyson, Panagiotis Rappas, Pat Crawford Brown, Pat Shinigawa, Patrick Bristow, Patrick Buchanan, Patrick Clark, Patrick Duffy, Patrick Gleeson, Patrick Hazen, Patrick Henry, Patrick Inness, Patrick Meighan, Patrick Stewart, Patrick Warburton, Patrick Welborn, Paul Andris, Paul Ganus, Paul Gleason, Paul Hegg, Paul Nam, Paul Scarlata, Paul Stanley, Paul Wee, Paul Young, Paula Abdul, Paula Lauterbach, Pauline Burns, Penelope Sevier, Perfecto Badillo, Perry MacFarlane, Perry Zombolas, Pete Elia, Pete Handelman, Pete Michels, Peter Busch, Peter

Chen, Peter Chernin, Peter Criss, Peter Frampton, Peter Gallagher, Peter R. Brown, Peter Riegart, Peter Roth, Peter Shin, Phil LaMarr, Phil Langone, Phil Stapleton, Philippe Angeles, Phillip Allora, Phyllis Diller, Piotr Michael, Portia de Rossi, R. Lee Ermey, Rachael MacFarlane, Rachael Stark, Rachel Butera, Rae McCarson, Rainn Wilson, Ralph A. Eusebio, Ralph Fernan, Ralph Garman, Ralph Kaechele, Randy Crenshaw, Raoul Bova, Raul Guerra, Ray Claffey, Ray James, Ray Kosarin, Ray Liotta, Ray Valenzuela, Raymond Arrizon, Reese Hartwig, Reginald Veljohnson, Regis Philbin, Reid Kramer, Reinaldo Yamada, Rene Auberjonois, Rey Espinola, Rhea Seehorn, Ric Quiroz, Ricardo Barahona, Ricardo Montalban, Rich Rinaldi, Richard Appel, Richard Dreyfuss, Richard Manginsay, Richard Rosenstock, Rick Chambers, Rick Del Carmen, Rick Ellis, Rick Farmiloe, Rick Kuhlman, Rick Logan, Rick McKenzie, Rick Springfield, Ricky Blitt, Ricky Garduno, Ricky Gervais, Rob Bou-Saab, Rob Corddry, Rob Gronkowski, Rob Huebel, Rob Lotterstein, Rob Lowe, Rob Narita, Rob Renzetti, Rob Schulbaum, Robert Costanza, Robert Downey Jr., Robert Foster, Robert Hughes, Robert Ingram, Robert Kesselman, Robert Lacko, Robert Loggia, Robert Romanus, Robert Tyler, Robert Wu, Roberto Casale, Robin Leach, Robin Walsh, Robson Menezes, Rochelle Linder, Rodney Griffis, Rogelio Martinez Barrera, Roland McFarlane, Rolando Molina, Ron Brewer, Ron Jeremy, Ron Jones, Ron Livingston, Ron MacFarlane, Ron Russell, Ron Smith, Ronnie Cox, Rory Hamilton-Battenfeld, Rory Thost, Ross Malorzo, Ross Marquand, Roy Allen Smith, Roy Scheider, Russ Leatherman, Russell Peters, Ruthie Redfern, Ryan Reynolds, Sage Ryan, Salene Weatherwax, Sally Young, Sam Black, Sam Littenberg-Weisberg, Sam Waterston, Samm Levine, Sanaa Lathan, Sandra Bernhard, Sandra Lee Calleros, Sandro Cleuzo, Sang-Chul Shon, Sanghoon Lee, Sara Fletcher, Sarah Bueno, Sarah Frost, Sarah Meyer, Sarah Mozal, Sarah Ramos, Sarah Utterback, Saundra McClain, Scarlet Sookyung Kim, Scott Bakula, Scott Grimes, Scott Hill, Scott Marder, Scott Wood, Seamus Walsh, Sean Bean, Sean Dempsey, Sean Fine, Sean Flynn, Sean Isroelit, Sean Kenin, Sean Penn, Sean Perry, Sebastian Siegel, Sendhil Ramamurthy, Seth Green, Seth Kearsley, Seth MacFarlane, Seth Podell, Seth Rogen, Seung Cha, Seung Woo Cha, Seunghwan Kim, Seungyong Ji, Shannon Ryan, Shannon Smith, Shanon Serikaku, Sharon Osbourne, Sharon Ross, Sharon Tay, Shavonne Cherry, Shawn Kerkoff, Shawn Michael Howard, Shawn Murray, Shawn Palmer, Shawn Pyfrom, Shawn Ries, Shawna Cha-Gallego, Sheetal Sheth, Shelley Long, Sherman Hemsley, Sherry Gunther, Sherry Romito, Silvana Ambartsoumyan, Silvio Cuadra, Simon Cowell, Sinbad, Sofia Randel, Sofia Vergara, Sookyung Guem, Sookyung Jang, Sookyung Keum, Sookyung Kim, Soonja Lee, Soonjin Mooney, Soorang Park, Spencer Balliet, Spencer Laudiero, Spencer Porter, Stacee Reich, Stacey Scowley, Stan Jones, Stanley Johnston, Stanley Kastner, Stark Sands, Stefania Campagna, Stephan Cox, Stephanie Escajeda, Stephen Bishop, Stephen Curry, Stephen Manders, Stephen Sandoval, Stephen Stanton, Stephen Wong, Steve Beers, Steve Callaghan, Steve Dierkens, Steve Marmel, Steve Robertson, Steve Urquilla, Steven Fonti, Steven K.L. Olson, Steven Luckett, Steven S.H. Yoon, Steven Zirnkilton, Stuart Bam, Sukgyoo Choi, Sukha Sherpa, Sukjin Yoon, Sukwon Lee, Sung Kang, Sunghye Park, Sungsoo Bang, Sungwoo Lee, Sunhyang Choi, Susan Crossley, Susana G. Esteban, Suzie Plakson, Suzy Beck, Swinton Scott III, Sylvia Keulen, Sylvianne Chebance, T.J. Miller, Taejoon Kim, Taesoo Kim, Tamera Mowry, Tania Francisco, Tanya Calderon, Tanya Gilmore, Tara Charendoff, Tara Lipinski, Tara Strong, Tara Whitaker, Tatum Hentemann, Taylor Cole, Ted Jessup, Ted McGinley, Ted Seko, Teresa Hsiao, Terry Pike, Thomas Dekker, Tia Carrere, Tico Wells, Tim Gunn, Tim Hwang, Tim Parsons, Tina Lugar, Tina Tseng, Toban Taplin, Todd Jacobsen, Todd Langner, Tom Archer, Tom Bosley, Tom Brady, Tom Dennis, Tom Devanney, Tom Dorfmeister, Tom Ellis, Tom Hollander, Tom Maxwell, Tom Mazzocco, Tom Selleck, Tom Wilson, Tony Danza, Tony Garcia, Tony Lunn, Tony Pulham, Tony Sirico, Tori Spelling, Tramm Wigzell, Travis Bowe, Trevor Tamboline, Tricia Garcia, Troy Brown, Tuck Tucker, Ty Burrell, Ty Simpkins, Un Lee, Ursula Taherian, Valentino So, Valerie Bertinelli, Valerie Fletcher, Valerie Giuili, Vance Caines, Vanessa B. Cruz, Vicky Luu, Victor J. Ho, Victoria Pricipal, Viet Phan, Virenia Lind, Vladi Rubizhevsky, Vonnie Batson, Wade Boggs, Wallace Shawn, Wally Wingert, Walter Murphy, Warren Kleiman, Waylon Jennings, Wayne Collins, Wellesley Wild, Wendy Jacobsmeyer, Wendy Miller-Smith, Wendy Perdue, Wendy Raquel Robinson, Wendy Schaal, Wentworth Miller, Whitney Port, Wil Wheaton, Will Blanchard, Will Ferrell, Will Phillips, Will Ryan, Will Sasso, Will Shadley, William Edwards, William Woodson, Willis Lombard, Wincat Alcala, Won Ki Cho, Wonkyoo Gang, Woody Kane, Xavier Allison, Yara Shahidi, Yeardley Smith, Yebbi Cho, Yelena Tokman, Yongho Lee, Yongho Park, Yoobong Park, Yooil Park, Young Baek, Young Kim, Young Lee, Younghee Higa, Youngmi Lee, Yvette Nicole Brown, Zac Moncrief, Zachary Gordon, Zeke Johnson, Zeus Cervas.

ABOUT THE AUTHOR

Frazier Moore is a charter-member fan of *Family Guy*. During a quarter century as television critic for the Associated Press, he wrote frequently about the show and the creative team that brings the Griffins to life, reaching back to 1999 and the series' debut episode, which he greeted as "hilarious." Prior to the AP and enjoying *Family Guy*, Moore wrote for publications including the *New York Times*, *Spy* magazine, *Interview*, *People* and *TV Guide*, and was an arts and feature writer for the *Atlanta Constitution*.

"Theme from *Family Guy*" from the Twentieth Century Fox television series *Family Guy*. Words by Seth MacFarlane and David Zuckerman. Music by Walter Murphy. Copyright © 1999 T C F Music Publishing, Inc. and Fox Film Music Corp. This arrangement copyright © 2019 T C F Music Publishing, Inc. and Fox Film Music Corp. All rights reserved. Used by permission. *Reprinted by permission of Hal Leonard LLC.*

Grateful acknowledgment is made to the following for the use of the images that appear throughout the text: MacFarlane family photographs courtesy of Ron MacFarlane (pages 35 and 36); photograph of Brian MacFarlane courtesy of Rachael MacFarlane (page 38); artwork photograph courtesy of Joseph Lee (page 74); photograph of Mike Henry courtesy of Mike Henry (page 82) and Meg roach painting photograph courtesy of Joe Vaux (page 216).

HarperCollins books may be purchased for educational, business, or sales promotional use. For information, please email the Special Markets Department at SPsales@harpercollins.com.

FIRST EDITION

Designed by Suet Chong and Mick Cassidy

Cover art by Julius Preite

Library of Congress Cataloging-in-Publication Data has been applied for.

ISBN 978-0-06-211252-1

19 20 21 22 23 WOR 10 9 8 7 6 5 4 3 2 1